Twentieth-century furniture

STUDIES IN
DESIGN
AND
MATERIAL
CULTURE

general editor
Paul Greenhalgh

Twentieth-century furniture
Materials, manufacture and markets

Clive D. Edwards

3542

MANCHESTER UNIVERSITY PRESS
Manchester and New York

distributed exclusively in the USA and Canada by St. Martin's Press

Copyright © Clive D. Edwards 1994

Published by Manchester University Press
Oxford Road, Manchester M13 9NR, UK
and Room 400, 175 Fifth Avenue, New York, NY 10010, USA

Distributed exclusively in the USA and Canada
by St. Martin's Press, Inc., 175 Fifth Avenue, New York,
NY 10010, USA

British Library Cataloguing-in-Publication Data
A catalogue record is available from the British Library

Library of Congress Cataloging-in-Publication Data
Edwards, Clive. 1947–
 Twentieth-century furniture : materials, manufacture, and markets
/ Clive D. Edwards.
 p. cm. — (Studies in design and material culture)
 Includes bibliographical references and index.
 ISBN 0–7190–4066–3. — ISBN 0–7190–4067–1 (pbk.)
 1. Furniture industry and trade—History—20th century.
I. Title. II. Series.
TS880.E39 1994
338.4′76841′00904—dc20 93–44612

ISBN 0 7190 4066 3 *hardback*
 0 7190 4067 1 *paperback*

Typeset in Times
by Graphicraft Typesetters Ltd., Hong Kong
Printed in Great Britain
by Redwood Books, Trowbridge

Contents

Contents

Figures

Figures

Acknowledgements

I would firstly like to thank Paul Greenhalgh, the general editor of this series, for encouraging me to undertake this project, and my wife, Lynne, for all her support and assistance in seeing it through. I would particularly like to thank Christopher Wilk who took the time to read the manuscript and was able to suggest detailed changes as well as offering much valuable help and criticism.

I would also like to thank the following for the assistance they have given me during the progress of this work: Judy Attfield, W. E. Bartlett, Paul Beale, Drew Bennett, Christie's, Conisborough Components, Peter Cook International, Ercol Furniture Ltd, Martin Fear, Peter Headington, Neil Morris, Clive Nathan, Larry St-Croix, Sotheby's, Neil Turvey, and the staffs of the London College of Furniture Library, the High Wycombe Public Library, the Wycombe Local History and Chair Museum, the National Art Library (Victoria and Albert Museum), and Loughborough Colleges Library. The library at the Furniture Industry Research Association was particularly helpful on more recent matters. The staff at the Geffrye Museum and ex-colleagues at the Victoria and Albert Museum have been helpful with archival material.

The author has made every effort to obtain permission to reproduce copyright material in this book. If any proper acknowledgement has not been made, or permission not received, we would invite any copyright holder to inform us of this oversight.

General editor's foreword

Furniture is one of the assumed commonplaces of the twentieth century. We all have it, and, at quite a fundamental level, we all perceive that we *need* it. Yet it was only during the course of the nineteenth century, as Clive Edwards showed in his previous volume in this series, *Victorian Furniture: Technology and Design*, that furniture truly achieved this level of availability. For most of us, it is in the choosing of it that we determine the appearance of our homes and work spaces.

Furniture occupies a fascinating space within our social fabric. For much of this century, it has been amongst the most expensive of commodities which most people have bought, and amongst the most durable. Thus, through longevity and cost, it has dictated the domestic atmosphere. Our furnishings identify and classify us. Publications and exhibitions have continually advised us on how to develop our tastes so as to be able to cope with this situation.

Modernist furniture, alongside one or two other key styles, has hitherto dominated the literature. One of the functions of this study is to provide a corrective to this dominance. It moves away from the idea of furniture as elite product, made by iconic designers, and concentrates on the reality of the furniture industry in our times. It explores the materials and techniques employed by the industry and its distributive structures, and examines the patterns of consumption which have developed over the past decades. What emerges is a complex pattern of activity; neither has the furniture industry been controlled by any one style, or styles, nor by any one technological approach or group of consumers. Rather, it has evolved pragmatically, constantly measuring technical innovation against marketability. Disparate factors have played significant roles in its evolution, including the World Wars, metallurgy, suburbia and department stores. We can only be grateful that such complexity is explored here with consummate clarity.

Abbreviations

BFM	British Furniture Manufacturers Association
BSI	British Standards Institution
CAD/CAM	computer aided design/computer aided manufacture
CNC	computer numerically controlled
CoID	Council of Industrial Design
DIA	Design and Industries Association
DIY	Do-it-Yourself
FDC	Furniture Development Council
FIRA	Furniture Industry Research Association
FPRL	Forest Products Research Laboratory
FTAT	Furniture Timber and Allied Trades Union
GRP	glass-fibre reinforced plastic
HIPS	high impact polystyrene
HP	hire purchase
KD	knock-down
MDF	medium density fibreboard
NC	nitrocellulose
PVC	poly vinyl chloride
NAFTA	National Amalgamated Furniture Trades Association
NARF	National Association of Retail Furnishers
NUFTO	National Union of Furniture Trade Operatives
RIBA	Royal Institute of British Architects
WPR	Board of Trade, *Working Party Reports, Furniture*, 1946

1 Introduction

Current research in the field of design history has begun to benefit from interdisciplinary scholarship, which has brought fresh ways of looking at objects and analysing the evidence surrounding their production, distribution, and consumption.

With the rise of material culture studies, there has been a move away from the modernist point of view with its frequent emphasis on names, movements, and icons. Furniture studies in particular have often been based solely on chronological summaries of the great and the good in design history. These works barely discussed the history and scope of technology and materials that have been introduced into the industry: while any analyses of the structures and scales of industrial organisations have often been isolated from individual object studies and carried out by economists or geographers.[1] However, it is clear that any discussion about innovative materials and techniques must include the pioneering work done by the well-known names in furniture history. For this reason the geographical parameters will sometimes extend beyond Britain, although this is the main focus of the work. The distribution system has received hardly any attention even though its role in the dissemination of goods is pivotal. Lastly, the purchases of the bulk of populations which make up the true material culture of a nation or period of time, are influenced by changing patterns of income and property ownership, and taste changes, as well as hierarchies of spending: these need to be analysed in conjunction with the above.

It is important to establish that this work is not another history of modern furniture; rather, it is an attempt to describe, illuminate and evaluate the roles of materials, technology, production systems, distribution, and consumption on the changes in furniture that have occurred in the twentieth century. Specific factors that need addressing in this investigation of furniture include: (i) the industry's

apparent conservatism towards economic, technical, and product design matters; (ii) the industry's rather selective adaptation of developments to suit themselves; (iii) the exciting innovations that have been developed; (iv) the dichotomy between innovation and tradition that is a continual feature of twentieth-century furniture; (v) the structure and scale of enabling organisations, trades and industries; and (vi) the influence of 'tastemakers', especially the retailer and the media.

The discussion around innovation, progress, and reform, versus convention, custom, and tradition, is related directly to questions about the cause and effect of changes and the manner in which they occurred. Technology and the manipulation of materials in the twentieth century has clearly brought about some far-reaching changes in the furniture industry. However, the enduring nature of the trade resulted in indirect progress, which arose from the use of spin-offs from other fields of endeavour, especially wars, transport, and architecture. This has resulted in an industry that remains a compromise between mechanisation, standardisation, and individual craft. Nevertheless it has also meant that the choice of techniques and materials has never been greater for furniture-makers.

In addition to these changes the rise of a mass market which expanded its appetite for furniture was essential as the complementary part of the economic equation. Prior to the nineteenth century, supply fitted demand. Along with the subsequent large population growth, increased spending power, and a shift in tastes, combined with changing patterns of income and expenditure, came changing concepts of need (in terms of furniture) and their expression as priorities in a hierarchy.

The methodology of this work is therefore based on a production-distribution-consumption model that has the effect of linking the various divisions that are part of the process of producing and consuming furniture. In this way, social, economic, and business history play their parts in the same way as does the history of production and technology.

Chapter 2 deals with the nature of materials used in furniture-making during the twentieth century. The major feature of the period has been the growth in the choice of materials for manufacturers and consumers, in conjunction with new techniques and production methods, and hence furniture designs.

2

The complexity of the range of materials available to the furniture-maker will be discussed in terms of the innovation and tradition argument mentioned above. Case studies will assist in this analysis. Topics covered will include: wood and wood-based products; plastics for construction, parts, and finishes; springing supports and systems and metals of various kinds.

Chapter 3 is concerned with the place of technology and production systems and their role in effecting changes in the twentieth-century industry. Whilst it may be argued that the mainspring of progress in the technique of furniture-making has been in the introduction of new materials, the techniques developed to process these have been important especially in terms of organising production methods and systems. By tracing the development of furniture production, it will be shown how the industry reacted to the demands made upon it.

The major influences of the results arising from work during World Wars I and II, and the continuing combination of craft and machine will be discussed. The rise of standardisation and the search for type-forms will be investigated, as will individual case studies, which will examine aspects of technology more thoroughly to give examples of the general points being made. The case studies will include the development and influence of machine use; timber technology, e.g. seasoning, bending, jointing, and laminating; upholstery, and finishing processes.

Chapter 4 investigates how the industry has organised itself to meet the demands made upon it, in terms of structure, entrepreneurial skills, distribution, and its attitude to design. This chapter will trace the development of the structure of the furniture industry to demonstrate how sectors of the industry have risen or fallen in response to the demands of the twentieth century. The role of design and the industry's attitude towards it is set out, and is followed by an analysis of central government's involvement with the industry.

The nature of the distributive processes and their effect on the production and sale of furniture has been virtually ignored by historians; Chapter 5, therefore, is of vital importance to the analysis of the period, and is included here as it is essential to twentieth-century furniture studies. The chapter will also discuss whether the 'retailing revolution' has affected furniture as much as any other commodity, by evaluating its organisation, policies on buying and selling, and its

apparent role as an arbiter of taste. The position of the furniture retailer as the pivot of the trade will be examined. To the manufacturers he or she is often seen as the hindrance in bringing innovative designs to the public, whilst to the public he or she is the source of furniture and furnishings and is therefore one of the instrumental agents influencing the taste of particular groups of people within society.

Chapter 6 looks at the consumption of furniture by the general public. Clearly there exist significant problems with any work that involves consumption: the enormous disparity between groups, let alone individuals, makes it necessary to generalise. However, as consumption is the last stage in the evaluation of products, an attempt has been made to look at consumer attitudes towards 'ordinary' furniture and furnishing in this century. After a brief introduction, the period has been divided into four convenient sections which seem to relate to the major changes in the industry.

The first period is 1900–25. The unprecedented rise in demand began to put a strain on the older systems of furniture-making, and this section discusses the nature of that demand and how it manifested itself. Factors affecting this included the communications revolution, resulting in increased cultural flow; the development of housing; greater disposable income, and the growing demand for design differentiation in furnishings.

The period 1925–40 is then examined to discuss the dichotomy between an apparent commitment to innovation and tradition in design. It will examine the tug-of-war between design evolution (and the imagery of the machine age, for example) and the symbolic nature of furniture with its links to the past. The concerns of social reformers as well as art and design critics meant that consumers in this period were inundated with advice. What were the results of all these efforts?

This is followed by a section which begins with the Utility scheme (which resulted in Government interference in design on a large scale), and ends with the throwaway imagery of the 1960s. This period is crucial: it witnessed the change from an austere wartime situation to one which allowed the possibility of greater freedom of expression through one's surroundings. The importance of market research, often based on social science methodology, resulted in the targeting of particular sections of the market.

The final section examines the consumption of furniture since the 1960s. The many and varied branches of the trade, the massive variety of designs, and not least the incredible interest in interiors and home furnishings, have made furniture a status indicator within particularly defined groups. From MFI to Memphis, the furniture world has changed rapidly throughout this period in order to cope with the ever-increasing demands made upon it.

An emphasis on business, technology and a social science approach has created certain limitations and constraints (i.e. no mention of the craft movement or contract furnishings) but the approach has allowed a number of aspects of the business of 'ordinary' furniture to be related and assessed. Whilst acknowledging the impact of major named designers, companies and design movements, the work mainly tries to investigate other areas of influence.

Note

1 Notable exceptions include the work of Pat Kirkham and the Geffrye Museum.

2 Materials

Furniture has always been made from a variety of materials but it was during the nineteenth century that there were a number of attempts made to deliberately introduce new materials into furniture-making. Some of these were successful and laid the groundwork for later developments; others were commercially unsuccessful, so were not realised. For the most part it was wood or metal materials that were used in innovative ways.[1] However, these changes, although noteworthy, were relatively minor when compared to the developments of the twentieth century.

There can be little doubt that the enormous progress in the development of materials in the twentieth century has been one of the controlling factors in furniture design and manufacture. The sheer range of materials now available has given the manufacturer an ever wider choice of opportunities: what is perhaps unclear is whether the changes have been a result of technology push or market pull.

Whatever the case, materials have a great many attributes which would support either view. The obvious ones are the physical (i.e. lighter, easier to clean), the tactile (i.e. feels comfortable when in contact with the body), and the structural (i.e. improved performance in use) and economic (reduced costs). In addition, material attributes will usually include (i) a visual or decorative feature, such as a veneer; (ii) a signifying role, as in the use of oak timber to symbolise tradition; and (iii) they are often complex in themselves, as for example, in an outer layer of a composite material. These multiple meanings therefore seem to indicate that changes in materials use occur in response to a consumer point of view (market pull) as well as from a technical and production stand-point (technology push).

Furthermore, the rise of new materials has progressively allowed the designer and manufacturer a greater degree of control over the end-product. This process had been identified by John Gloag, when

he quoted from *Men like Gods* by H. G. Wells. Wells had created a Utopia in which 'the artist had a limitless control of material, and that element of witty adaptation had gone from his work'. Gloag (1952) suggested that in the twentieth century the 'limitless control of material' was furnished by plastics, by light metals, and by plywood.[2] The 'witty adaptation' that Wells refers to was in the manipulation of obdurate materials, in which the worker had to use craft and ingenuity to achieve the best results. In his Utopian scheme it meant that this skill was lost to the certain end-product coming from reliable materials, such as plywood and particle board. H. G. Wells' fiction was soon fact. Some years later, David Pye (1968) put forward the view that there was a move away from the 'workmanship of risk' to the 'workmanship of certainty'. He was specifically talking about machine use, but the development of homogeneous materials, in combination with more and more sophisticated machinery, has meant that the making of furniture has become more and more certain.[3]

By the 1960s the extent of the substitution of traditional materials by new materials was phenomenal. In 1967 one commentator reporting on the trade in the United States, found that:

> Most of them [furniture manufacturers] seem to feel that utilization of new materials is of greatest importance. Plastics have become popular wood substitutes with wood textures and finishes. I have seen dressers and chests, 80 per cent plastic, which are incredibly accomplished wood imitations; I have seen cast aluminium supplanting bentwood, with a perfect wood finish. I have had to inspect applied wood carvings very closely before I determined that they were plastics.[4]

If this example is anything to go by, it appears that many material innovations seem to be used to maintain a symbolic taste pattern, in this case wood, at a profitable level. The use of modern materials to imitate traditional ones rather than be used in a novel way clearly says something about the market.

In contrast to the American example above, a plea for the acceptance of more suitable modern materials was made by Trippe (1962):

> The inertia of traditionalism on the part of the furniture-buying public is all the more unexpected when one appreciates the extent to which modern top quality stylists such as E. Gomme have weaned them on to modern designs. There is no doubt that the production engineer would

have his problems greatly simplified if only the general buying public could be persuaded that it was good, respectable mid-twentieth century taste to buy furniture made of mid-twentieth century materials instead of an unstable material like timber. This applies particularly to the use of metal.[5]

Whether or not the customer wanted new materials per se, or as substitutes for older ones, George Nelson (1949) suggested that the designer 'feels compelled to produce shapes that fit appropriately into his world.'[6] If this is true, then the extensive development of new materials that represent the twentieth century would appear to assist this process. The natural question to ask then was whether the customer wanted these new shapes in his or her world.

The difficulty and advantage for the design process in relation to materials in the mid-century was simply the great freedom that these materials offered. One attitude was summed up by Eero Saarinen (1962) when he said:

> New materials and new techniques have given us great opportunities with structural shells of plywood, plastic, and metal. The problem then becomes a sculptural one, not the cubist constructivist one.[7]

It is perhaps at this point that some designers lose touch with their customers, and begin to think of furniture in terms of sculpture or fine art, rather than objects that reflect an individual's aspirations and lifestyle.

Wood

It hardly needs saying that wood, in one form or another, has remained one of the primary materials of the twentieth-century furniture industry, despite attempts at substitution. This perhaps has as much to do with the connotations of wood to the furniture-buying public, as any desire on the part of the makers to remain with a traditional material.

Apart from the composite materials made from wood which are discussed below, there were many efforts by furniture-makers and the other woodworking industries to manipulate timber into a more manageable and reliable raw material. The desire for homogeneity and certainty were strong driving forces. Beginning at the initial stages of woodworking, the first of these efforts were developments in timber seasoning.

One of the earliest methods designed to expedite the seasoning process was the 'Powellising' technique. In this, timber was first saturated in a sugar solution with the addition of arsenic and other poisonous salts to defend against insect attack. The drying-out process of the prepared timber was apparently quicker and more satisfactory, as the sugar solution encouraged even drying throughout the log, thus avoiding splits and other damage.[8] The process had a substantial write-up in the trade press; in one instance it was described as 'an important development for furniture manufacturers'.[9] The same report discussed and illustrated some furniture produced by Birch and Company of High Wycombe, which had been made up from Powellised timbers. The range was specially displayed in Whiteley's store in Bayswater. Each item was carefully described, with a strong emphasis on the fact that most of the timber used had been in a 'wet state' only three to four weeks prior to manufacture. Although the process does not appear to have been a commercial success it is a clear example of progressive ideas being applied to woodworking.

Realistically, the direction for improvements in timber drying lay with advancements in the controlled kilning of timbers. Much work was done between World Wars I and II by the Forest Products Research Laboratory to develop scientific kiln-drying. Most manufacturers used a combination of methods, but as late as 1960, a High Wycombe manufacturer, Glenisters of Temple End, still only used natural open-air seasoning.[10] Nowadays, seasoning is a highly skilled, scientifically controlled process.

Although softwoods are increasingly popular, the role of hardwoods in furniture-making continues to be important in many branches of the industry.[11] Indeed the range of timbers available has increased considerably during the century. For example, the introduction of colonial woods at the British Empire Exhibition of 1924–25 included silver greywood and laurel from India, obeche and agba from Nigeria, and walnut and blackbean from Australia: these were all used either for their decorative veneer or for constructional parts.[12] However, oak remained far and away the most important timber, so much so that domestic stocks had to be supplanted by foreign imports. During the 1930s oak accounted for over one third of foreign hardwood imports. According to Brian Latham (1957), 'the bulk of it went into furniture manufacture of oak furniture, which was then very popular with the public.'[13]

It is quite clear that even by the end of World War II, the bulk of the trade still considered that timber and timber products, such as plywood, would be likely to remain the most important material for many years to come. It is also clear that the trade as a whole did not seriously consider the substitution and use of alternative materials.[14] In 1955 it was noted that 'Despite developments in both materials and production methods, solid timber remains the most important material for cabinet making'.[15]

A year later a trade journal (1956) could confirm, albeit with a vested interest, that

> timber is restored to its former glory as the premier material for furniture. The steel age has passed, and now pieces in tubular steel are mainly confined to chairs suitable for stacking, though even here the laminated timber chair has gained much ground.[16]

By the 1960s, wood technology had reached a point whereby the traditional methods of manufacture seemed somewhat archaic in the later twentieth century. One commentator (1962) considered:

> It is surely an anachronism in this day and age to slice up wood into thin strips, pay expert craftsmen to inspect each piece by eye, and then glue it together, just to make a piece of chipboard look like a natural piece of wood![17]

Trippe continued his castigating tone by commenting on the way other industries had accepted new materials with alacrity: 'In most industries if a designer can find a better material it becomes a publicity asset. The reverse is the case in the furniture industry.'[18]

Although not often used for publicity, many new materials have been quietly embraced by manufacturers in recent years. This is due partly to economic reasons and partly to ecological demands which have highlighted the problems of tropical timbers. Wood products, particularly man-made boards, will, however, surely remain important for many more years for reasons of economy, merit, and value.

Plywood

The history of plywood as a furniture-making material has been discussed elsewhere[19] and it is sufficient to say here that by the beginning of the twentieth century it had been usefully developed in certain sections of the trade. Apart from the simple material, the

features of twentieth-century plywoods have centred upon further developments. These have included multiply, blockboard, laminboard, battenboard, hollow-core construction, and moulded plywood.

Developments in the application of plywood had generally been of a rather specialist nature prior to the 1920s. The most well-known uses of plywood were for combined chair seats and backs, particularly in the United States, and for bentwood chair seats, tea chests, and packing crates in Europe. One of the first uses made by commercial furniture-makers was to substitute solid wood drawer-bottoms with plywood, and by 1927 this method had become almost universal. In many instances plywood was also introduced for the backs, tops, and dustboards of furniture.[20] Apart from the savings made by these innovations, it is clear that another major benefit of using ply components could be found in the weight reduction of the furniture. Although this feature was a customer benefit, plywood furniture was often compared unfavourably with 'solid wood', and was unjustly criticised for being flimsy.

The development of true plywood, from its substitute for solid wood in panel situations, to its use in the manufacture of curved and bent surfaces, progresses through the early to mid part of the century. Various architects and designers experimented with the material during the 1920s, and although Alvar Aalto is commonly credited with the first successful use of bent plywood, there were many experiments before his seminal products.[21]

Modernists clearly saw in plywood a truly contemporary material that might be used to demonstrate the design ideals of truth to materials, and the form following function. For example, in 1927–28 Geritt Rietveld designed a steel-framed plywood-seated chair that combined the two 'modern' materials – steel and plywood. Gerald Summers used aeroplane ply as an experimental material for furniture-making which resulted in the curved surfaces that were the hallmark of his company, Makers of Simple Furniture. The economy of production, requiring only four basic steps, and a cold moulding process made his single-sheet bent plywood armchair an exciting proposition.[22] Thirdly, in 1936, Marcel Breuer designed the famous plywood Isokon Long chair and associated furniture all using bent plywood.[23]

Although these designs were not popular, the ideas that came from these avant-garde pioneers were assimilated by the commercial

11

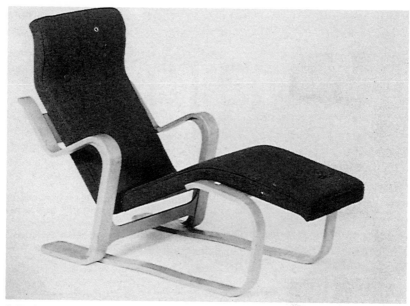

1 Isokon Long chair, designed by Marcel Breuer 1935–36

manufacturers quite easily. Bent plywood was used in the construction of many 'moderne' or 'art deco' -influenced trade designs for anything from coffee tables to cocktail cabinets. Indeed plywood lost favour with the avant-garde as the attractions of metal became clearly more modern.

Other ideas were attempted with little commercial success. One such was the development of the material 'Plymax' by Dr Love of plywood manufacturers Venesta. This comprised the fixing of thin metal sheets of galvanised steel or copper and Monel metal (nickel-copper alloy) to plywood. Although the first uses were in the panel-sides of vans in 1936, John Gloag described the possibilities of the material for furniture and Jack Pritchard designed and had made a small sideboard using ³/₄ inch (19 mm) plymax for framing.[24] Despite its undoubted qualities it was not adopted by the industry.

One major development in the use of plywood for furniture was the three-dimensional forms introduced by Charles Eames and Eero Saarinen in 1940. The Museum of Modern Art (New York) competition of *Organic Design* awarded these chairs first prize. The

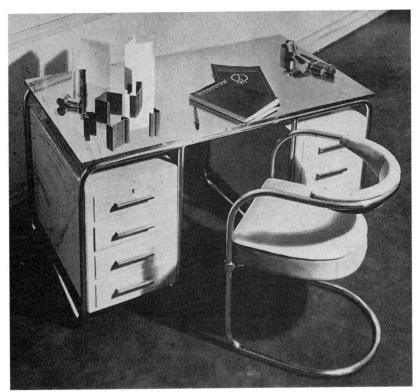

2 Copper-topped Plymax desk with a frame of copper tubing, *c.* 1933

team went on to develop plywood structures bent in two directions and it was soon declared that Eames had, 'with one stroke underlined the design decadence and the technical obsolescence of Grand Rapids',[25] a clear reference to the old-fashioned design and production ideas of one of the prime American furniture-making centres. The exhibition catalogue (*c.* 1941) recorded the importance of these chairs: 'A significant innovation was that, in the case of chairs by Saarinen and Eames, a manufacturing method never previously applied to furniture was employed to make a light structural shell consisting of layers of plastic glue and wood veneer molded in three dimensional forms'.[26]

During World War II, Charles and Ray Eames worked with the Moulded Plywood Division of Evans Products to further develop their work. The use of plywood components in items as varied as leg

splints and gliders was developed and again provided the break-throughs that would eventually feed into commercial furniture products.

After the war, the idea of making a non-upholstered chair from compound curvatures in plywood, was achieved by layering five plies of timber between two plates of a mould. The mould was inflated to shape the plywood into the required pattern, whilst at the same time cooking a melamine finish into the top ply.[27] A seat or back section could be processed in approximately ten minutes.

The difficulties of combining different types of material was high-lighted by the Eames's work. Originally the technique of cycle weld-ing (developed by Chrysler to bond rubber to wood or metal), was first considered by Eames and Saarinen for the fixings in their chairs designed for the *Organic Design* competition in 1940.[28] As this method was reserved for the war effort, the chairs had to be fixed in another way. In 1945–46 a satisfactory mass-production technique for con-necting the parts of the chair was finally achieved on the assembly line, by gluing the shock mounts to the wood pieces with a resorcinol-phenolic adhesive, applied with heat and pressure. The legs were then screwed to the shock mounted spine, and the seat was attached to the legs and spine by four additional shock mounts.[29] The inno-vation of new materials often meant that the associated processes also had to be re-thought.

Quite clearly the development of plywood during the war was to have far-reaching effects on the furniture industry. In World War II, major developments such as the work of the Eames's, as well as sandwich or stressed-skin plywoods[30] made the material respected in its own right. In Britain, plywood had been used very successfully in building gliders, landing craft and most especially in the Mosquito plane.[31] Commentators who noted that the fuselage of Mosquito planes and Vampires were constructed of plywood, considered that public awareness of this fact should go a long way to dispelling the prejudice towards plywood in furniture.

In a comment immediately after the war it was recognised that, 'the use of this "new" material was largely the means whereby it was found possible to offer attractive and serviceable furniture within the reach of the lower income classes.'[32] Despite this the practical application of suitable designs for manufacture incorporating ply-wood, did not appear to have been exploited to the full at this time.

The *Working Party Report* (1946) considered that although constructional and design changes had begun to be made, there was great potential to develop them further with plywood. In addition, the same Working Party showed some foresight when they questioned the time-consuming processes of building up flat or curved panels by edge jointing (coopering) and cramping boards.[33] They asked how long would it be before a reconstituted material was used which avoided the problem of built-up boards. This acknowledgement of plywood, and by implication other board material, seems to have foreseen the developing panel process for furniture-making.[34]

The situation in the United States was slightly different to Europe. The British Productivity Team (1952), commented on the relatively small part played by plywood in the American furniture industry at that time. They noted that the trade would rather use solid timber or 'core-stock' similar to blockboard.[35] This was in some measure due to the easier availability of hardwoods in the United States.

The developing use of plywood necessitated changes in furniture construction. Plywood panels encouraged flush surfaces in cabinet design, and the supply of pre-formed moulded shapes could be used for chair and seat parts. Not surprisingly, it was the architect-led contract market that encouraged these developments. A good example would be the Hillestak chair of 1949–50, designed by Robin Day for Hille, which used pre-formed plywood for the backs and seats combined with a laminated wood spine.

The development of Carl Jacobs's plywood stacking chair, produced by Kandya in 1953, was one of the more successful commercial designs. After twenty-five prototypes and months of development the one-piece wrap-around design with a jigsaw joint underneath the seat was found to be most satisfactory. Subsequent to their initial launch in plain beech or with an upholstered seat pad, they were made available with the exterior shells painted in colours to match the plastic laminates used on Kandya table tops.[36] Although designed to be sold with other Kandya furniture for domestic situations, they were also used in contracts, for example, three hundred of them were purchased for the London Festival Hall Restaurant.

The possibilities of plywood being used in a batch production system where standardised parts were readily available for straightforward assembly, was clearly advantageous. For example, the

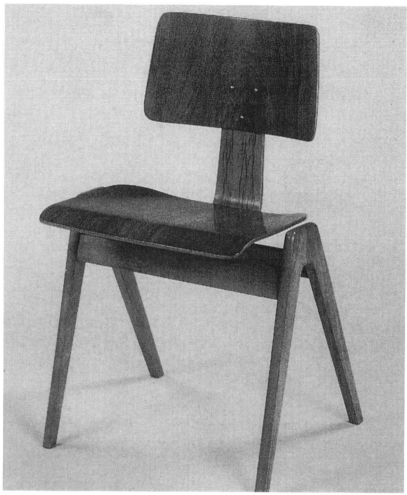

3 Hillestak chair by Robin Day for Hille. The chair uses pre-formed
plywood panels and a laminated spine, *c.* 1949–50

production of 'tubes' of bent ply and laminates pre-formed to shape
would allow parts to be sliced off to make complete arm sides or
frames, whilst the development of moulds enabled many complex
shapes to be built up, which could easily be fitted to frames.[37]

The pace of developments in other materials meant that plywood
was gradually superseded but designers continue to experiment with

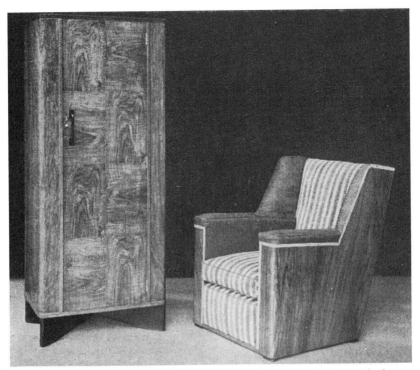

4 Two examples of the application of 'jointless' plywood. A wardrobe and chair by M. Spiers Ltd, *c.* 1948

plywood. Peter Danko's innovative one-piece ply chair produced from one sheet of laminated plywood is a good example. Originally made individually in the designer's workshop, it was taken up by the American Thonet company and was produced commercially from 1980.[38]

Laminated wood

Laminated wood, as opposed to plywood, has the grain of the veneers used all running in the same direction. Again it was well known in the nineteenth century, especially in the early chair designs of Thonet. Although Josef Hoffman used laminated wood as part of the structure of his 720/F tub chair of 1902,[39] it was only to be seriously revived in the 1920s when improvements to glues allowed

17

laminates to become lightweight structural components. Amongst the most well-known uses of laminations are the furniture ranges designed by Alvar Aalto. His use of laminations to create a cantilever chair from wood is one of the classics of twentieth-century design. His other triumphant use of laminations was in designs which used a solid leg into which laminations are introduced, allowing the piece to bend from a vertical to a horizontal plane. Two triangular sections are then bonded together so that they become corner supports for a table or a stool. Although Aalto often combined plywood as a seat with laminations for frames he was not unique in this practice.

Whereas Aalto designed furniture especially for his architectural commissions, Gilbert Rohde recognised the need for low cost and simple furniture for the twentieth-century consumer. He was employed by a number of furniture-makers including Hermann Miller and the Heywood-Wakefield Co. to produce modern designs for batch production of unit systems and upholstery.[40] One of Rohde's best-known chairs was made from single sheets of plywood for chair seats with the base of the chair in laminated wood.

The laminating technique was also suitable for cabinets and in 1946 in the United States, the Plymold Corporation produced a desk from bent laminations. The desk was particularly innovative in its drawer construction as it only used three elements, the back and sides being moulded in one piece.[41] This was to become a commonplace drawer construction method in the 1970s.

In England, even by 1955, one critic was disappointed to find that the successful wartime laminating technique used in the Mosquito aircraft had not been exploited by the trade:

> Laminated bends presuppose new, and for this country, strange forms and these the trade has generally rejected in preference to forms derived from the more conventional methods of construction. The attitude of the trade towards the bending of laminated wood is disappointing, especially as it is *merely one facet of the furniture manufacturers' deeply rooted antagonism to any change* [my italics].[42]

It is a clear example of the way the industry waited to be pushed by technology or pulled by demand rather than being in the vanguard of change.

Exciting developments in laminated wood technology are still

possible. In the early 1990s the Knoll company asked architect Frank Gehry to design and develop a new chair range. Gehry's approach used the concept of basket work to weave thin laminates of maple wood into chair shapes which had the seat and support integral with each other:

> Now structure and material have freed bentwood furniture from its former heaviness and rigidity, it really is possible to make bentwood furniture that's pliable, springy and light.[43]

Not to be confused with laminated wood is laminboard. This material is made from strip sections of solid wood which are glued together and veneered to make up a flat board material. Originally conceived by Richard Kummell, the boards first had core blocks of about 25–30 mm in width, which were produced by the Deutsche Holzplattenfabrikk at Rehfelde at least by 1910.[44] By 1921 experiments had led to a reduction in the size of the core strips to about 3.3 mm. This more reliable board became known as laminated board and later laminboard.

In 1927, Shirley Wainwright introduced the idea of laminboard (laminated board) to develop furniture-making and avoid the problems of jointing sections of solid wood to make up panels. This apparently coincided with 'a vogue for a simpler type of furniture depending for decorative interest on choice veneers rather than on mouldings, carving or fanciful contours.'[45]

These simpler designs required a substantial substrate, as they could not rely on decoration to hide their joints or supports, so the idea of laminboard was a sophisticated response.[46] Inevitably, it was eagerly accepted by the 'modern design' lobby.

Sir Lawrence Weaver (1930) declared: 'laminated board has become not only a desirable but an essential and inescapable element in furniture construction'.[47] Weaver seems to have hoped for nothing less than a minor revolution in design from the use of laminboard:

> Laminated board gives to furniture the same character that the use of steel and concrete tends to produce in architecture. Thus at length we may confidently look forward to a genuine revitalisation of design and decoration proceeding not from successive waves of imitative fashion but from the truthful application of a material of which the practical and decorative possibilities seem to be limitless.[48]

This was clearly a modernist manifesto in which the role of materials was paramount in expressing the truth and honesty of a design. Although still used on occasions, the block and laminboards have been generally superseded by high grade particle boards, and these have contributed to yet another change in furniture design.

Particle board and hardboard

Panel boards such as ply, block, and laminboard are all based on a layering process. The other types of man-made board used in furniture-making are made from particles of material: these boards include hardboard, particle board, and medium density fibreboard.

In 1898, early experiments, based on the breaking down of fibres of cellulose material, especially wood, led to the development of hardboard. The main innovations came in the early 1920s when wet pulp-wood was compressed in hot presses to produce rigid sheet hardboard suitable for furniture applications.[49] Used mainly for space filling in drawer-bottoms and cabinet backs, its image has perhaps suffered in furniture use because it has also been a favoured do-it-yourself material.

Particle board was developed in the late 1930s and consists of the conjunction of dry wood particles and synthetic resins fixed under pressure.[50] Commercially produced in Germany from 1941, it was introduced on to the British market from 1946–47, although it was not seen as a furniture material until the later 1950s. Although in 1953 Gordon Russell mentioned 'reconstituted wood boards as being suitable for furniture',[51] it was clear that the trade was slow to embrace the material. In 1955, Michael Sheridan noted that particle board, although used in panelling headboards and occasional table tops, was not considered suitable for carcase work at that time, and in a 1956 manual of contemporary cabinet design and construction it was not mentioned.[52] When it was introduced into furniture-making, it marked a major change in the construction of furniture as it used prepared panels supplied by outside merchants. In comparison, German furniture manufacturers had early on established their own wood-chipping plants, in order to control the quality and supply of the product.

Wood was not the only material used as a base for particle boards.

The residue of linen preparation from flax was converted into flaxboard and sugar-cane residue was made into bagasse board. Although these were not very popular, Hille were one company who used bagasse board successfully for the tops of their KD Kompass table.

Particle board is now a major part of furniture manufacturing, and its features of flatness, smoothness and freedom from warping, as well as dimensional stability, to say nothing of relatively reasonable cost, have ensured that it has been the basis of the mass market in cabinet furniture around the world. Its applications have been extended beyond cabinet work in recent years. Its use in the making of upholstery frames has meant that a 'squared off' design for much recent upholstery has been inevitable.

The most recent development of prepared board material is medium density fibreboard (MDF); based on fibres produced from wood chips mixed with wax and resin, it was developed in the 1960s in the United States.[53] The main characteristics of MDF are such that it is seen as a very acceptable substitute for solid wood, with many features that commend it to the furniture maker. It is very smooth, and can be machined without breakout or material loss and can be finished with a variety of materials applied directly to its surface. Contrary to particle board it needs no extra edging or surface treatment. The use of MDF has encouraged a trend in designs using moulded edges and raised surfaces.

Finally, an interesting experiment in developing 'synthetic woods' was undertaken in the United States during the 1960s; the so-called Atomic wood.[54] This was wood that was impregnated with plastic and irradiated by placing the wood in a vacuum chamber where air and gases were removed and replaced by a monomer. The timber was then subject to gamma rays causing the monomer to polymerize resulting in a solid wood-plastic composite. Lockheed Aircraft Corporation made use of this process and called it Lockwood. This composite needed no finishing and had many of the basic properties of wood with few of the disadvantages. It seems that the product known as densified wood was similar to atomic wood in that it was made from a large number of veneers, impregnated with resin and then bonded under great pressure. The result was a very strong material that was only suitable for engineering purposes as it was too dense to be used with ordinary woodworking tools.

Bentwood

The history of bentwood has been dealt with elsewhere but there are a number of aspects that need to be highlighted here.[55] Christopher Wilk has rightly pointed out that the bentwood phenomenon was not new to the twentieth century, rather it was the continuity of the popularity originally found in the latter half of the nineteenth century.[56] What is noteworthy is that bentwood enjoyed both an elite modernist, as well as a commercial, critical success in the twentieth century. The 'high-brow' success lasted for a while, i.e. until the realisation that the material bent was actually the despised and old-fashioned wood; this resulted in a change of heart and the consequent embracement of bent metal. The commercial success of bentwood chairs appears to have continued to the present day, both in domestic and contract use. There was a particular revival of bentwood as a domestic fashion in the 1960s when inexpensive imports from Eastern Europe meant that this furniture was exceptional value. It was also ideal for the more eclectic interiors promoted by Habitat and others, as it was often stained in a variety of bright colours.

Although the bentwood chair represents a classic type-form, it is relevant to ask how widespread the taste was for this type. It perhaps should not be seen as a cheap working-class solution to furnishing problems; it is rather a conscious design statement. However, the potency of the bentwood chair as a type-form is such that it is often reproduced in coloured metals or plastics, often as a direct copy of an original shape.[57]

Plastics

The role of plastics is now so ubiquitous that it is difficult to imagine a time when they were not part of everyday life. Even in the conservative furniture industry, manufacturers have embraced many of the myriad plastics that have become available during the twentieth century. The chemistry and history of plastics has been well covered elsewhere[58] so this work will not dwell on the material history; rather it will investigate the nature and role of plastics in furniture design during the period.

The uses of plastics in furniture cover a wide range of applications, including construction, finishing, gluing, upholstery covers and

fillings, fittings, and accessories, such as handles and applied decoration. Some of these applications will be discussed in other appropriate sections of this work.

Yet again the precursors of plastics can be found in nineteenth-century developments where, for example, gutta-percha was fabricated into mouldings and parts for furniture decoration. The use of this particular material declined on the grounds of cost, but other composite materials were developed for use as substitutes for carving during the nineteenth and early part of the twentieth centuries.[59] The first application of plastics to furniture appears to have been in 1926 when the Simmons Company of Racine, Wisconsin, produced a reproduction style chair-frame, made from eight separate phenolic mouldings with an upholstered timber-framed seat and back.[60] In 1932 a French manufacturer used phenolic plastic for functional outdoor table tops, chair seats and backs, and achieved great commercial success. By the 1940s the acrylic plastic, Lucite, was introduced as a furniture material and was highly regarded for its clear glass-like qualities.[61]

Further developments using PVC material occurred in the 1940s with the development of inflatable PVC cushions. The first use of such an arrangement was in the Numax chair made by Elliot Equipment. This had PVC bag-cushions fitted on to a metal or timber frame to make a chair. In 1944 the Gallowhur Chemical Company was producing a chair with a PVC 'tyre' in the shape of a doughnut, fixed to a timber frame with netting. In 1948, Davis Pratt, whose chair used an inflatable tyre inner tube within a fabric bag, mounted on a simple metal frame, won second prize in the Museum of Modern Art's Low Cost Furniture Competition in New York. The low cost and portability of the 'tyre chairs' made them seem 'a natural' for the market at the time. They were not commercially produced although the idea spawned numerous later versions.[62] For most consumers at this time, the only contact with plastics in furniture was their use in handles or radio cabinets.

In Britain, interest in plastics for furniture began to develop soon after World War II. For example, International Plastics and Runcolite Ltd began production of some furniture designs by Gaby Schreiber. The former company produced an aluminium drawer unit with a plastic skin and recessed handles, while the latter made a complete plastic moulded cupboard.[63] It would appear that these were intended

for contract use rather than for the domestic market, as they were rather institutional in style.

In 1953, a major article in the British trade press noted that: 'the use of plastics in furniture has so far been limited practically to wireless cabinets.'[64] This assessment, which was broadly correct, referred to the use of moulded material in radio cabinet construction but it was not to be very long before plastics began to have a much bigger impact on the furniture industry.

One of the earliest and most consistently successful uses of plastics in the British furniture trade was with laminates. Discussing plastic laminates in 1956, Denise Bonnett argued that: 'Nothing quite so significant has made such an impact on the furniture trade for many years'. It was likely that its success owed something to the fact that it was fundamentally a veneering process, already so familiar to the trade. However, that cannot be the whole story. The attractiveness of laminates to the public, not only in kitchen situations but also for dressing-table tops, desk tops and various other items, helped to encourage a whole new style of furniture finish.[65] Their visual appeal, based on colour and pattern, coupled with the practical advantages of heat and scratch resistance, ensured their success. Indeed this success encompassed many areas of furniture design: laminates were used by Robin Day for Hille furniture as successfully as unknown designers used them for inexpensive dinette sets.

Some of the most important post-war developments related to the use of plastics in chair design. Many plastics have been applied to chair design, including polystyrene, polyurethane and glass-fibre reinforced plastic (GRP) (see further below). The development of chair designs and their relation to materials and technology can nowhere better be seen than in Hille's 'Polypropelene' plastic stacking chair.

This advance was a major breakthrough as it used a new material to produce a self-supporting shell that could be fitted to a variety of bases. Although these were promoted and sold to the domestic market, large-scale contract use was the most important outlet.[66] By using an inexpensive plastic material, combined with the injection moulding process, the product could be sold at very competitive prices. Although from an ergonomic point of view there was some criticism of the initial design, a second revised design was introduced and this has remained hugely successful.[67]

The versatility of plastics meant that the material could be fabricated into both progressive or traditional designs. For example, in 1965, high impact polystyrene was used by Arkana to produce their innovative Mushroom range of dining and occasional furniture, designed by Maurice Burke. This was the first furniture to be rotationally moulded using polyurethane filled bases and a double skin.[68] Whilst the Arkana Mushroom range was an example of contemporary design, many manufacturers continued to use plastics as a replacement for wooden components in traditional designs, ranging from fascia mouldings to complete frames.

In 1967 the use of high impact polystyrene (HIPS) for components was still relatively new but it was stated that, 'It is now possible to reproduce a plastic part that is almost impossible to distinguish from wood.'[69] The desirability of this from the manufacturers' point of view was that plastic parts were necessary to meet price points, sustain regularity of supply and standardisation, and still maintain an element of style. The customer demand for more ornate surfaces was often prohibitive in traditional materials, so even for small runs plastics were economical. Apart from the cost factors, the plastic suppliers sold other advantages of plastic over wood. There was no movement or shrinkage, plastic was more impact resistant than wood, and it was easier to colour match to other parts of a group. American manufacturers were particularly happy using plastic for reproductions of Colonial and Early American and other decorative styles: 'You can put in extra design without extra cost ... merely put the detail into the mold, including the wood graining'.[70] This attitude to materials and design was noted by one perspicacious commentator:

> The difference between American and European furniture is that in America they are making things of the past with methods of the future; in Europe we are making things of the future with the methods of the past.[71]

This obviously refers to plastics in particular but could be related to many other aspects of furniture-making as well. The big advantage, and the reason for the success of HIPS structural foams in the USA, seems to be that there is no antipathy to mock antique furniture as there is (was) in Europe.

The benefits to the customer who purchased furniture with plastic components were clear to Kenneth Booth, a vice-president of the

25

American business, Ward Furniture Manufacturing Company. He listed them as follows: greater style, intricate design details, greater durability, complete uniformity, and better performance, e.g. non-stick drawers and decorative elements that were child-proof. Even with this impressive list the need to sell the idea of plastics was clear. To do this, Booth thought that a good salesperson should include in the sales talk, discussion about the space-age material, the value of modern research, and the good value offered by plastics.[72] With all these selling points, it is not surprising that plastics have made such inroads, rather it is more surprising that timber products still hold a prominent place in the market.

The development of the use of plastics, as often found with other materials, rests with the supply industry. In terms of design the industrial designer, Massimo Vignelli (1968), pointed the way for plastics: 'after breaking out of the cast iron stage of plastics i.e using it to imitate other materials, the designer will find the true significance of the material itself.'[73] Whether this prophesy was true or not, experimentation in plastics furniture reached a peak in this period and showed its amazing versatility.

Following developments in plastics for cabinet-making and side chairs, attention was turned to plastic shells for large upholstered chairs. In 1957 the famous Egg chair by Arne Jacobsen was produced from glass reinforced plastic shells. This idea soon moved down market so that shell swivel chairs were soon available to all sectors of the market. In the mid-1960s experiments were conducted that allowed rigid polyurethane-foam shells to be used for upholstery.[74] The other well-known plastic was polystyrene, which in 1969 was used in granular form for the innovative Sacco chair and the innumerable bean bags that have been derivatives of this original ever since.

In 1967, the change in the attitude to plastics was clearly moving towards acceptance. The range and number of applications in furniture-making were growing and now included chair shells, drawer and wardrobe fitments, decorative laminates, foam upholstery, fabrics, fittings, finishes, and adhesives. The benefits of plastic in terms of economy and value were beginning to become clear with higher raw material and labour costs for traditional methods. As well as the possibility of using unskilled labour and automation on a production line, the added advantage was seen that different items could be made on the same line, as moulding tools were easy to interchange.

Further developments included drawers made from moulded polystyrene and extruded PVC; fittings, including nylon catches and polypropelene hinges; and plated plastic handles and knobs in imitation of metal were all common.[75]

Despite these developments, as late as 1969, Stanley Little, director of upholsterers Guy Rogers of Liverpool, attacked the head-in-the-sand attitude of the furniture trade towards the material, by saying that 'Unless we use plastics and the new techniques offered, we will disappear like the blacksmiths who refused to become motor mechanics'.[76] His concern was that the industry would lose business to specialist plastic companies if the material wasn't welcomed into the furniture-maker's repertoire.

By the early 1970s it seemed as if the march of plastics would be inexorable:

> Plastics are likely to be the success story of the seventies. The extent of the impending plastics explosion can be judged from the fact that the United States, where plastic mouldings have almost entirely replaced wood for decorative carvings, the amount of polystyrene has increased from two million pounds weight in 1965 to an estimated thirty-five million pounds weight in 1968.[77]

However, the plastics story has not all been one of uncritical benefits. For example in 1970, the fashion for 'wet-look' plastic coated upholstery covers was in vogue. *The Times* commented that:

> Research experts are unable to predict beyond eighteen months how the fashionable polyurethane-coated fabrics will wear, but this has not stopped manufacturers and retailers selling such suites at £300 or more with no warning to the public.[78]

Inevitably there were problems with surface peeling and many consumer complaints ensued: these perhaps fuelled the return to fabrics such as synthetic-fibre velvets or the later popularity of cotton prints and loose covers.

Nevertheless, complaints and problems aside, the relationship between plastics and furniture grew and grew. Thelma Newman (1972) summed up the new attitude to plastics, and, more importantly, emphasised the way that materials can direct furniture design, when she wrote:

> new materials bring new designs, the four legged chair looks the way it does because the raw materials dictate, in part, what it would do, and

tradition fills in as guide; a chair made of plastic, however, could have many more legs or none. It could be a ball, cube, cone, hard or soft.[79]

Although plastics have given a number of new dimensions to furniture design (especially in the Italian furniture business), in popular furniture, plastics have played an ambiguous role. They are essential in helping to maintain a reasonable cost base, whilst at the same time they can express either tradition or modernity. The sight of a cabinet made from particle board held together with plastic components, fitted with plastic drawers, veneered with a plastic 'wood-finish' foil, and finished with a metallic-coloured plastic trim or 'wood' moulding is very common. The required style can be created simply by changing the colour of the foil finish and selected added details. Plastics are now being used to produce frames for traditionally shaped, fully-upholstered side and wing chairs.

One of the most important sub-divisions of plastics is the combination of glass fibre and plastic resin, commonly known as glass fibre or GRP (glass-fibre reinforced plastic). In 1948 the Eames's DAR chair, the first self-supporting one piece glass reinforced plastic chair shell, won second prize in the Low Cost Furniture Competition in New York. Even so it was innovative. This was the first chair to have a moulded fibreglass seat in which the natural surface of its materials was exposed.[80] It is important to note that the Eames's originally intended the chair to be made from stamped aluminium or metal. It was a commercial decision to produce the chair from GRP. Arthur Drexler points out how simple it was to conceive of a chair for production in metal but actually make it in GRP. So much for 'the nature of materials as significant determinants of form'.[81] Process has transgressed material boundaries.

Further developments in GRP shells for chairs came with Eero Saarinen's Womb chair of 1948. Manufactured in moulded GRP, it was a response to his perception of a market for a large, really comfortable chair. Considering that people were sitting differently in the 1950s to the 1850s, Saarinen gave the chair three planes of support as well as 'psychological comfort by providing a great big cup-like shell into which you can curl and pull up your legs (something which women seem especially to like to do)'.[82]

One commentator pointed out that manufacturers' limitations constrained experiments in the field. In fact Young (1958) makes the

interesting point that the Eames-Saarinen collaboration was effectively the fusing of the two-dimensional wood laminating process with the moulding techniques established by the papier-mâché manufacturers of the nineteenth century.[83]

Whatever the origins of the processes, the methods of production were based on either a hand lay-up method or a moulding system. The former, used in Britain, resulted in 20–30 shells being made from one mould in a week, incurring hardly any tooling costs. Alternatively the use of matched moulds could give an output of about 500 shells per week, but with a tool and equipment cost of between £10,000 and £15,000. In 1970, Young could still say that the use of GRP was limited, due to the cost of tooling and material, therefore manufacturers still used hand laying-up techniques and small runs.[84] It is not surprising to find that moulded polystyrene chair shells were more successful than the relatively expensive GRP models.

In 1960, the true benefit of GRP was developed when Verner Panton produced his famous stacking chair. This was the first one piece plastic chair.[85] Although an impressive design statement, its direct impact on the domestic furniture market seems negligible.

However, whilst there has been an emphasis in this work on the conservative nature of design in much of the furniture industry, in the 1960s there was a rise in demand for modern design, at the expense of traditional styles. This was noted by Herbert Wood, a manufacturer of a successful range of reproduction oak furniture.[86] His response was to establish in his works a range of glass-fibre upholstered chairs mounted on metal or wooden legs and supplied with easily removable covers, and were marketed under the brand name of the Lurashell range. These chairs were extremely successful, being sold in Heals as well as the high street stores and additionally being supplied to the export and contract markets.[87]

It would seem that like all fashions in furniture, this trend passed on, and although plastics have found a niche for themselves in the many components mentioned above, on the domestic market they remain mainly used for inexpensive chairs.

Latex rubber and synthetic foams

The work involved in the time-consuming and skilful task of springing a seat, layering stuffing materials, and fitting a tight cover on to

an upholstered item is considerable. In addition the making and filling of loose feather cushions is tedious and troublesome. Anything that began to cut down the cost of these processes was surely welcome. The change in the use of materials in upholstering resulted in the application of developments that were not always specifically made for solving furniture problems.

Latex rubber as a cushioning material was one such development. Foam rubber began with the early experiments at the Dunlop company, where a food mixer was used to whisk liquid latex with additives, which was then cured like a meringue in an oven.[88] The result was a flexible and resilient sponge material that returned to shape after being pressed. Dunlop's first commercial use of Dunlopillo was in 1929 when their latex cushioning was used in cockpit linings, but by 1930 cavity moulded cushions[89] were being supplied for the Austin Seven car. By 1932 Dunlopillo latex cushioning was used in theatre seating in the Memorial Theatre, Stratford, and for London's buses.

These contract markets (auditorium and vehicle seating) accepted the new material well, but most domestic furniture manufacturers were reluctant to change.[90] Prior to World War II, foam rubber was used in chair designs by Marcel Breuer for Heals reclining chairs and in combination with other filling materials: for example the early use of latex foam and hair fillings together have been noted in PEL chairs of the 1930s.[91] The new latex technology also encouraged the use of rubberised hair, and the first use of this composite material appears to have been in cockpit seats during 1929.[92] Developments appeared to be slow in the use of latex in the domestic market. In 1946 it was still referred to as a 'new' filling material, and metal springing was still considered the universal method for upholstery and bedding.

As late as 1951 an industry commentator rightly thought that, 'the potentialities of latex foam for upholstery and the influence it can exert on the design of chairs and seating units have not yet been fully realized.'[93] Like many new materials, latex foam was clearly versatile enough to be used not only as a substitute but also to become the basis for completely new designs.

New designs were indeed developed. The benefits of latex cushioning were such that chair frames no longer needed to support a webbing and spring ensemble, therefore it gave the designer much more

flexibility than the traditional methods. Frames could be pre-formed in one piece of ply or metal, therefore drastically reducing assembly time; the costing of the cushion-making was much easier due to the regular shape of the cushion: it was the logical choice for contemporary furniture due to its shape-retaining capabilities, whilst the resulting lighter weight, limited support, and frame size, in comparison to fully upholstered traditional methods, was a major selling point.

Another design innovation was the use of sectional seating in which units were pushed together (often to make a Tele-viewing circle): a level surface match could be achieved much more easily by using regular latex cushions rather than by hand methods. The only drawback appeared to be that the price remained comparatively high.

Perhaps one of the most important upholstery innovations in the twentieth century was the reinforced rubber webbing that was invented in 1948 by the Pirelli company. In 1950 they set up a company called Arflex to develop foam-rubber furniture. Here again is an example of a prime supplier entering the market to develop a product. Marco Zanuso was commissioned to develop the potential of the conjunction of foam and rubber webbing in upholstery. The well-known Lady chair of 1951 was one of the first to be made, and acted as an inspiration for many commercial copies.[94] The rubber webbing was designed to be fixed to wood or metal frames so it was versatile enough to be hidden within traditional seating or it could be used as a revealed support in a minimal design. According to Zanuso the exciting possibilities of the new materials were such that 'one could revolutionize not only the system of upholstery but also structural, manufacturing, and formal potential'.[95] Indeed, this turned out to be the case. This attitude to design solutions was typical of the Italian furniture industry in the early post-war years. Pirelli's interest in development was well illustrated in the later introduction of the four-point platform or rubber diaphragms that were designed to fit show-wood furniture frames so as to give a full support to the seat area.

The combined advances of latex cushions and rubber webbing were related to the design developments of popular chairs and sofas in the 1960s. The show-wood frame which echoed a Scandinavian ideal of open-plan living in which cabinets and upholstery were related in timber was extremely popular. Even if traditional-style suites were required, the new materials meant that they could be produced

5 The Tele-viewing circle, specially made for the viewing of television, *c.* 1954

6 Cut-away view of an easy chair, showing webbing with a latex foam cushion, 1950

at a lower cost and faster pace than the original built-up support system.

The enthusiasm for plastic and foams was linked to the culture of the period with its emphasis on experimentation, novelty, and comfort. The change from a fully upholstered frame via a flexible frame and cushion to a combined foam-based, structural, and flexible unit was a major leap, but it occurred within this decade and at all levels. It was nothing short of a complete re-think about the way people used upholstery and how they sat. Needless to say it was not universally applied and more traditional methods remained important.

The introduction of plastic (polyether) foam as an upholstery material further broadened the range of possibilities. Not only could it act as a substitute for latex,[96] it could also offer its own possibilities. Many avant-garde designers in the 1960s used foams to create eye-catching and flamboyant designs deliberately produced for short runs and limited editions. In the popular market, foam engineered products included mattresses, complete bed-settees and easy chairs.

The more recent developments in plastic foam technology have resulted in a range which has a wide choice of densities and hardness factors, special features like fire retardancy, and ancillary developments that have included polyester wraps which give a softer feel

and look to cushions, as well as variable density made-up cushions that give support and comfort. The change during the century from a construction of springs, webbing and fillings such as rags, cotton waste, horse hair, and feathers to the continuing advances in rubber and plastics technology, give a clear view of the immensity of the transition in terms of materials.

Springing

In the same way that foams revolutionised the filling of cushions and the padding process of upholstery, changes in spring technology allowed a move away from the coil-sprung platform that was the mainstay of upholstery prior to World War II. The hour-glass shaped coil spring had remained the same for much of the nineteenth century. One of the first major changes that occurred in the early twentieth century was in 1904, when a patent was granted to W. E. Morris for a spring assembly unit.[97] The process of building up a sprung seat-unit from single coil springs, each individually tied to its neighbour and to the frame, was a demanding and time-consuming method of providing a seat suspension. The newly invented assembled spring unit was made up from a number of coil springs fastened together with clips and surrounded with a bent wire frame. This, the forerunner to the common spring unit used in upholstery well beyond the middle of the twentieth century, was a useful innovation for speeding up the process of laying springs into a frame for a fully upholstered chair. Further developments included the double spring unit with a wire mesh top, as well as interior sprung seat cushions that were often used in conjunction with the spring units.

While metal springs remained the basis of the support system for upholstery, further developments were inevitable as demand grew and the older methods slowed down progress. The introduction of the tension spring, sometimes encased in cloth, allowed chairs to have the spring benefits without the deep frame profiles that were needed to accommodate full coil springing.[98] This was particularly useful on fireside and wing chairs, designs for which were often loosely based on early eighteenth-century models.

Another version of metal springing introduced in the twentieth century was the sinuous or zigzag spring. This enabled upholsterers to fit a support system into a deep profile chair or sofa without the

cost and materials involved in traditional upholstering. The American use of these spring systems was apparently worth comment by the trade team sent to the United States by the Productivity Council in 1951. They saw zigzag springs with a sprung edge as well as steel lathes fitted with tension springs, upon which were attached coil springs in cut out spaces. Their most interesting comment on the use of springs however, was reserved for the consumer's understanding of the techniques employed: 'Even the American housewife seems to understand the implication of "eight knot lashing" in advertising'.[99]

Advances in the construction of 'traditional' upholstery have not been great in the latter part of the century. Techniques of fabric cutting and parts supply on a multiple basis have speeded up this aspect of the work. The 'cell system' of production has again resulted in economies of time and material,[100] whilst the fixing of outer fabrics by the pneumatic staple gun, which began in the 1950s, must be the greatest advance in speedy assembly. Subtle developments have derived from this process itself. For example, in order to avoid an unsightly line of tacks on the top of the back, a hidden tacking strip was devised to fix material to backs. Despite all the advances in technology, much contemporary upholstery remains based on traditional materials and the distinctions between these are often trumpeted by quality manufacturers as a selling point.

Metal

Yet again iron and steel are furniture-making materials that have many precedents way beyond the well-known cast-iron and light steel products of the nineteenth century. Indeed the relationship between iron and steel and furniture can be traced back to the first use of the material for hinges, locks, and fixings.

In the twentieth century, metal has taken a major place in the furniture-maker's repertoire be it for domestic or contract use. For the avant-garde in the 1920s and 1930s, tubular steel furniture particularly represented modernity, whilst in the post-war periods it has seemed modern to other generations. On the other hand the trade did not immediately welcome the material. In 1931 the *New Survey of London Life and Labour* found that:

a striking technical change in the post-war years has been the steady invasion of metal work. Already metal furniture has invaded the office,

the kitchen and the nursery and perhaps in a few more years metal tables, chairs, sideboards and bookshelves will be common. This change of course attacks the whole 'furniture' trade as hitherto understood by operatives and employers. Metal furniture requires neither sawyers, machine wood-workers, carvers nor french polishers. *Already the furnishing trades are alive to this menace and retailers are praising the superior look of wood to their customers with a view to maintaining a preference in its favour* [my italics].[101]

This clearly demonstrates a number of attitudes found in the trade. The traditional image of furniture as being of wood is supported, whilst the fear of the new is demonstrated along with a clear attempt to fight rather than embrace any changes: a microcosm of part of the twentieth-century British furniture industry.

During the 1930s much 'commercial' furniture was produced using metal, and deriving its design ideas from the innovative work of architect/designers of the later 1920s. The original and exciting work had been done and what followed were poor attempts at novelty and difference. The industry seemed to continue its apathy towards metal as an innovative and modern material.

Over twenty years later, the trade was still criticising metal as 'Lacking the life and warmth of wood, it is cold to the touch and looks both hard and cold.'[102] Although in hindsight we can see that the conservative sections of the trade were fighting a holding action, metal has by no means usurped wood as a favoured material, rather it passes through fashion cycles and rises and falls in and out of favour.

By the 1940s another generation of designers were claiming metal as an ideal material for mass producing furniture. Charles Eames gave his rationale behind this material use:

Metal stamping is the technique synonymous with mass production in this country, yet 'acceptable' furniture in this material is noticeably absent. By using forms that reflect the positive nature of the stamping technique in combination with a surface treatment that cuts down heat transfer, dampens sound, and is pleasant to the touch, we feel that it is possible to free metal furniture from the negative bias from which it has suffered.[103]

Ironically, most of the Eames's designs were executed in wood or plastics, sometimes with metal underframes or legs. Mass produced stamped metal chairs did not develop.

Whatever the merits of, or the fashionable fads for metal furniture in the twentieth century have been, there has been no shortage of ideas. Metal furniture has been made from sheet steel, rod, tube, and wire mesh. It has been bent, wrought, pressed, drawn, cast, or spun. It has been painted, polished, printed, coloured, or otherwise disguised in some way.

Sheet metal

Perhaps some of the earliest applications of sheet metal to furniture in this century can be found in the burgeoning office furniture market. By 1920 there was a large manufacturing sector producing metal furniture such as filing cabinets, desks, and work benches.[104] A successful off-shoot of sheet steel used presses to form a pressed-steel chair. A lightweight stacking chair using this method was produced by Evertaut in England and also by the French manufacturer Société des Meubles Multiples, Lyon.[105] Not surprisingly the nature of the material tended to disqualify it as suitable for domestic furniture except for its application for internal chair frames.

Other uses for metal in furniture included the wartime development of internal metal upholstery frames. Yet again, this was an idea that had been known and widely used in the nineteenth century. In that time the frames had been designed to give a flexible curved shape to chairs. In the mid-twentieth century, the metal frames were either designed to imitate the shape of an existing wood frame from rolled steel sections with wooden tacking strips and were unimaginatively box-like in shape, or they were much more innovative and were used to produce more organic shapes using welded steel rod with sewn-in rubberised hair[106] (see below). In recent years some designers have returned to sheet metals but the designs have generally been limited editions and not 'commercial' ones.[107]

Tubular metal

Developments in tubular steel technology began with the German firm of Mannesmann, who, in January 1885, perfected the technique of heating a billet which was pierced and then rolled into the required tube.[108] It was ideal for the new developments in bicycles but was too heavy for furniture. A later development by Machinefabrik Sack, in 1921, produced tubes with thinner walls which were

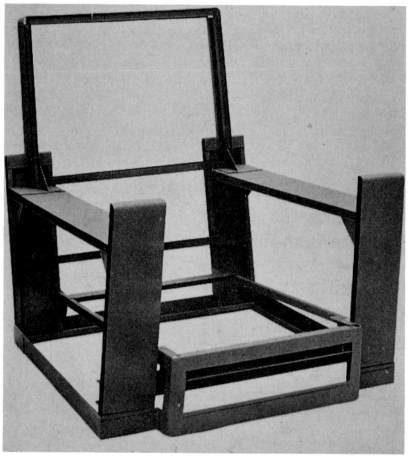

7 Rolled steel frame, as a substitute for wood, but still using the same design, 1955

therefore lighter and less rigid, i.e. more suitable for bending into furniture shapes.[109]

Marcel Breuer was the first to be credited with the initial use of precision steel tubing for furniture, his 'Wassily' club chair of 1925 being the first of a range of tubular products that would be developed world-wide.

Once the bent metal chair had been established, there was an amazing proliferation in models based on the precedents set by

Marcel Breuer. Breuer's stated aim in using metal tubing for furniture was to 'contribute to the social yardstick of a price which could be paid by the broadest possible mass of the population'.[110] Interestingly, it was not until the 1970s that this ideal was achieved.[111] Until that time the chair had remained exclusive, and it was only through the efforts of stores like Aram and Habitat and subsequently other companies that were able to import inexpensive copies, that the chair found universal sales appeal.[112]

Once the principle of tubular steel frames had been established, the next important development was the design of the cantilever chair. The well-known but complicated history of the development of the early models does not need reiterating here.[113] What is worth mentioning is that by the late 1930s tubular steel furniture was as ubiquitous as bentwood furniture and had lost much of its avant-garde status.

The results of the introduction of tubular steel to furniture-making in Britain during the inter-war years were that it 'made no serious inroad into the domestic furniture field and certainly offered no substantial competition in the market for low priced and medium-priced furniture'.[114] In another field of furnishing, where the modern ethic was more readily acceptable, tubular steel furniture became relatively successful. Gordon Logie suggested that in the British contract market it practically superseded all other forms. In office and school furniture it found a steady market but he confirmed that 'in domestic furniture it has largely failed to be accepted'.[115]

The contrary seems to have been the case in the United States. Sharon Darling has pointed to the influence of the 1933 World's Fair, in which tubular steel furnishings were used in over 80 per cent of the buildings. She suggests that this established tubular steel as an 'essential ingredient for a modern interior'.[116] Although Breuer- and Miesian-inspired tubular chairs were manufactured in large quantities in the United States, the truly popular ranges of tubular steel furniture came after the war with the 'dinette' sets. These comprised a table with a plastic laminate top, on tubular steel legs, and four tubular dining chairs. In the early 1980s one company was turning out 2,000 such sets per day from two factories.[117]

Whether popular or not, metal furniture became one of the battlefields in the feud between modernists and traditionalists conducted during the inter-war years. John Gloag (1929) attacked the metal

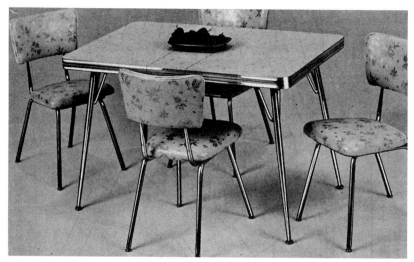

8 The classic dinette set, comprising a plastic-laminated table and four plastic-covered side chairs, all on chromed tubular steel legs, *c.* 1965

furniture of the 'Robot modernist school', which, he thought, showed through its 'relentless logic, its utter inhumanity'.[118] By 1933, Gloag's attitude seems to have mellowed somewhat. Discussing the steel-tube chair he saw it 'as intelligent in its sleek functionalism as that almost perfect traditional design, the Windsor chair'.[119] Others saw the merits of metal furniture in even more significant terms. Charlotte Perriand considered that 'metal plays the same part in furniture as cement has done in architecture.'[120]

The rather futile arguments of the 1920s and 1930s centring on the acceptability of metal furniture were neatly demolished by a correspondent to the *Architects Journal* in an article entitled 'Chromium tubing is as dead as mutton'. The correspondent asserts that metal furniture was simply a passing fashion, fired by modernism, which had already been burnt out.[121] This of course echoes the complaints of such diverse commentators as Reginald Blomfield who complained that 'collectivism is to take the place of individualism',[122] and Maurice Dufrêne who expressed the same idea more pointedly: 'the same chair, mechanical and tubular, is to be found in almost every country – Austria, America, Germany, Sweden, France etc. It

is the anonymous neutral universal chair.'[123] Dufrêne was writing in 1931: it could have been 1991!

Wire and rod

The example of steel's flexibility through wire and rod was exploited in furniture manufacturing throughout the century. An early example was from 1909, when the Royal Metal Manufacturing Company of Chicago took out a patent for side chairs made from twisted rod.[124] However, the use of wire and rod, usually in combination with other materials, has became synonymous with the 1950s, both in the 'Contemporary' style in Britain and in the work of designers such as the Eames's and Bertoia in the United States.

The immediate post-war British furniture industry suffered from severe timber shortages, and not unnaturally turned to other materials that were more readily available. A chair designed and made by Ernest Race and Co. which used welded rod and a plywood seat to make a semi-traditional style chair for the Festival of Britain in 1951, seems to have helped to change attitudes since the designs were not considered outlandish. As well as complete frames, manufacturers also utilised the wire rod as a skeleton for upholstering easy chairs and sofas, but most importantly for the general market was the adoption of wire rod legs with ball feet. This underframe or leg was found on every furniture object that it could be applied to – from coffee tables to easy chairs.

In the United States, Harry Bertoia was designing his famous sculptural wire frame chairs which were recognised as a form of interior sculpture. The wire rods used for the seat-back were bent and formed by hand, whilst the base rods were a simple support. This was similar to the Eames's who used steel rod for chair bases in combination with completely different seat-back materials. This then enabled chairs to fit a variety of bases from a cat's cradle of wires to a pair of wooden rockers. Wire rod has remained a favoured material for avant-garde designers but its popularity within the mass market did not outlast the 1950s.

The popularity of steel in its many forms has risen and fallen as fashion dictates. For a number of years around the 1970s the 'chrome and glass dining set' which used large-section square or round chromed tube was often seen with a matching upholstered suite

made from the same material. These sorts of sets are still available but are often relegated to the role of a kitchen dinette.

Aluminium

Aluminium has never been a truly popular material for furniture-making; however, there have been various re-considerations of its potential. The benefits of aluminium were seen as its corrosion resistance, light weight, malleability, flexibility and resilience, and not least, the silver-like finish. When compared with tubular steel, however, its weakness was a disadvantage and any designs had to build in a degree of support that was not needed in tubular steel. Whilst it was originally experimented with in 1927, it was Marcel Breuer who seriously started to design aluminium chairs from mid-1932. The Alliance Aluminium Company of France sponsored an international competition for the best aluminium chair. It appears to have generated some interest in the international design community as the competition attracted entries from fourteen countries, comprising 209 chair designs of which 54 were in prototype. Breuer entered his designs with the help of the Swiss Embru Company and won unanimously.[125] The range of aluminium furniture was not a commercial success partly because of the numerous different versions, and partly because they did not fit into contemporary interiors very comfortably. Apparently sales improved once they were marketed as outdoor furniture.[126] Indeed the recent success of aluminium in furniture-making has rested on its suitability for outdoor locations.

Developments continued in Europe for specialised applications such as for the airship company, Zeppelin, who used L and C Arnold's aluminium tubular-framed chairs in the airship *Hindenburg* in 1935.[127] The combination of light weight and a modern image was clearly attractive to the airship-builders. A little later, in 1938, Hans Coray designed a lightweight aluminium chair for the Swiss National Exhibition, which was however primarily for outdoor use.[128] Technically it was interesting as it used a tempered aluminium alloy into which was stamped the chair shapes, which were then punched with holes to give a distinctive proto high-tech look.

After the end of World War II a revival of interest in aluminium was clearly a response to the timber shortage. In his *Furniture from Machines*, Logie devotes a number of pages to 'Light Alloy Furniture' and considered that there could be a future for aluminium in

both structural and decorative form. At one time, Sir Stafford Cripps, President of the Board of Trade, considered using the aircraft industry to provide aluminium furniture. This was intended to take surplus production capacity, and not surprisingly was viewed with alarm by wood-furniture-makers who considered that the ensuing price cutting and competition would become ruinous. Gordon Russell was invited to inspect the American use of aluminium in furniture, but his findings were such that the manufacturers of wood furniture had little to fear. He thought that metal was only of use if there was absolutely no wood available at all.[129] Interestingly, the Utility furniture scheme included aluminium divan bed-frames and dining chairs c. 1946–47.[130]

One of the most famous British chairs of the twentieth century was undoubtedly the Race-designed aluminium BA chair. Famous and successful, between 1945 and 1969, 250,000 BA chairs were produced. The use of aluminium was seen as a pragmatic substitute for wood, and it was not considered by Race to be the beginning of a new genre.

What was important about this chair was the relationship between precision engineering and furniture manufacture at a reasonable cost. Wartime experience had shown that furniture makers could work to engineering tolerances. The example of Race and his design revisions, in which he moved from sand-casting to die-casting, reveal how a process change can achieve a number of gains. In this case they were as follows. Firstly, greater strength was achieved by a better grain flow in the aluminium; secondly, there was a weight reduction of 25 per cent over the sand castings; and thirdly, finishing, which had been time and labour intensive in the sand-blasting instance, was dramatically reduced, resulting in a factory cost cut of almost half.[131]

It does not always follow that metal furniture is suitable for mass production. The production process of the range of tables to match the BA chair shows this well. The BC/BD tables had legs hand-cut from sheet aluminium, then hand-filed, radiused, and hand finished with wire wool and oil!

Yet again though, the innovative materials and techniques tended to by-pass the ordinary customer as the products were not generally stocked by retail furnishers. According to White (1973) who uses the BA chair as a case study, it was aimed at 'the professional buyer

9 Aluminium BA chairs and matching table and sideboard with a teak finish by Ernest Race, *c.* 1950

who is more objective in his criteria than the retail trade.' This meant architects and specifiers rather than retail buyers. He goes on to say 'They [Race and Co.] had not made the mistake of selling the right product to the wrong market'.[132]

However, there were post-war commercial applications of aluminium to furniture which were potentially interesting. In *Modern Homes Illustrated* (1947), the furniture retailers, Frederick Lawrence, advertised the 'Basildon, new period furniture'. This was a range of bedroom pieces that had aluminium exteriors impressed with a fine pattern, finished in pastel colours and fitted internally with an applied rayon finish. In the same volume the retailers, John Perring and Company, advertised 'Floton' beds which were manufactured by Premier Crafts and Industries. These were patented divan frames made from an aluminium alloy with an option of a coloured finish. Its main selling point appeared to have been its 'simple one hand lift [that] permits easy underneath cleaning'.[133]

Other examples of aluminium use in furniture might include Clive Latimer's chair and cabinet designs in 1946 for Heals, and in 1949, a most unlikely use of aluminium alloy was in the Toledo fireside wing chair by Parker Knoll. These generally remained as prototypes, but the range of anodised aluminium Woodmet trays and tea trolleys introduced in 1947, using the trade name of Colourdysed, remained a top seller for many years. Aluminium therefore had some brief success in furniture whilst timber was at a premium.[134]

Other developments in aluminium relied on its conjunction with other materials. Technological experiments during World War II resulted in the development of stressed-skin materials which gave a combination of lightness and strength.[135] Again it was Ernest Race who worked on a sideboard cabinet unit range made from such a material – Holoplast. This was a stressed-skin material which had either a honeycomb section of plastic or a core of expanded rubber which was finished with an aluminium exterior. The production appears to have been quite labour intensive. There was a problem with an edging needed to hide the honeycomb, so the result was to use an aluminium strip, heated then fitted so that it shrunk round the frame edges. Screws were fitted at 3 in. (76 mm) intervals, and the heads were filed down and then the whole edge was burnished.[136] Despite all this effort, and although the strength, light weight and rigidity of the aluminium products would have been strong selling

points, the public acceptance of aluminium cabinets did not happen. In the same way as Plymax in the 1930s, aluminium in the home must have been just too far beyond the accepted image of furniture for any commercial success in the high street.

However, aluminium continued to be considered suitable for furniture use and in order to promote it further, in 1961 the British Aluminium Company sponsored a furniture design competition. The winning design was for a contract bed-frame and the second prize went to a design for an outdoor chair. The third prize was awarded for an aluminium swivel base for a chair.[137] It was in fact to be for chair bases that aluminium would be most used during the following years. Extruded tube, cast, or spun aluminium was an ideal material for stool and swivel-chair bases. The fashion cycle has taken its toll on aluminium and it has lost popularity in the domestic market in favour of materials that are softer and less high-tech in their imagery.

Other materials

The century has seen experiments in most materials for furniture-making. These have often been more for artistic statements or limited editions and are beyond the scope of this work. However, a number of other initiatives ought to be mentioned, as they were aimed at trying to provide a material that would be widely used for making inexpensive domestic furniture. Some of these experiments were doubtful from the start. For example, in Tomrley's *Furnishing your Home* (1940), the author promoted wood substitute materials made from plaster board or concrete. These consisted of cast plaster or concrete panels that would be reinforced with wood or metal and lipped and veneered to resemble wood![138]

Another example, developed in High Wycombe, which appeared to have more potential, was the idea of moulded wood pulp as a material for chair shells.[139] The use of wood wool as a shell material was also experimented with.[140] In the United States, resin-impregnated wood fibre was used to make a prototype chair for the 1948 Low Cost Furniture Exhibition.[141] Although the use of the material in a one-piece chair won an award, it seems that none of these intriguing possibilities reached a market.

Perhaps one of the most successful man-made materials that was

ideal for furniture, was Lloyd Loom. The invention of the process that combined the making of furniture from a (usually) bentwood frame and an integrated surface material is credited to Marshall B. Lloyd. In 1917 he patented a method of weaving a sheet of partly wire-reinforced paper strips, to produce a flexible sheet material that imitated wicker but had its own characteristics. Initially successful in the making of perambulators, it was an even greater success for furniture. In its heyday, between 1920 and 1940, over one thousand designs were produced by the Lloyd company in the United States and by the British licensee, Lusty, in Britain.

The use of bentwood frames which are often hidden behind the woven paper 'skin' is important to remember as this method provides a firm but easily shaped frame for the paper 'fabric' to be fitted to it. Because the chair had a basic frame of bentwood, it is not surprising that like Thonet, Lloyd Loom went on to produce furniture with bent metal frames in the 1930s. Lloyd Loom were never as successful as Thonet but their foray into this market is an interesting example of technological transfer related to market tastes.[142]

Lloyd Loom was a genuine mass market product which was able to satisfy the demand for a range of relatively inexpensive chairs and accessories in the inter-war period.

The importance of this trade, and the fact that 'before the war one factory was producing over 300,000 pieces of woven furniture a year', gives an indication of the scale of this branch of the industry.[143] Although used as part of the Utility range, as well as being produced after the lifting of controls, Lloyd Loom did not retain its pre-war eminence and it gradually declined as a product range until 1968 when the British makers – Lusty's – closed down.[144]

Although Lloyd Loom was advertised as 'Neither cane nor wicker – superior to either', both these natural materials also featured in the home furnisher's repertoire. Wicker has tended to play an ambivalent part in the history of twentieth-century furniture. It does not seem to have settled into a niche; perhaps because it is suitable for both indoor and outdoor use. Indeed the transition of furniture originally designed for outdoors, to being used indoors, is an arena that needs exploring.

Experiments at Leicester School of Art led to the establishment of the Dryad company which offered wicker furnishings to the upper quality markets.[145] Other manufacturers met the following demand

10 Lloyd Loom bentwood chair-frame for the model No. 60. Produced from 1924–40

for less expensive models. Inevitably, attempts at cost reductions in the weaving process led to a change in design from the tightly woven (closed) to the looser open styles, which in turn may have opened up a gap in the market for inexpensive closely woven models that was easily filled by Lloyd Loom.

It is clear that the benefits of cane or wicker in furniture-making are that they combine strength and lightness with elements of simplicity and tradition. The wider popularity of these materials coincided with the post-World War II interest in open-plan interiors and the lighter weight furniture required for them. Examples can be found all over Europe and the United States. In this period three techniques were employed to provide a variety of styles and cost brackets. The first of these was the fully woven where the warp is the frame; the second was where thicker canes making a frame were tied together at intervals; and the third was where multiple loops of cane were fitted into the frame and tied or pinned to the framework and bound at intervals.[146]

Although wicker and rattan furniture was introduced from Malaysia and the Philippines during the latter part of the century, in recent years its popularity has grown enormously, no doubt due in part to the combination of lower cost, 'conservatory lifestyles', and heavy advertising promotion. Even a straightforward natural material such as rattan has been the subject of imitation. In America during the 1950s, the idea of fabricating a rattan substitute from round section steam-bent wood, coloured to the tone of cane and charred at intervals, was introduced to create the 'rattan look'.[147]

The use of paper in furniture-making yet again has precedents in the nineteenth century. Papier mâché was used extensively during its fashionable period between 1835 and 1870, although it was often combined with a timber frame and was usually used as a surface for decoration.

The earliest use of paper as a constructional material in the twentieth century that I have been able to find is Hans Gunther Reinstein's patent process from 1908.[148] This process used cardboard as 'an autonomous self-supporting material'.[149] Although the furniture produced from this patent process continued to be made up to 1929, when the company was dissolved, it never became a mainstream product.

The revived use of papier mâché during World War II for pilots' bucket seats, glider wing tips, tail planes etc., led Dennis Young to later develop the material for shell chairs. In this case, despite the introduction of quick-setting glues and heat sources to enable the shell to be produced rapidly, it was nevertheless unable to compete commercially with plastics.

The heyday of paper furniture was in the 1960s when Leslie Julius

could say of the development of cardboard throwaway furniture that 'disposables are here to stay'. At the time it might have seemed that furniture was to become a true fashion item, being discarded once it had lasted a season or two. It was in this period that David Bartlett's flat, folded, carry-away paper tub chairs were produced from a printed laminated card, and Bernard Holdaway designed a range of cardboard and particle board tables and chairs for Hull Traders. Although this furniture was purchased by 'trendy young things' it was not popular on the mass market so the initiatives were short-lived. These sorts of developments hardly touched high street retail shops either because they were recognised as transient fads or perhaps because they were not seen as 'real furniture'.

In the 1970s, Canadian architect Frank Gehry used laminations of corrugated paper laid at right angles to each other to create a firm yet bendable material for furniture-making. A patent was eventually granted in 1978 and Gehry has rightly been acclaimed for producing a range of furniture that is both cheap and resourceful.[150] Yet again it did not suit the main market.

This survey of materials has highlighted the increased range of choice available to furniture-makers and has reflected the ambivalence of twentieth-century furniture. It has shown that on the one hand there have been a number of advanced innovations that have improved furniture and made it available to a wide market, yet on the other hand, many developments have remained hidden within the furniture, or if on the surface, have been disguised as more traditional types. Thirdly, some innovations in materials, once hailed as the future, are now rejected. It is certain though, that some particular materials have been continually favoured over others, due to process, cost, or tradition.

Notes

1 See C. Edwards, *Victorian Furniture* (Manchester, Manchester University Press, 1993).
2 J. Gloag, *English Furniture* (London, A & C Black, 1952), p. 144.
3 D. Pye, *The Nature and Art of Workmanship* (Cambridge, Cambridge University Press, 1968).
4 W. P. Baermann, 'Furniture industry in transition', *Industrial Design*, 14 (May 1967).
5 P. Trippe, 'Mass production methods in a craft industry', *Mass Production*, 38 (February 1962), pp. 53–62.

6 G. Nelson, 'Modern furniture, an attempt to explore its nature, its sources, and its probable future', *Interiors*, 108 (1949), pp. 76–117.

7 C. Wilk, 'Furnishing the future: Bentwood and Metal furniture 1925–1946', in D. Ostergard (ed.), *Bentwood and Metal Furniture: 1850–1946* (New York, University of Washington Press, 1987), p. 168.

8 L. J. Mayes, *The History of Chairmaking in High Wycombe* (London, Routledge, 1960), p. 127.

9 *Furniture Record* (August 1913).

10 Mayes, *Chairmaking*, p. 129.

11 The distinction between hardwoods and softwoods has nothing to do with their relative strength. Hardwoods are deciduous while softwoods are coniferous.

12 B. Latham, *Timber: A Historical Survey of its Development and Distribution* (Harrap, 1957), p. 64.

13 *Ibid.*, p. 66.

14 Board of Trade, *Working Party Reports: Furniture* (HMSO, 1946), p. 39 (hereafter referred to as WPR).

15 M. Sheridan (ed.), *The Furnisher's Encyclopaedia* (London, 1955), pp. 35–6.

16 *Timber and Plywood Annual* (1956), p. 170.

17 Trippe, 'Mass production methods in a craft industry', p. 62.

18 *Ibid.*

19 See Edwards, *Victorian Furniture*.

20 S. Wainwright, *Modern Plywood* (London, Benn, 1927), p. 54.

21 For an account of these experiments see Wilk, 'Furnishing the Future', in Ostergard (ed.), *Bentwood and Metal Furniture*, p. 147.

22 M. Deese, 'Gerald Summers and Makers of Simple Furniture', *Journal of Design History*, 5:3 (1992).

23 J. C. Pritchard, *View from a Long Chair* (London, Routledge, 1984), pp. 112–16. Jack Pritchard, the man behind the Isokon company, revealed an interesting episode about the problems of untried materials and techniques when he describes a problem that occurred with the shaped plywood Isokon Long chair. When used in the warm surroundings of a swimming pool, the 'Scotch glue' broke down and the chairs collapsed. The introduction of a non-soluble glue solved the problem.

24 Pritchard, *View from a Long Chair*, p. 55.

25 Eliot Noyes quoted in D. A. Hanks, *Innovative Furniture in America from 1800 to the Present Day* (New York, Horizon, 1981), p. 67.

26 Museum of Modern Art, New York, *Organic Design*, c. 1941, p. 4.

27 J. and M. Neuhart and R. Eames, *Eames Design* (London, Thames and Hudson, 1989), p. 60.

28 A. Drexler, *Charles Eames, Furniture From the Design Collection* (MOMA, New York, 1973), p. 12.

29 Neuhart and Eames, *Eames Design*, p. 61. NB: George Nelson says that two Italian architects Cristiani and Frastino developed this technique. See *Interiors* (July 1948), pp. 96–7.

30 Sandwich and stressed-skin plywoods were made to combat instability in the thickness dimension with the use of a lightweight core; e.g. synthetic rubber.

31 G. Logie, *Furniture from Machines* (London, Allen and Unwin, 1947), p. 76. The Mosquito was built using plywood framing with balsa wood inners designed to overcome the natural lack of stiffness.

32 WPR, p. 54.
33 For a description of the coopering process, see Nathan Rosenberg in P. Kirkham, R. Mace and J. Porter, *Furnishing the World, The East End Furniture Trade 1830–1980* (London, Journeyman, 1987), p. 128.
34 WPR, p. 84. The 'panel process' is a manufacturing method that relies on finished boards that can be cut and profiled to pre-determined shapes that simply need to be put together with fittings at the end of a line.
35 British Furniture Trade Productivity Team, *Report on a Visit to the USA in 1951* (1952), p. 3.
36 *Design*, August 1953.
37 Logie, *Furniture from Machines*, pp. 95, 98–9.
38 Hanks, *Innovative Furniture*, p. 72.
39 Ostergard (ed.), *Bentwood and Metal Furniture*, pp. 238–9.
40 Hanks, *Innovative Furniture*, p. 66.
41 Ostergard (ed.), *Bentwood and Metal Furniture*, pp. 331–2. This was an early experimental example of moulded drawers that was not commercially successful until the utilisation made by companies such as Schreiber in the 1970s.
42 M. Farr, *Design in British Industry* (Cambridge, 1955), p. 4.
43 'Frank Gehry Re-invents the Chair', *Blueprint* (September 1992), and *Domus*, 739 (1992).
44 A. D. Wood and T. G. Linn, *Plywoods, Development Manufacture and Application* (London, Johnstons, 1942), p. 118.
45 Wainwright, *Modern Plywood*, p. 58.
46 Laminboard is composed of thin strips of wood that are glued together and covered with a veneer.
47 L. Weaver, *Laminated Board and its Uses. A Study of Modern Furniture* (London, Fanfare, 1930), p. 63.
48 *Ibid.*, p. 74.
49 William Mason was one of the first major commercial suppliers and gave his name to the American version – Masonite.
50 L. E. Akers, *Particle Board and Hardboard* (Oxford, Pergamon, 1966), p. xi.
51 G. Russell and A. Jarvis, *How to Furnish Your Home* (London, 1953).
52 Sheridan, *Furnisher's Encyclopaedia*, p. 20. D. Bonnett, *Contemporary Cabinet Design and Construction* (London, Batsford, 1956).
53 I am grateful to Tony Sparkes of FIRA for information on this topic.
54 M. Weale, *Contributions of Designers to Contemporary Furniture Design* (unpublished thesis Florida State University, 1968).
55 See for example, Ostergard (ed.), *Bentwood and Metal Furniture*. The bibliography is extensive and very valuable.
56 Wilk, in Ostergard (ed.), *Bentwood and Metal Furniture*, p. 122.
57 For example, see 1992 IKEA furniture catalogue with composite plastic chairs in bentwood designs. Also Habitat catalogues. In addition it must be borne in mind that one of the most successful uses of bentwood furniture was in the contract markets. See C. Wilk's work on Thonet.
58 D. N. Buttrey, *Plastics in the Furniture Industry* (London, Applied Science Publishers, 1964); S. Katz, *Plastics, Design and Material* (London, Studio Vista, 1978).
59 An example was the Lignine brand of composition carvings sold by Maxine and Co., trade catalogue in the National Art Library, Victoria and Albert Museum, London, *c.* 1912.

60 Katz, *Plastics, Design and Material*, p. 60.
61 Weale, *Contributions*, p. 273.
62 Hanks, *Innovative Furniture*, pp. 106–7.
63 H. Robertson, *Reconstruction and the Home* (London, Studio, 1947).
64 Kape, *Cabinet Maker* (25 July 1953).
65 Bonnett, *Contemporary Cabinet Design*, p. 99
66 R. Carr, 'Design analysis, Polypropelene chair', *Design*, 194 (February 1965).
67 *Ibid.*
68 Katz, *Plastics, Design and Material*, p. 86.
69 R. A. Helmers, 'What's happening in plastics', *Furniture Design and Manufacturing* (April 1967), quoted in W. Skinner and D. Rogers, *Manufacturing Policy in the Furniture Industry* (Homewood, Illinois, 1968), p. 156.
70 *Ibid.*, p. 157.
71 P. Covell, 'Structural foam for furniture', *British Plastics*, 44 (June 1971), quoting Dr F. Ullman.
72 Skinner and Rogers, *Manufacturing Policy*, p. 164.
73 S. Grant, 'Plaesthetics', *Home Furnishings Daily*, NY (27 March 1968), p. 6, quoted in Weale, *Contributions*.
74 In 1966, Hille formed a company, HIA Plastics, to develop the process.
75 'Growing acceptance of plastics', *British Plastics*, 40 (April 1967).
76 'New furniture; the domestic market', *Design*, 242 (February 1969), p. 44.
77 According to Katz, HIPS was made with only 12 presses in 1964, producing 130 tons; by 1969, 350 presses were producing 150,000 tons: *Plastics, Design and Material*, p. 86.
78 *The Times*, quoted in Katz, *Plastics, Design and Material*, p. 129.
79 'Plastics perform in furniture', *Industrial Design* (1972).
80 Hanks, *Innovative Furniture*, pp. 108–9.
81 Drexler, *Charles Eames*, p. 34.
82 Hanks, *Innovative Furniture*, p. 112.
83 Young, *Design*, 118 (October 1958).
84 Young, 'New developments in chair manufacture', in Whitechapel Art Gallery, *Modern Chairs 1918–1970*, exhibition catalogue 1970.
85 Although see A. Andersen, *Der Kragstuhl* (Berlin, Alexander Verlag, 1986), pp. 16–19.
86 Sold under the trade name of Old Charm.
87 H. W. Wood, *Old Charm Forever* (Arthur Stockwell, Ilfracombe, 1990).
88 E. Murphy, 'Some early adventures with latex', *Rubber Technology*, 39 (1966).
89 Cavity moulding results in a series of hollows within the solid body of the cushion.
90 Marcel Breuer's design for reclining chairs for Heals (1936) and Isokon (1936) used latex cushions.
91 L. Wilson and D. Balfour, 'Developments in upholstery construction in Britain during the first half of the 20th century', in M. Williams (ed.), *Upholstery Conservation* (East Kingston, NH, 1990).
92 *Ibid.*, p. 305.
93 R. Desbrow, 'Latex foam in furniture design and manufacture', *Rubber Developments*, 3 (1951), p. 2.
94 K. Gill, 'Approaches in the treatment of twentieth century upholstered furniture', in M. Williams (ed.), *Upholstery Conservation*, p. 307.

95 Quoted in C. and P. Fiell, *Modern Furniture Classics* (London, Thames and Hudson, 1992), p. 53.
96 It originated in Germany during World War II as a substitute for latex and was derived from oil-based chemicals.
97 Discussed in E. Flowers's lecture to FDC Conference at Attingham, June 1965. Lecture notes held in London College of Furniture Library.
98 The tension spring is a tightly looped continuous spring that extends the width (or length) of the chair frame and is fitted to the sides by a variety of methods. It is usually cloth covered. They were developed by Wilhelm Knoll and were commercially applied to chairs made by Frederick Parker of High Wycombe, later Parker Knoll.
99 British Furniture Trade Productivity Team, *Report*. Eight knot lashing was a reference to the process of 'tying in' coil springs to each other and the chair frame as part of a skilled suspension building process.
100 The cell system refers to the method of production whereby a group of people work on the production of one part of a range, i.e. a sofa, and become highly proficient in making up the arm front or back as the case may be. The division of labour in this manner has been perfected by the Christie-Tyler Group plc.
101 London School of Economics, *New Survey of London Life and Labour*, 2 (1931), p. 217.
102 Kape, *Cabinet Maker* (11 July 1953).
103 Neuhart and Eames, *Eames Design*, p. 97.
104 Logie, *Furniture from Machines*, p. 111.
105 See Logie, *Furniture from Machines*, p. 118, and Vitra Design Museum collection.
106 Sheridan, *Furnisher's Encyclopaedia*, p. 100.
107 The example of Ron Arad and One-Off are perhaps the best known.
108 Discussed in J. Heskett, 'Germany: The Industrial application of Tubular Steel', in B. Campbell-Cole (ed.), *Tubular Steel Furniture* (London, The Art Book Company, 1979).
109 It is worth noting that the British Furniture Trade Productivity Team *Report* of 1952, mentions that tubular steel was made in the United States by bending flat strips into tube shapes and welding the joints, p. 12.
110 Breuer, 'Metal furniture', in T. and C. Benton and D. Sharp (eds), *Form and Function* (London, 1975), 116, p. 226.
111 See Technology and production, chapter 3, this volume, for further details.
112 The efforts of manufacturers were clearly essential and the contribution of Knoll in the United States and Gavina in Italy must be acknowledged.
113 See C. Wilk, *Marcel Breuer, Furniture and Interiors* (New York, 1981); O. Macel, 'Avant-garde design and the law litigation over the cantilever chair', *Journal of Design History*, 2:3 (1990).
114 WPR, p. 131.
115 Logie, *Furniture from Machines*, p. 120.
116 S. Darling, *Chicago Furniture, Art Craft and Industry 1833–1983* (New York, Norton, 1984), p. 311. See also Sears catalogue (1934) showing tubular steel suites as the most modern available.
117 Darling, *Chicago Furniture*, the Douglas Furniture Corporation, p. 325.
118 J. Gloag, 'Wood or Metal', in Benton and Sharp, *Form and Function*, 119, p. 230.
119 J. Gloag, 'Towards a style', *Architectural Review* (July 1933), p. 30.
120 C. Perriand, 'Wood or Metal? A Reply', in Benton and Sharp, *Form and Function*, p. 232. Compare these remarks with L. Weaver's regarding laminated wood.

121 H. Faulkner, 'Chromium tubing is as dead as mutton', *Architects Journal*, 86 (October 1937), pp. 535–6.
122 Blomfield, *Modernismus* (1934), quoted in Benton and Sharp, *Form and Function*, pp. 175–8.
123 M. Dufrêne, 'A Survey of Modern Tendencies in Decorative Art', *The Studio Yearbook of Decorative Art* (1931), pp. 1–4.
124 Hanks, *Innovative Furniture*, p. 89.
125 Breuer long chair and side chair in aluminium, Wilk, *Breuer*, p. 115.
126 M. Droste, 'Marcel Breuer's furniture', in *Marcel Breuer Design* (Cologne, Taschen, 1992).
127 Ostergard (ed.), *Bentwood and Metal Furniture*, p. 301, catalogue entry.
128 See C. Wilk's entry in *Design 1935–1965: What Modern Was*, ed. M. Eidelberg. (New York, Abrams, 1991), pp. 48–9.
129 G. Russell, *Designer's Trade* (London, 1968), p. 213.
130 Geffrye Museum, *CC41 Utility Furniture and Fashion, 1941–1951* (ILEA, 1974), pp. 22–3.
131 J. N. White, *The Management of Design Services* (London, 1973), pp. 149–56.
132 *Ibid.*
133 F. R. Yerbury (ed.), *Modern Homes Illustrated* (London, Odhams, 1947), xxv, xii.
134 The contract use of aluminium is shown by the American Cessna Aircraft Company who produced a storage unit with drawers lined in aluminium with a baked enamel finish, 'Modern furniture', *Interiors* (1949), p. 108. Also the British Esavian company, who in 1948 introduced a range of school furniture made from aluminium frames and plywood seats.
135 According to David Joel, the Board of Trade were experimenting with stressed skin construction, *Furniture Design Set Free* (London, Dent, 1969), plate 102.
136 I gratefully acknowledge Hazel Conway's work on Ernest Race for this section.
137 See *Design* (December 1961), pp. 17–20. An example of an aluminium chair frame was the Hille 'Axis' chair from mid-1960s.
138 C. G. Tomrley, *Furnishing your Home*; A Practical Guide to Inexpensive Furnishing and Decorating (London, 1940), p. 194.
139 See *Design* (January 1957).
140 *Ibid.*
141 Hanks, *Innovative Furniture*, pp. 108–10.
142 L. Curtis, *Lloyd Loom Woven Fibre Furniture* (London, Salamander, 1991).
143 Logie, *Furniture from Machines*, pp. 108–10.
144 In recent years Lloyd Loom has been successfully revived. See Curtis, *Lloyd Loom*.
145 For Dryad, see P. Kirkham, *Harry Peach, Dryad and the DIA* (Design Council, 1986).
146 H. Dunnett, 'Furniture since the War', *Architectural Review*, 109 (March 1951), pp. 151–66.
147 British Furniture Trade Productivity Team, *Report*, p. 12. Yet another example of an imitation finish that was not new to the twentieth century but an up-dated revival of attempts in earlier centuries.
148 Ostergard (ed.), *Bentwood and Metal Furniture*, p. 82 and p. 263.
149 *Ibid.*, p. 82.
150 Hanks, *Innovative Furniture*, pp. 117–18. After the initial production by Gehry's own company, the prices rose substantially. My thanks to Christopher Wilk for this information.

3 Technology and production

Introduction

The twentieth-century furniture industry has only gradually made the transition from machine-assisted craft to a full-blown industry, and it is still characterised by a wide range of business types whose production facilities are just as varied. The history of furniture production in the twentieth century has generally been one of adapting to the new demands put upon the industry. The changing nature of the market, and any consequent alterations in production, meant that in many cases production and distribution were not properly integrated, as they were, for example, in the automobile industry. Manufacturers allegedly lost contact with the market whilst large retailers thought that producers were unable to respond to new trends. The production systems of the larger-scale manufacturers were not flexible enough to deal immediately with changes in demand, and the small-scale makers had too limited an output to make any difference.

This chapter charts the physical changes as well as the attitudes of the industry, by looking at various aspects of the production process and the influences upon it. In retrospect, some of the major advances in twentieth-century furniture-making have owed much to the influence of the two world wars. These influential periods are discussed, to show what the changes were and how they altered the nature of furniture-making by helping to change the craft into an industry.

For much of the century the trade, or more likely its critics, were advocating improvements in efficiency and this is dealt with in the second section. Following these influences, an analysis of the various parts of the production process is made. Starting with the factory layout, examining machine use, construction, finishing and decoration, the changing methods of manufacture are discussed. Following

a brief examination of upholstery, the vexed question of standard-isation is used as a case study to identify some of the ways designers have tried to influence the nature of furniture production and design in the twentieth century.

Influence of wartime

The old truism, 'necessity is the mother of invention', never shows itself more accurately than in a war situation. This remained just as true for the furniture trade as it did for other, more strategically critical, products. Naturally enough, the woodworking expertise of the furniture-makers was called upon to assist the war efforts, but often not exclusively in a furniture-making capacity. Whatever the experience of individual factories, it seems clear that both world wars gave opportunities to the furniture trade to raise itself and its standards into the twentieth century.

During World War I some 60 per cent of all furniture-making firms were employed in war work of some kind, perhaps the most influential being aircraft construction.[1] The resulting influences on the industry were particularly related to organisational matters, such as work study, scientific management, and working the sub-assembly principle, as well as specifically new approaches to technical matters, e.g. timber kilning, and working to fine tolerances. The import-ance of the changes during 1914–18 was not lost on contemporary commentators:

> During the past twelve month there have been in the furniture trade sev-eral developments of historic interest. The most important of these is the definite entrance of the industry on the work of aircraft construction.[2]

This historic change was not particularly appreciated by much of the trade who were accustomed to their own ways of doing things. Concern over the need to work to close tolerances, for example with jigs and accurate measuring instruments, was noted by the *Cabinet Maker*:

> This consternation was caused by the fact that the first class chair-makers have been trained to judge shape by the eye and have become so pro-ficient that they need not use testing instruments for anything but straight lines.[3]

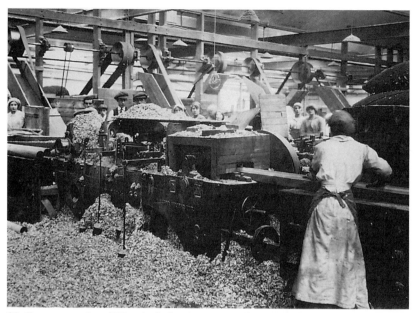

11 One example of Harris Lebus's war work during 1914–18: the manufacture of tent pegs

This attitude meant that there had to be various degrees of involvement. At one level there was an insatiable demand for simple items like tent pegs, ammunition boxes and blocks. There was also an increased demand for office and barrack furniture whilst a demand for invalid furniture was also recognised. However, it was aircraft work that was to lay the foundations that put the craft on the road to becoming a fully fledged modern industry. The range of work turned out by furniture factories during 1914–18 can be exemplified by the case of E. Gomme of High Wycombe. This company initially produced simple bomb slings for the safe manoeuvre of bombs from one site to another: they were then sub-contracted to produce aircraft ribs and spars and, eventually, complete left-hand wings for the de Havilland DH9. A little later they began real precision work with a contract from Integral Propellers Manufacturing Company for shaping propellers.[4] This change from simple woodworking to complex precision wood engineering clearly shows the benefits to the companies that were involved in war work. It is apparent that the

end of World War I prompted the beginning of the general demise of craft workshops and the growth of machine-assisted production. *The Times* neatly summed up the results of 1914–18 war work for the furniture industry:

> Having regard to the world shortage of furniture, perhaps the most valuable result of war-time experience will be the education of our manufacturers in mass production. The absolute accuracy and precision demanded by the A.I.D. for all aeroplane work accustomed heads of factories to the idea that intensive production need not necessarily mean bad work.[5]

The benefits that had accrued during World War I were again seen to have been useful as a result of World War II. The importance of the sub-assembly principle, derived from wartime experience on aircraft manufacture, was particularly singled out as it 'reduced to a minimum the amount of work that had to be done in the main assembly jig, and [it] enabled the higher skills of the available workers to be used to utmost advantage'.[6]

In addition to sub-assembly, the facilitation of orderly progress through the factory was considered an important development. This is discussed further below. The application of production engineering methods meant that some of the larger concerns would have a hefty advantage over their smaller competitors in the post-war markets, which led to a substantial contraction of the number of businesses. Other major improvements that were beneficial for the industry included the introduction of power clamps, the use of synthetic glues, and accelerated settings by radio frequency, all of these improvements being directly taken from developments in aircraft construction.

Indeed, it was in aircraft construction that some of the larger manufacturers gained valuable experience in the use of new materials and processes. Harris Lebus, for example, had experience of aircraft manufacture in making the entire Handley Page 0100 plane from spruce and English ash timbers. Lebus later built the Horsa and Hotspur gliders. In the former example, innovative stressed plywood skins were used in conjunction with wooden frames. In 1942–43 Lebus, along with up to 400 other firms, began work on the Mosquito aeroplane which had been especially designed for speedy manufacture utilising skilled woodworkers. Indeed, hardly any metal

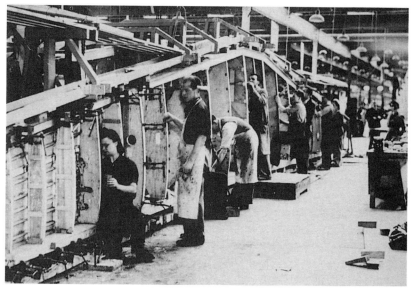

12 The Harris Lebus company's war work-glider construction, 1941

was used at all. By using huge jigs, the whole fuselage was con-
structed from a plywood and balsa sandwich fitted with hardwood
reinforcing-ribs. It was in this work that low-voltage glue heating
and gap-filling glues were first used.[7]

As stated above, aircraft manufacture was not the only wartime
activity for furniture-makers. Lebus, for example, was also involved
in the manufacture of canoes and landing craft from plywood, while
another major business involved in war work was that of Lucian
Ercolani and his Furniture Industries. The war contracts they worked
on ranged from munition boxes, picketing posts, and pulley blocks
by the thousand, to millions of tent pegs![8] One particularly inter-
esting contract that might have led to a greater interest in built-in
furniture, was the production of a wooden kitchen/bedroom unit for
prefabricated houses. This provided a whole central wall which di-
vided rooms, having kitchen cupboards on one side and fitted
bedroom cupboards on the other.[9]

It was not only technology and materials science that benefited
from the wartime experience. Apart from the well-known Utility
scheme (see further below), other design themes were developed.

The Ercol Windsor range, although based on historically well-known types, was adapted from a wartime contract for chairs by Ercolani. By breaking down the manufacturing process into small operations for subsequent assembly, he had laid the groundwork for the development of the range into, what is today, a well known and respected brand of furniture. In addition, the use of traditional English timbers such as elm and beech partly bridged the gap between the taste for Scandinavian modern and English vernacular. The brilliant combination of the traditional Windsor chair image with modern machining and production controls, technical advances in methods as varied as timber kilning and upholstery suspensions, has allowed this range to continue growing for over forty years.[10]

The direct applications of wartime processes and methods to the peacetime economy were exhibited by some governments interested in promoting design and manufacture. Mindful of the potential results that could be harnessed for post-war economic growth, the Canadian National Research Council supplied the 1946 'Design in Industry' Exhibition with examples of plywood aeroplane parts and details of the use of autoclaves in plywood component manufacture. The idea was to promote the use of ply in chair-making. Two prototype chairs by the Canadian Wooden Aircraft Company and Granby Aviation were displayed. These chairs were made on the same principles as aircraft fuselage construction and were shown with didactic panels illustrating famous antecedents, such as the chairs designed by Alvar Aalto. In addition, examples of other wartime materials adapted for post-war use were shown. These included an aluminium cantilever chair, and experiments in plastic and glass fibre.[11]

In immediate post-war Britain, the Board of Trade established working parties for various industries which were set up to provide recommendations for future growth and organisation. The brief to the Furniture Committee included investigating the industry and reporting what steps 'should be taken in the national interest to strengthen the industry and render it more stable and more capable of meeting competition in the home and foreign markets'.[12]

The Report highlighted some of the problems of furniture production, and in particular, machine use. It considered that the true significance of volume production was overlooked, and there had been a tendency for volume purely for volume's sake. They argued

that whilst the continual use of machinery was necessary to justify its purchase, there seemed to be no understanding of the balance between business size and machinery to create an optimum manufacturing unit. They also found that ignorance of improvements in technology and materials science, as well as competition, tended to keep any developments on the horizon. The most impressive result of the Furniture Report was the establishment of the Furniture Development Council and its later offshoot, the Furniture Industry Research Association (see further below).

Production efficiency

Although the development of machines and production management in furniture-making has taken great strides in the twentieth century, the nature of the trade has been such that it will support a large number of relatively small enterprises that co-exist with a comparatively small number of larger ones. One of the reasons for this relates to the findings of an industrial geographer who also identified the limitations on a furniture business in the 1960s:

> furniture is an industry in which the economies of scale in a single plant fail to yield higher returns beyond a rather modest size. It has been estimated that the most profitable kind of firm is probably one only in the 50 to 100 worker range even today.[13]

More recently Chandler (1977) commented on the lack of innovation:

> The process of production in other non-heat using industries had the same characteristics as those making cloth, leather and wood products. Total output was increased more by adding men and machines than by continual technological and organisational innovation. For this reason the increased size of the enterprise brought few advantages in terms of increased productivity and decreased costs.[14]

Even if large-scale businesses were not suited to making furniture, increased efficiency meant better profitability, so innovations to improve productivity and earnings were made from early in the century.

The first steps in improving production efficiency in the twentieth century started with the kilning or seasoning of timber. The importance of correct timber seasoning was crucial to twentieth-century precision furniture-making. According to Herman Lebus, the early part of the century's production used an unscientific method of

drying timber that sometimes resulted in split wardrobe sides and chest tops.[15] The problems were initially solved by the Lebus company using a small army of men who were kept busy 'splintering up' at certain times of the year. To combat the problem technically, the company later installed Erith Progressive drying kilns.[16] Not only was there a problem with customer satisfaction should a piece of furniture become split or warped, but the cost of traditional open-air drying tied up capital in material for a long time, so it was clearly an economic imperative to improve kilning methods.

The pioneering examples of Lebus, and later, Ercol, had predecessors in the trade. The chairman of the William Birch Company of High Wycombe spoke about the need for such technical progress in 1912:

> Fashions in furniture were very ephemeral. Every year the public taste was much better educated and it was more critical. To meet these contingencies it was absolutely necessary and imperative that every manufacturing firm should have its plant and facilities for manufacturing goods right up to date and fully abreast of the time.

The Birch Company practised what they preached. After World War I, they introduced the Powellising process of wood preparation which avoided lengthy spells of kilning and produced an interesting timber colour as well. The 'turn-round' from green timber to a furniture product could be as quick as two to three weeks.[17]

The benefits of research into kilning were acknowledged by Ercolani in his work with elm timber in 1945. Because of its unpredictable nature, elm is not normally associated with factory furniture production; Ercolani, in conjunction with the Forest Products Research Laboratory, succeeded in discovering a satisfactory way of reducing the moisture content of elm so that it was quite suitable for manufacturing a range of 'Windsor' furniture.[18]

Developments in production efficiency followed on the main factory floor. The sub-assembly system was a major improvement in productivity between the wars. Initially there was very little subassembly, and even in large factories, one man alone often made the whole job, sometimes employing one or two boys whom he paid.[19]

Before full flow-line operations could be carried out, a comprehensive analysis of processes had to be undertaken. This would involve the establishment or extension of the division of labour as well

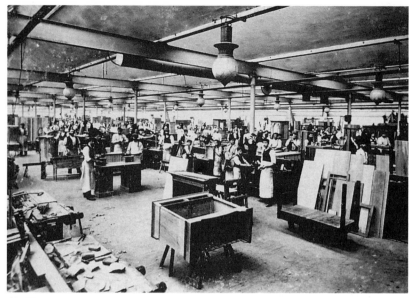

13 The Harris Lebus company's cabinet-makers shop at Tottenham, *c.* 1910

as production planning based on the close examination of each operation. In an effort to apply the principles of scientific management to their works, Lebus in 1931 set up a time-study department. The development of this management tool coincided with the splitting-up of operations and the development of the sub-assembly system along with the beginning of progressive assembly lines in that company. In conjunction with these changes, the Lebus Company introduced inspection processes and a separate drawing office to produce detailed dimension sheets.

Despite these improvements, efficiency was disrupted by delays which inevitably occurred in the veneering and cramping operations: for example, the setting of glues often took up to twenty-four hours.[20] This bottle-necking at crucial points during the production process has been a major problem for furniture-manufacturers who have engaged in flow production. As one process is improved, the inadequacies of the next or previous one are shown up. Although quicksetting glues and faster-drying finishing materials, as well as developments in woodworking machinery, have attempted to iron

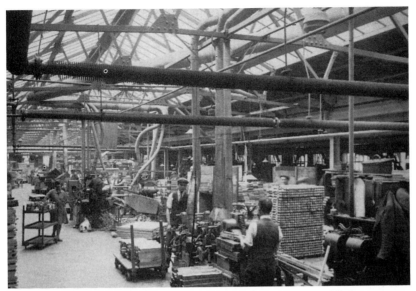

14 E. Gomme's new machine shop in the Spring Gardens High
Wycombe factory, *c.* 1927

out the delays, only a total revision of the production process could
ensure that there was continuity between processes.

Notwithstanding what has been said earlier about the relationship
between size of firm and its output, it was indicative of the applica-
tion of new techniques in larger factories that between 1935 and
1938 net output figures showed that the efficiency gap between small
and large firms was widening.[21] However, even if productivity was
increased, there were other limitations on the efficiency of the trade.

Whether they liked it or not, the furniture manufacturers were
in the fashion business, and the problems associated with that were
clearly set out by William Birch in 1912 (see above). The extent of
the problem was noted later by George Nelson (1947). In that year,
the American furniture industry apparently offered approximately
three hundred thousand different models. This meant that the average
manufacturer put a model on the line and let it run for 200 to 300
cuttings, then had to reset the machine for the next one.[22] This ex-
ample from the United States clearly shows that the problems of the
quantity of designs had to be addressed.[23] The physical production

65

difficulties caused by the diversity of ranges encouraged manufacturers to make cost savings wherever possible. For example, to try and overcome the machine re-setting problem mentioned above, the system used by Lebus in the late 1940s is worth recording. According to Jack Pritchard, it

> consisted of a library, with drawings and costs of each item used in the construction, from the smallest item to each sub-assembly. When a new model was introduced, the maximum number of existing bits and pieces would be used. As design changes were usually superficial this was easy.[24]

This perhaps compares favourably with the traditional method which was to lay out a design on rods, and to derive from it cutting-lists and quantities to guide the mill operation.[25] More fundamentally it illustrates an attitude to design that was related to stylistic changes and profitability.

An economically sound approach which limited the diversity of designs was initiated during World War II in Britain. Firms were restricted to producing 25 per cent of their pre-war range of designs. According to the *Working Party Report*, many manufacturers soon realised the economic sense of the reduced ranges and tried to keep to the lower level after the war so as to improve efficiency.[26]

Whatever efforts were made, the British industry was undoubtedly in a state of hiatus as it went into the second half of the century. The *Working Party Report* summed up the main problem: 'Traditional methods of the handwork shop were grafted on to the new machine production industry'.[27]

Although there were many similarities, the differences between the American and the British experiences were highlighted by two reports of the post-war era. The Working Party Group who visited the United States were impressed by the degree of mechanisation and hence the productivity levels that they considered were due to spacious and well-planned premises. They commented on the absence of wardrobes in ranges and the loose fitting of drawers, both of which reduced assembly times; the speedier polishing and drying methods, and the internal movement of items within the factory, were designed to limit the amount of man-handling. All the operations, in both cabinet and upholstery workshops that were seen, were sub-divided to be more efficient.[28] The British Furniture Trade

Productivity Team Report on Furniture (1952) likewise stressed the importance of production engineering in the United States, whilst the minute division of labour was considered essential for the efficient running of the plant.

In comparison, an American commentator found that, in Britain:

> Material handling of work in progress is backward in most English factories. Conveyorised plants such as we have in America are virtually unknown in Britain. In some of the larger factories, pieces in production are placed on the floor between operations. This not only adds greatly to the cost but increases the liability of damage to the various parts.[29]

Not much could be done before the lifting of controls, but as soon as this happened improvements to the British industry were mooted. In 1953 the *Cabinet Maker* ran a long series of articles by William Kape which evaluated all the then current processes and methods in the furniture industry. Discussing the scientific approach to furniture-making by mass production, Kape pointed out that the method must be applied to all aspects of production, especially to waste disposal, materials handling, the rapid setting of adhesives by electronic methods, and work study. He set great store by work study as the basis of accurate costing, hence profitability.[30]

These ideas were gradually put into practice in some of the larger enterprises. For example in 1962, it was reported that Gomme, the makers of G-Plan, had made attempts to use Detroit-style mass production on a continuous and automated line. Inevitably perhaps, with a fashion object such as furniture which has a wide choice factor, this process was not going to be successful. However, the idea of the link-line process, in which various machine operations were linked to avoid intermediate handling, did make sense.[31] The problem remained that there were too few large enterprises to take advantage of large-scale production techniques. According to Leslie Julius (1967), joint managing director of Hille Furniture, in order to take advantage of new mechanised production processes, rationalisation similar to that which has taken place in the cotton industry would also have to occur in the furniture industry.[32]

A year later in 1968, the Lebus business began to think about such rationalisation. Just as had been predicted twenty years previously, the company was forced 'by its diverse 400-item catalogue to

make furniture in short-run batches. Rising sales figures were inevitably accompanied by falling profits.'[33] Basing its new 'Europa' range as far as possible on standard-sized panels, the company installed automatic finishing equipment in conjunction with flow-line conveyor systems. This did away with the labour intensive hand-finishing processes. In addition to the changes in the factory, the company also set up franchise dealers who maintained a fixed showroom of Europa range furniture. Orders were taken, based on a 3–4 week delivery to the retailer, which compared very favourably to the industry's norm.[34]

The idea of link or flow-line production continued to generate interest. This process seemed especially appropriate for the growing panel-based products and was particularly well developed in the German and Belgian furniture industries. An example of the efficiency gains can be seen in the development of flow-link cutting and gluing systems, especially when used with automatic, computer controls. An example of another development from the United States was the V-grooving and folding process. As Heughan (1972) pointed out, 'The system permits cutting panels to size, machining all grooves, rebates and chamfers, automatic spraying application of adhesive and final folding into carcase form by mechanical means.'[35]

An adjunct to the question of efficiency was its relation to cost-effective production, including proper job-costing and financial controls. The furniture industry has been notorious for its lack of management skills in terms of planning, costing, and control. At one time, guesswork and experience were often the only methods of arriving at a selling price. The example of the ad hoc nature of price setting without any reference to the actual costs involved can be seen in the process that Lebus used prior to 1914.[36]

> there was no costing system; the Partners would assemble at Tabernacle Street on Saturday morning and would stand in front of a suite, each with a scribbling pad and independently put down a suggested selling price. They would then compare notes and usually end up with some compromise.

Amazingly it was not until 1934 that Lebus introduced a system of budgetary control: it was apparently the first firm to employ such a system. From this arrangement, standard costings could be introduced and the 'real' cost of the firm's products was known.[37]

One of the important roles of the post-war Furniture Development Council was to increase an awareness of costing procedures through its Product Cost System,[38] an example of one of the tools that enabled the post-war generation of managers to tighten controls and costs.

It is clear then that productivity markedly increased in parts of the industry due to a number of factors. Firstly, the use of new cost-efficient materials, especially particle board. Secondly, an improved range of management methods and systems, especially cost control and work study. Thirdly, the growth of capital investment in the industry including the development of special-purpose machines and control systems. Fourthly, simplified and rationalised designs to reduce the number of processes and components. Production efficiency was also related to factory layout, yet another stumbling block for the industry.

Factory layout

At the beginning of the twentieth century all manner of factory and furniture-making premises could be found in the industry, from the large establishments like Lebus and Herrman, to the smallest backyard maker in the East End of London.

These backyard furniture-making establishments did not seem to be considered worthy of the name of 'furniture maker'. In 1912 a trade journal commented on the quality coming from these establishments:

> A few years ago the ordinary cabinet works consisted of a few sheds, where a number of men worked from Wednesday afternoon making a number of articles, called by courtesy, 'furniture'.[39]

Having made this point, the trade journal offered some rather more constructive criticisms. For example, it suggested that the best location for a furniture factory was likely to be in the suburbs on the banks of a canal or stream.[40] Clearly some of the larger enterprises began to take this advice, and a number of factory colonies grew up on canal or river banks. The benefits of the truck system running on lines for conveying parts around the factory floor was also recommended, whilst the ideal factory type was seen as the single-storey

building where raw material arrived in the 'rough mill' at one end and left by van at the other. This consideration of flow production, which is now taken for granted, took a long time to filter through the strata of furniture-makers. Many enterprises were established in premises which already had a number of floors, or when they were newly designed, on expensive land, they were built up rather than out.

Cabinet shops where batch production was carried on were usually based on the following flow process even if it meant moving part-finished goods between floors. The initial rough mill-machining was followed by the finishing mill, the veneering shop, and the cabinet assembly area. In Britain, this last operation often involved skilled drawer and door fitting.[41] Finally, cabinet polishing was either by hand or later by spray-guns located in the finishing shop. In the larger firms there was little mechanical handling, except perhaps for some conveyor belts.

In any enterprise using flow production it was essential to have ready-cut parts which could be both easily identified and have guaranteed regular dimensional standards. The World War I experience had brought home the significance of these factors to flow production. The application of these principles of factory layout can be seen in the suggestions made in the 1920s for re-organising the Birch Company's High Wycombe factories on the lines of one continuous works.[42]

The nature of many of the processes in flow-line furniture-making necessitated an investment of capital in special-purpose machinery, and the provision of skilled workers to operate them. Therefore the medium to small-sized business often sub-contracted such specialist activities as veneering, door-front preparation and surface decoration. In addition upholstery frames were often bought in, and trade mills and kilns were frequently used for basic timber preparation. On the other hand, some large-scale manufacturers were virtually self-sufficient.[43]

Concomitant with the flow-line factory layout were developments in power sourcing. In many factories the flexibility achieved by having individual motors for machines was eagerly adopted; however, until the completion of the national grid, High Wycombe, a major centre of furniture production, suffered from the restrictive old DC electric system. This was one of the reasons for the persistence of

gas and oil engines powering overhead belting rather than the individual motors used in other parts of the country.[44]

Nevertheless this situation was corrected once the national grid had been extended to all parts of the country and by 1939 the new High Wycombe factory of Castle Brothers was using grid electricity for woodworking machines, heating and other processes in the factory.[45] The layout of this purpose-built factory used the flow principle which started with timber seasoning for a period of about ten days, with fan-assisted kilns. These used low-pressure steam to control humidity and temperature. After the usual machining and preparatory processes, the production system allowed for assembly using pneumatically-operated presses. The frames then reached the first floor for toning, staining, and polishing. Even with a new factory the design of the production process allowed for a two-storey building flow pattern.

The problem with a large number of factories was that they were old and often multi-storied thus retarding the full development of flow-line production. Even if they were well equipped there was still a problem of movement between floors. Not surprisingly by the second half of the century there was a greater tendency towards single-storey factories to allow successful flow production.

A generalised criticism of the state of British factories immediately after World War II was noted in 1949 by an American trade delegation who found that:

> most English factories are of multi-storey construction and, with few exceptions, are very old buildings to which additions have been made. Small windows result in poor lighting and the old uneven floors are very inferior. Housekeeping in most plants is not of the high level we know in this country.[46]

Clearly, advances have been made since this report, and a number of companies have erected purpose-built factory 'sheds' to augment or replace older buildings. One of the most impressive examples of the 'shed' layouts was the Schreiber factory at Runcorn. This was planned to take advantage of panel-processing plant as well as incorporating large storage areas for the stocking of ready-for-dispatch goods.[47] Factory layouts still reflect the diverse nature of the industry, ranging from small workshops to acres of storage and production facilities.

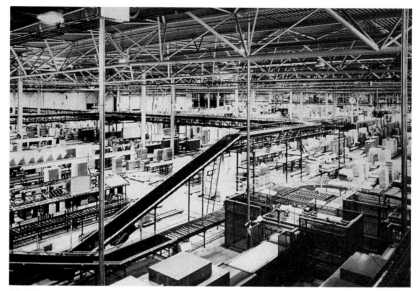

15 The flow-line factory system in the purpose-built Schreiber factory at Runcorn, 1980

Machine use

The incredibly diverse nature of the furniture trade and its variable relationship with innovation and tradition is nowhere better exemplified than in its use of machinery. During the nineteenth century, great advances were made in woodworking machinery but many of these were only gradually accepted by furniture-makers. The patchy adoption of machinery during the first part of the century, even in a supposedly industrialised country such as the United States was clear. Between 1899 and 1927 horse power per wage-earner in the US furniture industry increased 79 per cent compared with a figure of 117 per cent for all manufacturing industry in America.[48]

The situation in England was similar. Two examples taken from commentaries on High Wycombe exemplify the different attitudes to machines. A report on the William Birch factory dating from 1895 showed that:

> on the first floor, nine machines [were] used for planing, moulding, rabbiting, boring, tenoning, square framing etc., in fact chairs were being made to use a popular expression 'untouched by hand'.[49]

Over twelve years later, the *Cabinet Maker* could report on a visit to the firm of Henry Goodearl:

> [He] astonished us with the information that they had no machinery whatever, and here it was that we had the pleasure of seeing some of the methods of fifty years ago still practised and practised successfully, even in competition with modern machinery.[50]

Whatever individual factories did about machine use, and even if other industries were more advanced, it was clear that the new century would bring sophisticated machinery four square into mainstream manufacture; not necessarily to change methods of manufacture in the early stages, but certainly to improve quantity and quality.

The modern woodworking machine-makers were knocking on the furniture-makers' doors and there was much discussion in the trade press about the efficacy of particular machines in furniture production. By the turn of the century the basic processes had long been successfully mechanised; it was therefore the more specialised jobs that needed attention to attempt mechanisation of the line of production. In particular, American tool-makers who specialised in woodworking machines thought that their products could be useful in British cabinet-making factories. Among the specialist machines introduced before 1914 were Madden's automatic Gluing Cramps, Billstrom's Automatic Glue cramp carrier, glue spreaders, E. B. Hayes Machine Company's dowel door machines, McKnight's automatic Screwdrivers, and Maddox's Rubbing and Polishing machine.[51] From the descriptions it seems clear that these were intended for large-scale operations and may have found more favour with woodworkers supplying builders with doors and window frames and the like.

Although there were many hand-operated machine tools for the smaller enterprise, to operate most machinery a power source was required. In the nineteenth century this was a steam engine, and although this form of power remained in use well into the twentieth century, it was electricity, in a variety of supply methods, that was adopted in a number of factories prior to World War I. The Lebus business, for example, installed a turbine and a Siemens generator in 1911, to supplement the work of three coal-fired Lancashire boilers which operated shafting and belting. It was not until 1928 that they were connected to a public supply, but even then they still required

16 A traditional saw pit still in use at the beginning of the century. A good example of the stubbornness of the old methods

their own generating capacity.[52] The superiority of an electricity supply soon became evident. The banding and shafting connected to steam engines was too proscriptive; electricity meant flexibility.

By 1928 electric motors with starters and push button controls were becoming common. Their importance was recognised because they allowed machines to be fixed at optimum points in the factory, allowing not only a better flow of production but also an improved machine design.[53] By the middle of the 1920s, many machines were fitted with ball bearings which improved precision, accuracy, and speed. For example, in 1906, a spindle moulder would operate at 2500 rpm, in 1920 this had risen to 9000 rpm.

Another power innovation in the 1920s was the use of compressed air to drive certain machines. This raised spindle speeds for example, from 500 rpm to 15,000 rpm.[54] By 1932, routers were introduced that were capable of speeds up to 24,000 rpm. These improvements resulted in a better finish in a shorter time.

However, the introduction of new machine processes were not always successful and the traditional methods were often upgraded

and improved instead. Built-up panels which required timber boards to be jointed using the edge planning process (which allowed boards to be finely planed so that a butt joint could be used to build up a flat surface), are a good example. In the 1920s Lebus introduced a Linderman jointer in an attempt to improve the technique. This machine produced a male and female dovetail, glued the sides and slid the two pieces to be joined together. It was not too successful and was discarded after it became possible to joint the boards directly from the saw.[55]

Nevertheless, most machines were a great improvement in efficiency although they altered the relationship between the maker and the products. Since the nineteenth century it had been argued that the conjunction of machine and hand methods would offer a solution to the problem of industrialisation, and in one particular instance the experiment clearly worked. The application of a combination of machine and hand methods has been successfully operated by Ercol Ltd, since the 1950s. They were able to produce an article that was efficiently produced but still had something of a craftsperson's finish:

> Each chair has a sculptural feel deriving from a true appreciation of form. Effective sanding of curved members is accomplished by air filled rotary balloon type abrasive drums which yield to the contours, and hand-waxing completes the job.[56]

Using these techniques Ercol were producing 2,000 units per day. Today the company uses CNC machines to create motifs in Windsor chair back splats but still follows a philosophy of combining high technology with hand finishing.

The developments in machine use meant a change in skills. The cabinet maker had given way to the production engineer, the semi-skilled assembler to the machine controller. This process was recognised as early as 1929 when Sir Lawrence Weaver pointed out that:

> the skill of a man who can set forty knives in a power lathe to turn a table leg which is part a spiral, part round, and part octagonal and hexagonal – a thing that can be made in less than a minute – may be far from the skill of a cabinet maker, but it is a prodigious skill nevertheless, and must command our respect.[57]

In practice, in the Lebus business the employment of specialists in a separate Cutter shop, where removable cutters were set up away

from the machine and its minder, was aimed at reducing the machine-setting times.[58] This of course had the effect of further dividing labour into skilled, semi-skilled, and unskilled divisions.

The division of labour and the advantages of sub-assembly were known by the beginning of the century, but it was World War II that hastened the progress of the system through much of the industry. The advantages of the technique, which facilitated the flow-line system, was further improved by developments in automatic and power operated jigs.

With the increasing demand for plain and simple surfaces often based on a combination of particle boards with veneer or paint finish, the linking of panel-processing equipment became important after the 1960s. This system required a new type of furniture production practice which used machinery such as conveyors, automated rough cutters, high frequency drying of glues, abrasive planers, optical scanner routers, and continuous panel and coating operations. These methods were especially designed to suit the production of flat-pack and self-assembly goods, although they could be used for making furniture ranging from melamine-surfaced or white-painted bedroom furniture, to foil-finished wall units.

By the 1960s, the confusion between the terms 'mechanisation', 'mass production' and 'automation' in describing furniture production resulted in some misunderstanding. For example, a commentator noted that in 1964 the Bassett Furniture Industries plant in Virginia was 'so automated that it produced one bedroom suite per minute'.[59] The idea that in the 1960s America was producing most of its furniture in automated factories on a mass-production system was clearly incorrect. More realistically, the president of Thomasville, furniture manufacturers, pointed to the nub of the problem of furniture and automation:

> Mechanisation is merely the moving of products through the plant. Today there is no automation whatsoever and how much will come about I don't know. I don't think anyone can predict. The variety of the production line and the variety of styles do not lend themselves easily to automation.[60]

In the same paper the president of the Stanley Furniture Company was quoted:

We have not begun to automate. We are slowly beginning to see some advances, primarily in the application of materials, but not in the application of work methods. Advances which have been made in cost reduction and simultaneously in the style field have come through introduction of new materials and not through new methods.

It is important to note the emphasis on materials advance rather than production technology.

The nature of the furniture industry has meant that developments have been towards increasing sophistication of materials, controls and methods, rather than mass production. The use of computers and programs made for designing have become common and the conjunction of computer-aided design and manufacture is clearly one way ahead. Other developments have entered the furniture field, for example the recently developed laser technique used by Baker Furniture designed to cut out fret-work and marquetry in high quality reproduction ranges. This utilises a PC, and reduces the time taken to cut frets by about half.[61] Clearly, as pressure continues on manufacturers and designers to use resources carefully for ecological and financial reasons, machines and their design and control systems will be far more important than machines that simply help to produce multiple copies.

Construction methods

One of the sources of the continuing criticisms of the trade arises from the constructional quality of its products. The problem for the quality manufacturers was that superior construction usually meant higher costs: this often meant that another could easily adapt your design and undercut the price. Whilst retailers sold and the public accepted such products, improvements in construction would remain elusive.

One commentator in 1932 wrote that the cheap grades of furniture which could be sold at 'absurdly low prices, can be recognised by poor quality timber which is often of mixed kinds with the addition of cheap plywood for panels.' His second point was that the construction was 'mere sham' being based on a dowelled butt-joint instead of a full mortise and tenon, 'so also with the dovetailed carcase, various trick substitutes are adopted which it is impossible to detect when the pieces are finished'. Thirdly, to disguise these constructional

deceits, a finish was applied which looked like 'a muddy-red solution which dries with an ugly grin and looks like jam.'[62]

Not surprisingly, another commentator suggested that the furniture trade's problem was that its cheap furniture was equated with shoddy furniture as

> the furniture trade with its craft tradition has never acquired, so far as its cheap productions are concerned, the standards of precision and quality which are applied to mass-produced articles in newer industries such as plastics, motor-cars, radio.[63]

This of course explains why the continuing development of more homogeneous materials as replacements for wood were searched out during the century so that cheaper products might be precision made.

The changes in construction methods and their relation to design often hinge on the nature of newly introduced materials. Some of these new materials were discussed above, so in this section the main furniture material – wood and its products – will be discussed. During the twentieth century, there were two major changes in the basic construction of wooden furniture, and they both occurred in response to the availability of new materials. The first, occurring during the 1920s, was based on plywood; the second, related to particle board panels, began in the 1950s. The introduction of new materials could have meant the application of new manufacturing processes, methods of construction, and design, but it was often the case that the materials were used as substitutes for traditional wood, rather than in a way especially designed for them. This meant in reality that old construction techniques were often adapted to suit the new materials.[64]

In addition to complaints about precision and quality, the trade's blinkered approach to machine use came in for chastisement:

> It is indicative of the outlook of the trade that although most of the present types of machinery were invented by the beginning of the nineteenth century, published research into the theory of machining was practically unknown until 1932 when the F.P.R.L. [Forest Products Research Laboratory] issued its preliminary survey *The Principles of Woodworking*.[65]

In addition to the efficient use of modern machinery to assist construction, Booth (1935) considered that the other factors in cost

reduction were mainly the use of materials and labour. In the matter of materials he suggested that in the satisfactory construction of cheap furniture 'the choice lies between the cheaper hardwoods, used in the solid, and deal stained or painted.' He pointed out that although deal was not normally considered a furniture-making timber, fairly successful products could be made from it.[66] The problem here was not one of construction so much as one of image. Deal or pine was not considered a suitable wood for furniture by the public in the 1930s. It was only elevated to a popular position during the 1960s when the fashion for stripped old pine became a commercial proposition.

As far as labour-saving was concerned, Booth thought that amending the making process rather than introducing machines was an answer. The use of constructional features as part of the design could improve both. His examples included projecting tops which avoided dovetail jointing, dowelling tops to bases, and avoiding separate bases, as well as constructional features such as hanging wardrobe doors to the face (thus avoiding the shooting to fit process), and flush-framing using ply rather than the grooved frame and panel arrangement. Many of these suggestions were soon applied to less expensive ranges.

Booth commented further on the nature of construction and looked forward to the day when furniture could be produced like any engineered product:

> In cheap drawer work, as in cabinet-making generally, a technique of designing, machining and assembling to carefully controlled tolerances, as in engineering practice, in order to eliminate fitting on individual pieces and provide complete interchangeability of parts has yet to be evolved.[67]

In 1935 the possibilities of composite boards and plastic materials which allowed such tolerances were yet to come on stream, but it is interesting to note that Booth saw that:

> Interesting experiments have been made in the use of plywood as a structural material, and in the future it is possible that present techniques may be superseded by the increased use of ply shaped and bent to form carcases etc.[68]

All these ideas were aimed at improving the construction of 'cheap' furniture. It seems that the direction Booth was suggesting led to a

functional-minimalist design that was to find favour with design reformers but not necessarily with the general public. It was extraneous circumstances that finally encouraged developments towards Booth's suggestions.

During and after World War II, the results of the Utility scheme began to change the way furniture was made. Its construction was based on a minimum of solid wood, combined with plywood and hardboard, and designed and produced to rigid specifications. The resultant improvements in the construction were applauded by the trade union leader Alf Tomkins:

> A useful feature of the new furniture is the fixation of constructional details, and it is generally agreed that the standard set by the return of the mortise and tenon and the dovetailed joint instead of the crude forms of jointing which have become the rule in machine production jobs, is a feature which should be retained by Government control after the conclusion of hostilities.[69]

Although considered, control over construction did not continue after the end of the Utility scheme, but the benefits of improved materials use and construction designed to harness the benefits, were studied:

> When plywood is used in conjunction with soundly constructed framing, and is 'grooved in' or alternatively overlaid on framing, an almost monolithic quality is obtained with great durability and real economy of labour and material.[70]

This resulted in the production of cabinet goods which had no solid wood of greater dimensions than 1 in. by 2 in. (25 mm by 50 mm) thick. To obtain rigidity, the sides were held together by the top and base while all four were held together by the back. The base, side, top and bottom were made from ply, the doors often being made from blockboard. The plinth or base might be of plywood reinforced with corner blocks. Shelf rails were glued on the plywood with radio-frequency heated glues that were as strong as screws, thus saving time. The construction process only required an operator who simply needed to be able to apply glue and cramp the job.[71]

Alf Tomkins' concern about standards (see above) was echoed by the 1946 *Working Party Report* who recognised that when the Utility controls were relaxed, the industry might fall back into its old ways of production. It therefore suggested the establishment of minimum standards for 'essential' articles of furniture. The devising

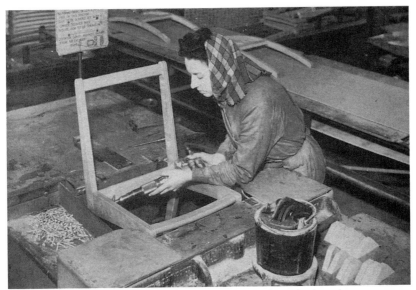

17 Morris of Glasgow's chair assembly, *c.* 1949, clearly showing the use of framing-jigs as well as the importance of female labour especially during the war periods

of these standards needed to be either based on specification or performance. The need was for standards that were precise without being too rigid. The Working Party recommended performance standards over specifications which were seen as overly proscriptive.[72]

The Utility scheme had partly been intended to be a guarantee of performance brought about by working to tight specifications. In 1950, in order to try and maintain the quality control that had thus been introduced, the Furniture Development Council's Technical Information Service began to prepare a set of tests of furniture to establish a performance standard, rather than a specification standard. Once completed, the British Standards Institute was requested to draft a standard, based on the testing methods. In 1953 BSI Standards were introduced.[73]

Although large furniture retailers like Great Universal Stores were apparently very supportive of the scheme, others in the trade, especially the higher quality makers, thought that comparisons would not sufficiently identify their goods' finer qualities.[74] According to Jack Pritchard, the scheme thus withered through lack of support.

By 1965 the trade were still reluctant to accept imposed standards. Manufacturers disliked the stipulation in the British Standard as to the types of materials and components that could be used; secondly, they again regarded the standard as too uniform and rigid, because it used the same bench mark for the passable as for superior furniture. Thirdly, even if there was merit in compliance, the manufacturer thought that the consumer did not recognise the value of the standard due to poor publicity.[75]

Whether standards were accepted or not, basic scientific research had been applied to cabinet construction since 1953. One result of the Development Council's experiments showed that the members of a cabinet frame did not contribute to the rigidity of the whole in equal proportion. Secondly, they found that a five-sided box shape could be made rigid by stiffening only one side of the box. Prior to this, the idea was that bulk constituted rigidity; it was now shown that a cabinet could be improved using 20 per cent less timber.[76] Despite the significance of these findings, the industry's reception of the research paper on cabinet rigidity was apparently appalling.[77] The elementary scientific principles seemed to elude 'furniture men', but once they had seen a model demonstrating the principles, they recognised the value of such research.

However much scientific research goes into furniture-making, there are many cases when it still has to be an integration of science and 'craft'. An example from Gomme's factory in the 1960s shows this. The not inconsiderable throughput of 1,000 wardrobes and 12,000 drawers per week (in 1962) meant that automation could be applied to parts of the Gomme factory whilst in other parts it still retained some traditional craft elements. An example of the craft skills was the 'veneer-tailor' whose job it was to match veneers and check for blemishes by eye, before passing them for making up;[78] an example comparable to the case of Ercol (see above) which also combines craft and technology. The important but difficult balancing act of straddling two different cultures of production was also noted:

> Furniture-making is very much a traditional craft, and it has been essential to retain the craft element without losing it somewhere in the machinery of mechanisation. The planning policy thus provides an exceptional example of mass-production of a craft product – almost a contradiction in terms.[79]

The author quoted, rightly considered that the most revolutionary innovation was the development of a woodworking factory operating to strict engineering tolerances. As I have shown this concept was not new, rather the practice had been difficult. For manufacturers, one problem was that machinery suppliers were still equipping machines with just three settings, coarse, medium and fine, thus not allowing for any precision adjustment that may be required.

The reduction of handwork, particularly on features such as door-shooting and drawer-fitting was the inevitable result of this demand for tight tolerances. The result was the beginning of a true inter-changeability of component parts, one of the features of mass production.

The changes to the production of Breuer's Cesca side chair demonstrate how a manufacturer – Thonet – can adapt production to suit an increase in demand which resulted in a better use of timber resources, subtle appearance changes, and of course more chairs. The main changes were from using a bentwood frame for the chair seat to shaped moulded parts that were jointed. This enabled short ends to be used up economically. Tolerances were also tighter due to the use of a finger joint for the frames sections, and some operations were eliminated which eased the cost.[80] Thonet were thus able to profitably produce this chair in increased numbers more efficiently.

One post-war development that demanded increases in precision, careful specifications, and homogeneous materials, was flat-pack furniture. The development of knock-down (KD) furniture after World War II was a major phenomenon that was to affect the whole industry. Again it was not new. The method of making furniture so that it could be dismantled for easy and cheap dispatch had been well known in the nineteenth century, with such products as Thonet's bentwood chairs. However, it appears that in that period most furniture was assembled by the retailer before being sold. In the second half of the twentieth century, the role of KD changed. The opportunity was taken to sell flat-pack furniture directly to the customer so that they might assemble the furniture in their own home. This satisfied the demand for immediate gratification as well as reducing costs, but demanded quality construction. It is perhaps no coincidence that these developments paralleled the growth of the Do-it-Yourself movement.

The Swedes, Danes, Germans, and Americans were the innovators in this field. Swedish expertise in prefabricated parts, e.g. timber-framed houses, had long been famous, whilst in furniture the KD method was essential for the growing export trade between Scandinavia and the rest of Europe and the USA. In conjunction with the design expertise, the development of special fittings such as cams, bolts, screws, plates etc., were vital to the success of self-assembly furniture. In addition to constructional rigidity, simplicity and clarity of instruction are essential for the satisfaction of customers.

In 1969 it was predicted that the furniture industry would eventually become purely an 'assembly-marketing' operation which only used prepared parts from other makers.[81] Because of the diverse nature of the industry and the variety of work it produces it seems that this possibility will only be partly realised.

Finishing processes

From one of the meanest tasks in furniture-making to a highly scientific and controlled process, the scale of change in finishing processes has been extraordinary. Always considered a potential bottle-neck, the original methods of hand-polishing were bound to delay production, therefore it is not surprising that efforts were made to speed up the process.

The most universal finish for furniture at the beginning of the century was french polish. Although the results of french polishing, a mirror-like shiny surface, were condemned by design reformers, they appealed to customers who enjoyed finishes that made furniture look expensive, especially in comparison to the 'cottage furniture' they were more used to. However, the process of application was specialised and time consuming.[82] The french polishers had established themselves as a separate part of the trade, and therefore in many instances they worked in their own workshops. In larger factories they were employed as hands. Both men and women were employed as polishers, the women usually working on small items and the cheaper work.[83] Two circumstances hastened its general demise: changes in application methods and new consumer demands. The time-length of the old polishing process can be compared to the new spraying techniques, for example it took up to nine and a half hours to polish a sideboard by hand, whereas by nitrocellulose spray

it took only twenty-five minutes.[84] In addition, french polish was not the best finish for furniture that was to have heavy daily use, so the search for substitutes was to be as desirable for the manufacturer as for the consumer.

The first stirrings of change in the development of finishes was as a result of experience during World War I. The benefit of cellulose acetate, used as 'dope' (a surface dressing of varnish) for aircraft during 1914–18, was that it could be converted to cellulose nitrate which was an element of nitrocellulose. This product was the basis of the cellulose lacquer which became standard in the industry. Its main advantage was that it could be sprayed directly on to furniture thus reducing costs of time and materials.

In December 1920, as a result of visits to the USA, Lebus decided to introduce cellulose spraying. Initially it was applied with hand guns, individual booths, and rise and fall turntables.[85] Experiments with automatic spraying were based on the simple idea of mounting a gun, controlled by an electric eye, on a beam over a moving runway. After many trials it was discontinued as it needed a throughput of many articles of the same type to make it efficient. However, the use of cellulose, with its quick-drying facility, enabled the polishing shop to be conveyorised. This allowed interior spraying, overhauling, spray matching and hand finishing to be done as a continuous operation.[86] This method apparently remained at least up to 1965. The conveyors were extended to the warehouse so that finished goods would go straight to storage without being man-handled.

The economic reasons for introducing mechanical polishing were clearly shown in 1931: 'The result was the introduction of "spray outfits" with mechanically operated pistols, by which the labour cost of polishing has been greatly reduced'. It was not only the mechanics that saved money. For many years polishing had been women's work and as female labour rates were some one third less than the male rates the economies were clear.[87]

The technique of application of finishes using synthetic lacquers like cellulose, was usually to spray on and then 'pull over' the finish with thinners; it was then cut down and the lacquer re-applied. The 'pull over' method used in Britain temporarily softened the lacquer and required some hardening time.[88] In the United States a quick-hardening lacquer which allowed immediate packing was used, to avoid the drying time experienced in British factories.

During the 1960s the development of phenolic resins and synthetic resins with special properties such as heat resistance were becoming popular with the trade as well as the public. The most important development was of synthetic lacquers that provided greatly enhanced resistance to heat, water, and spirit damage. Acid-catalysed finishes used a process whereby the solids were converted into a film by a catalyst. The formulae may include urea and phenol formaldehyde, melamine, and other resins. The matt finishes that were a result of the use of these spray-applied lacquers were ideal for teak-finished furniture. More recent developments include the use of pre-catalysed lacquers which make the application much easier.

For furniture that was required in gloss finishes, the use of polyester lacquer was ideal. Its mirror-like finish was extremely hard and was perfectly suited to flat panel construction. Other lacquers such as polyurethane are very strong and resistant to household damage and have become one of a range of alternative finishes.

Along with the new finishes, revised methods of application had to be devised. It was in this area of the industry that the change from a craft to a science was most noticeable. The development of curtain-coating and roller-coating methods which offered economic precision application of paints and lacquers enabled panels to be finished on line thus superseding spraying.

Apart from stains and finishes designed to either disguise or enhance natural timbers, the twentieth century has seen the maturing of some of the ideas devised in the nineteenth century regarding imitation finishes. The most important ones perhaps have been the developments of laminates and paper foils. These vary immensely in technical specification, use, and wear, but they are important in as much as they are both a substitute for other finishes as well as a material in their own right. Melamine laminates have been used for many years on working surfaces such as kitchen units and tables; more recently paper foils that imitate teak, oak, black ash and other real timber veneers have been used extensively in the cheaper end of the market. Melamine-faced chipboard is also another development which makes it relatively easy for a manufacturer to use prepared boards to make simple KD cabinet furniture.

Whilst most of these finishes are attempting to emulate more costly and exotic surfaces, other techniques have been used during the century which have been a short-lived rage or a longer term

popular taste. These include bleaching and liming,[89] fuming, oiling and gilding. The role of finishes was ambiguous as they had to be practical, decorative, easy to apply, and inexpensive.

Machine decoration

It cannot be very surprising that the early twentieth-century furniture-makers should try and meet the demand for both reasonable price and high decorative value in their products. For in many cases, furniture was being purchased for reasons far and above any utilitarian values in the object. Decoration served as a signifier of style, taste, and quality, so it is clear that manufacturers would try and appeal to those demands. In order to do this cheaply, the furniture-maker of pre-World War II Britain had many sources for a multitude of applied decorations. Firms specialised in providing embossed or machine-cut carvings, mouldings, marquetry panels, decorative veneered panels, turnings, all of which would be simply applied to carcases.[90]

Design critics censured these added decorations: 'The press mouldings for tacking on to plain surfaces and built-up legs are travesties of the ancient art of carving, and are cheap and convenient treatments with no respectable future.' This attack was made in the 1950s and its attitude to decoration took as its keyword, 'legitimacy'.[91] This argument had been raging for more than one hundred years with little result in the mass market as it appeared that imitation was demanded by the customer. What critics required was another approach to satisfying the desire for inexpensive decoration, whilst it remained legitimate, so therefore it would almost certainly be machine produced.

Michael Farr, rather surprisingly, expressed the idea that although the machine might copy the carver, 'in no moulding did I find a conscious attempt to reproduce either the wood-carver's touch or his inconsistencies.'[92] Surely a muddled idea of legitimacy.

Machine decoration did, however, have its champions during this period. David Pye, one-time head of the Furniture School at the Royal College of Art, London, argued that machine-made decoration is quite acceptable and indeed desirable and appropriate to contemporary furniture. He saw it giving its own effects of regularity, straightness, symmetry, and flatness. These effects were achieved by

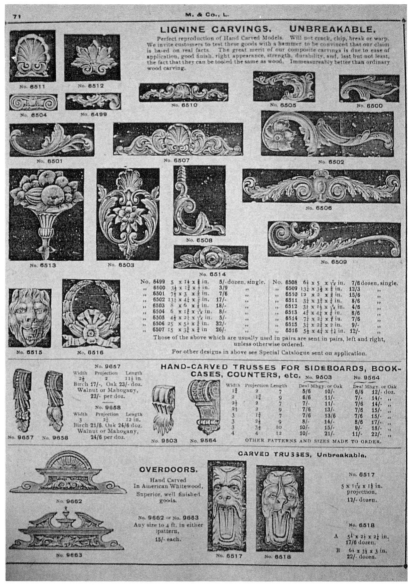

18 Ready-made 'Lignine carvings', made from a composite material and claimed to be unbreakable. Maxine & Co., c. 1912

a wide variety of processes, including mouldings, carving, grooving, turning, marquetry, inlay, applied or planted ornaments, scoured grain by wire brush or sand blasting techniques, impressed reproductive techniques, and applied cast or moulded ornaments.[93] Another example of modern machine decoration was the so-called 'organic' method of moulding decoration. This consisted of a process that was essentially a routing of the top veneer to reveal the substrate. Farr considered that these 'method[s] of decoration are completely unrealized by the trade in general'.[94]

In an important article published in the design press in 1952, it was considered 'too early to discern a trend towards the use of true ornament in furniture.'[95] Although the author could not discern a trend, he did provide some examples of machine-produced decoration that would later have an effect on the general design of furniture. H. Morris's laminated light and dark wood ply chair designed by Basil Spence is a good instance of wartime techniques being used for furthering the benefits of the constructional material as a decorative medium. As the tapering lathe turns the spindles, for example, oval designs develop automatically.

Other methods of ply-board decoration included incising the surface decorative veneer with a router so that the substrate can be seen in pattern form. Interestingly, Tomrley recommended that 'a study of Tonbridge Ware might be rewarding', since the 'stock veneer patterns used were made from thin slices cut across bundles of differently coloured slivers of wood.'[96] It is possible that this suggestion led to the use of 'fineline' veneers, popular in the 1960s as a surface finish which did not require matching, but was still real wood.[97]

More recently, developments in plastics (see above) have further increased the decorative repertoire, but they are often still used in an imitative way. Reproduction furniture with plastic mouldings or modern furniture with metallised plastic finishes are quite commonplace. The combination of computer controls, sophisticated machinery and simple designs have meant that applied or incised decoration can still be produced economically.

Upholstery

Superficially, the upholstery branch of the furniture-making industry would seem to have been the least affected by changes in the

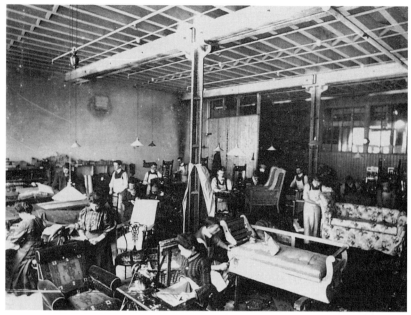

19 Harris Lebus company's upholstery workshop showing the individual production of items, 1902

twentieth century. Chairs are still made with springs on a wooden frame, they are upholstered over a variety of fillings and covered with a wide range of materials. The longevity of Richard Bitmead's work, the *Practical Upholsterer and Cutter-Out* which was first published in 1912 and reprinted four times subsequently in the same edition until 1949, gives an idea of the unchanging nature of this part of the industry. After the mid-century the pace of change was more rapid, although many of the fundamentals stayed the same.

All upholstery consisted of four basic elements: the frame, the supporting system, the padding or cushioning, and the outer cover. During the century, the nature of all of these elements has changed in varying degrees. Perhaps the most significant change has been the gradual use of ready-made parts such as spring units, needled and layered fillings on paper backings, foam and polyether cushioning all cut to size, as well as ready-made frame sections, all of which meant that the skills of an upholsterer changed.[98]

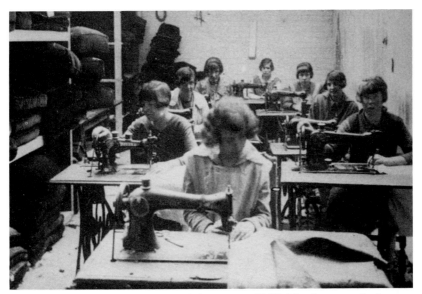

20 The sewing room at the Ercol factory, *c.* 1925. The increase in loose cushion suites created a demand for seamstresses

In the United States it was recognised early on that the upholsterer's job could successfully be broken down into minute segments to improve efficiency: whilst in the United Kingdom it remained for many years, one man to a whole job. More recently in Britain, Christie-Tyler plc, the largest upholstery manufacturing group, have developed the cell system of production. They employ a semi-skilled workforce who can produce one part of a job extremely well and quickly, and by an additive process produce upholstery which is based on a careful cost control related to retailers' demands.

Twentieth-century attempts to improve upholstery were to change the internal structure and begin using new materials to substitute for traditional ones. The traditional method of upholstery-frame making often relied on a separate craft of frame makers, who built wooden frames to a specification and then delivered them to upholstery workshops. These were usually a framework for the suspensions and coverings, and in many cases were completely hidden after upholstering. At various times fashion has created 'show-wood' upholstery which called for exposure of the frame. This varied from a hint,

such as an arm knuckle, to a fully polished show-wood frame with loose seat and back cushions, which called for considerable skills.

In addition to wooden frames, the revival of the nineteenth-century idea of metal frames was used in times of timber shortage. In 1942, Dr West, of the Wrought Light Alloys Development Association, drew attention to

> the very comfortable chair which is used in aircraft, for example, by bomber pilots. It is built up on a light alloy tubular framework, covered with sponge rubber and then with fabric. I would commend that type of furniture to the serious attention of furniture designers, putting forward its light weight as one of its major advantages.[99]

In the late 1940s, the hammock principle used in upholstery based on aircraft seating using rubberised hair filling was patented by Christie-Tyler.[100] This suggestion was again taken up in the 1960s and early 1970s, when the fashion was for chairs made from chromed tubular steel fitted with hammock cushions.

Another example from after World War II was upholstery frames that were made from cut sheet steel. Although introduced to save timber, they used the same shaped designs as pre-war wooden models. Metal frames were also utilised by designers such as Ernest Race who created new lightweight organic shapes from metal wire (see further above).

With advances in technology and design strategies during the 1960s, chairs were produced which incorporated frame, structure, and padding in one item. The plastics revolution that allowed this, was responsible for an incredible range of very varied objects including the Sacco chair of high resistance foamed polystyrene balls; the Blow chair in inflatable PVC; the Pratone of integral foamed polyurethane foam; or even the Up chair, made from polyurethane foam, vacuum packed in a box which 'came to life' in your living room as it was unpacked.

However, it is important to remember that these fashion chairs did not generally make inroads into the essentially conservative world of domestic upholstery.[101] Although the design of upholstery for the high street market has remained stubbornly traditional, a variety of innovations have been introduced. These include frames made from particle board or plywood, pre-formed plastic arm, wing and leg sections and even complete plastic frames for 'Queen Anne' chairs. These developments reflect the fact that the three-piece suite, the

21 A cut-away of a chair frame showing the chipboard frame, plastic padding and plastic imitation wood fascia moulding, 1992

fireside chair, recliner chair, and sofa beds still remain the staple ranges of most stores. The reasons for this will be discussed further, in the chapter on consumption below.

Standardisation and type-forms

The development of furniture types has been a continuing process throughout its history. Some items have long established themselves as type-forms, e.g. the table with four legs at each corner, the dining

chair with an upright back and four legs, and the rectangular storage cupboard. All of these, although being traditionally made from natural wood products, often vary quite considerably in detail of form, decoration, and finish.

Towards the end of the nineteenth century, as the market for ordinary furniture began to grow, there was a rise in interest in more stable and regular materials, standardised dimensions, and the development of modules which would all simplify the manufacturing process. These objectives were all seen as economically sound, as well as orderly and unified. They were also seen as the pre-requisites for 'democratic furniture'. Democratic furniture is a phrase meant to identify the inexpensive, simple furnishings that would be used by the rising number of urban workers during the last part of the nineteenth and first half of the twentieth centuries. It seemed as if this sort of furniture would have to be produced in large quantities, with little differentiation, using inexpensive materials and simple processes. John Heskett has argued that by the early twentieth century, timber technology was available to produce a reliable and homogeneous product; dimensional specifications were standardised along with performance standards that regulated the use of these materials and the consequence of all this was that three-dimensional forms, e.g. furniture, could be designed and produced in a much more uniform way.[102]

Precedents had been set in the eighteenth and nineteenth centuries for chair types especially. The Windsor chair and its fabrication from prepared parts was one such example of democratic furniture. Although clearly not in the same category, one of the first documented, standardised ranges was produced as early as the 1880s. In addition to being a standardised range, the American Globe-Wernicke Company's interlocking bookcase system was also one of the first unitised furniture systems. However, it was to be in Europe that the wider scope of type-furniture was to be developed.

The desire of some post-World War I governments and cities to democratise building, furniture and furnishings gave an impetus to architects and designers, especially in Germany. The German concept of 'typenmobel' was based on simple machine-made objects that were related to each other.

As early as 1906, Richard Riemerschmid presented 'machine furniture' at the Third Arts and Crafts Exhibition in Dresden, which

22 Riemerschmid standard furniture designed for machine manufacture, 1906

was defined as, 'popular furniture which, although machine produced, fulfils all the requirements of style and taste'.[103] Using painted pine wood, he based his models on simple vernacular precedents but they were fixed with screws at all joints, and were even supplied in a knock-down form for home assembly. This was a pragmatic decision based on the fact that the machines were apparently not so accurate at cutting joints. Riemerschmid therefore designed furniture so that joints were overlapped and screwed thus automatically making them KD. The success of the idea can be judged by the fact that by 1910 the Dresden Workshops employed 500 men. Others followed suit and in 1908 the United Workshops in Munich were producing a 'standard furniture programme' using designs by Bruno Paul.[104]

In 1909 Riemerschmid and Bertsch developed 'typenmobel' which allowed the designer to select from a variety of ready-made parts and combine them in various configurations. This led to a wide range of permutations, which negated the possible mass-produced image. Tim Benton has shown that: 'Riemerschmid was keen to point out, the whole process ensured that the furniture had an "individuality

and character of its own, without betraying the use of machinery in its production".'[105]

This notion that the use of the machine would lead to problems of identity when compared to hand-made objects and the individuality that went with them, was also seen by others. It was the fear of the monotony of anonymous type-designs that made Karl Schmidt, manager of the Deutsche Werkstatten in Hellerau, decide to exchange designs yearly to encourage sales and exclusivity.[106]

Typenmobel was seen as the key to reduced costs by offering a limited number of objects that could be produced by a process similar to mass-produced cars, provisions, etc. Inevitably it was thought that this reduction to essentials would result in a functional form. Christopher Wilk (1987) has suggested that the Thonet bentwood chair epitomised typenmobel: 'It fitted neatly into, and may even have helped inspire the idea of Typenmobel.'[107] It met all the requirements of this furniture type; it was cheap, mass produced, lightweight both physically and visually, and finally was popular.

The ubiquity of the Thonet company's bentwood range and its subsequent productions in tubular metal are examples of the great success of truly popular type-furniture.

Although Thonet's chairs (both wood and metal) have been used as artistic statements by architects and designers, they have also been adopted by a popular market which has seen their interpretation in a variety of guises. Perhaps one of the most popular is the reincarnation of Breuer's bent metal and wood framed seat dining chair which can still be seen in most high street stores as well as exclusive showrooms. In addition to this is the image of the bentwood type which has been reproduced in wood, metal and plastic, in bright colours, on fixed and swivel bases and even in other furniture types.

Arguments about the success of the typenmobel idea inevitably arose. According to Ferdinand Kramer (1929):

> The problem of Typisierung lies in the standardising, not only of forms, but also of work-processes. The individual manufacture and finishing of one-off pieces has given way to industrial production which aims at a precisely worked out prototype which can be mass-produced on an assembly line.[108]

It would seem that Kramer saw that the provision of 'mass-produced' furniture for the working classes also had the result of an

alienating effect by limiting the initiative of the workers involved in the production on an assembly line. This surprisingly perpetuated the myth of the artist-craftsperson, ignoring the alienation that would have come about whether the maker was working in a garret producing the same item every day (often without a clear sales outlet), or in the slightly more secure position of a factory.

Perhaps the essence of this sort of furniture, far removed from interior designers and co-ordinated furnishings, was best summed up by Willi Lotz in 1927. In his article, 'Suites of furniture and standard furniture design', he expressed the idea that furniture must be self-sufficient. For Lotz, suites of furniture were nonsensical as he considered that each item had its own form and should not have any bearing on what it is next to. The Thonet chair and the iron bedstead were again used as examples. Secondly, he considered that the design of furniture for use in rooms where space is the essence, should be lightweight and made from materials suitable for such use, steel tube for example. This would then avoid the desire for suites: 'things which have sprung from a similar rationale will be able to be seen together without needing to be specially matched up.'[109]

However, in France, Le Corbusier took the ideals even further and proclaimed that as furniture is an extension of ourselves, and we are fundamentally all the same, we should expect 'type furniture'. Le Corbusier suggested that objects of decorative art, 'are extensions of our limbs and are adapted to human functions that are type functions',[110] therefore type-furniture was made to suit type-functions.

The inter-war period saw many developments in modularised and functionally based furniture designs especially those based on cabinets, so much so that in 1929 the Gewerbemuseum in Basle held an exhibition entitled Typenmobel.[111]

Although Switzerland encouraged initiatives in typenmobel, it was the developments by Marcel Breuer in the Bauhaus that extended the typenmobel concept to include the idea of modules. Breuer's development of cabinets made to the module of rooms is one example. Another attempt during the 1930s was made by Serge Chermayeff and his company Plan Furniture.[112] Although respected in certain quarters, the Plan range of seating and unit furniture was not commercially successful. However, the company survived for six years before its liquidation and after the war the unit range was taken up by Easiwork Ltd who marketed it under the trade name of EFE.[113]

It is interesting to note that Gordon Logie (1947) pointed out that the Plan system has been 'adapted twice in an attempt to make it more palatable to public taste'.[114]

It seems clear that the sober mid-European taste for orderly and functional design was not seen as attractive in Britain at the time. This does not mean that certain functional ranges were not successful. The Minty range of sectional bookcases produced in the 1930s were aimed at a popular market but were limited in their impact in developing a greater taste for the modular home.[115] Clearly it was one thing to have unit bookcases, quite another to have cupboards, storage units, wardrobes, and chests that all fitted together without any surface decoration.

In Britain, further developments of standardised components for easier manufacturing, as well as developments in built-in furniture, seem to have stemmed from the wartime Utility scheme. The specification required a simplified component size of $2\frac{1}{4}$ in. (57 mm) for nearly all the constructional parts: the advantages of this arrangement were evident in simpler machining processes, so many manufacturers continued with the idea after controls were lifted.[116]

Of course, the concept of modules and unitised furniture was not new. The classic example of this process must be from the early part of the century when office filing systems were based on paper and card sizes. There was, however, another change that encouraged manufacturers to develop modular or unit systems:

> The advantages of standardised dimensions for economy in production were obvious, but what had hitherto been unrealised was the 'sales appeal' of allowing the purchaser to accumulate individual units one by one until his house was complete.[117]

The type of furniture range that employed this approach was the original co-ordinated style of G-Plan for example, which some thought had 'in fact changed the whole philosophy of furniture purchase, by offering unit furniture rather than self-contained suites'.[118]

The true modular system was based on the idea of building up a whole range of units from very few basic items. This was often done by adding the extension to the existing part and thus making a completely new object. In the case of the Meredew Extend range, the system was designed to use flat panels that could be locked firmly together using drum-shaped cams, fitted into the panels and locked

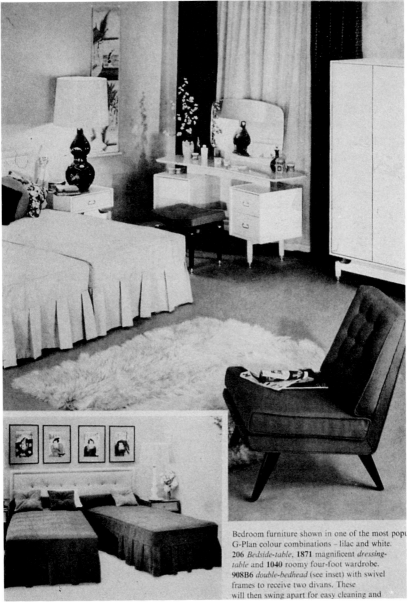

Bedroom furniture shown in one of the most popu
G-Plan colour combinations – lilac and white.
206 *Bedside-table*, **1871** magnificent *dressing-
table* and **1040** roomy four-foot wardrobe.
908B6 *double-bedhead* (see inset) with swivel
frames to receive two divans. These
will then swing apart for easy cleaning and

23 Bedroom furniture from the G-Plan 1960 catalogue

with a key. Apparently the items were delivered KD to the retailer who then asked the customers to provide a sketch of their desired arrangement, and the pieces were then assembled to their requirements and delivered made up.[119]

Serious thinking about modularisation was expressed in the design press. In the 1950s, manufacturers tended to work to even feet, then sub-divide this into halves and quarters. Mark Hartland-Thomas urged that all manufacturers work to a module for unit and built-in furniture of 4 in. (101 mm), so that builders and architects could think on the same lines.[120]

To support these aims, the Modular Society adopted the 4 in. (101 mm) module. They tried encouraging furniture manufacturers to work within this module, so that architects would also use it when designing and building houses. One company which did this was Hille, who in 1952 launched 'Hilleplan', a modular system using a 4 in. (101 mm) module. If this had been followed, it would have enabled prepared parts such as wardrobes, room dividers and kitchen units to be fitted direct from the factory and also allow units to act as walls to divide areas.[121] Clearly this was inimical to the interests of retailers and the market developed in other ways.

By the 1960s built-in bedroom furniture was becoming more widely available, but there was a concurrent development of bedroom ranges supplying a fitted look – they were in fact free-standing. These wardrobe units invariably included a dressing unit and mirror, signalling the final demise of the dressing table as a separate piece of furniture. Indeed the popularity of the bedroom suite declined in the face of the onslaught of fitted or fitted-look bedroom furniture.

Another casualty of the unit system was the sideboard. The development of wall units, either as large buffets, or more systematic assemblies that were either wall mounted or free-standing, met the demand for more storage space in smaller rooms, often with an added bonus of glass-enclosed display space.

For parts of the mass market the combination of the following factors has resulted in cabinet goods being made to a unitised typeform, but with a wide variety of finishes to try to make them distinctive. The regular panel sizes mean that various manufacturers often work to the same module. The variety of finishes which can be applied to panels give a range of choice, and new type-forms for wardrobes, wall units, and tables have become established.

24 Austinsuite wall units, white with aluminium trim, *c*. 1975

This review of the production of furniture has shown that the change from craft to industry is not clearly made as the present diversity of manufacturing processes, from small workshops to quantity production factories, shows. The next chapter will examine aspects of this multi-form industry.

Notes

1 H. Reid, *The Furniture Makers* (Oxford, Malthouse, 1986), p. 68.
2 *Cabinet Maker*, 29 December 1917.
3 *Cabinet Maker*, 26 October 1918.
4 L. Ercolani, *A Furniture-Maker, His Life, His Work and His Observations* (Tonbridge, Benn, 1975), pp. 76–7.
5 *The Times*, 28 February 1920.
6 Board of Trade, *Working Party Reports, Furniture* (HMSO, 1946), p. 86 (hereafter referred to as WPR).
7 *A History of Harris Lebus 1840–1947*, typescript, 1965, Furniture Collection Archives, Victoria and Albert Museum, London, p. 59. This work is located in the Information Section of the Furniture and Woodwork collection in the Victoria and Albert Museum. I am grateful to the Furniture Collection for their kind assistance.
8 Ercolani, *A Furniture-Maker*, pp. 132–5.

9 *Ibid.*, p. 134.

10 Ercol's patent suspension for rubber webbing used in the upholstered chairs and sofa of the Windsor range was ingenious as it used a simple slot and peg which enabled the straps to be fitted to the solid wood frame without any metal fixings.

11 J. B. Collins, 'Design in Industry Exhibition, National Gallery of Canada, 1946: turning bombers into lounge chairs', *Material History Bulletin*, 27 (Spring 1988).

12 WPR, p. 3.

13 J. E. Martin, *Greater London. An Industrial Geography* (London, Bell, 1966), p. 185, footnote 22.

14 A. Chandler, *The Visible Hand, the Managerial Revolution in American Business* (Cambridge, Mass., 1977), p. 248.

15 It can be assumed that this was a combination of open air and poorly controlled kilning.

16 *History of Harris Lebus*, p. 19 and p. 20. Splintering up is a reference to the repair and replacement of split parts on a cabinet item. According to V. Radford, the Stag furniture company seasoned timber in their cellar and judged when it was dry by the weight of it. V. N. Radford, *The Stag and I* (Nottingham, 1981), p. 37.

17 The Powellising process consisted of introducing a saccharine solution into the felled timber which was simply left to dry out. After some 6–8 weeks it was apparently bone dry and ready to work.

18 Ercolani, *A Furniture-Maker*, pp. 141–3.

19 Lebus employed *c.* 3,500 employees in the 1920s and used the payment by results method rather than a flat rate.

20 *History of Harris Lebus*, p. 23.

21 WPR, p. 60. Although see Reid, *Furniture Makers*, p. 109, for a contrary opinion.

22 G. Nelson, 'The Furniture Industry', *Fortune* (January 1947).

23 A British example reveals a similar problem. Prior to 1939, the Put-U-Up settee bed by Greaves and Thomas was available in over one hundred different styles.

24 J. C. Pritchard, *View from a Long Chair* (London, Routledge, 1984), p. 143.

25 Rods were virtually full-scale sectional layouts of the article to be produced. For a detailed explanation see Radford, *The Stag and I*, p. 39.

26 WPR, p. 161.

27 *Ibid.*, p. 88.

28 *Ibid.*, Report in Appendix, pp. 158–67.

29 BFM, Private Papers 38/49: Report of Mr Kindel of US National Association of Furniture Manufacturers, 1949.

30 Kape, *Cabinet Maker* (28 November 1953).

31 P. Trippe, 'Mass production methods in a craft industry' *Mass Production*, 38 (February 1962).

32 L. Julius, 'The Furniture Industry', *Journal of the Royal Society of Arts* (May 1967), p. 436.

33 P. Varley, 'Lebus introduce new techniques in the furniture industry', *Design* (February 1968).

34 *Ibid.*

35 D. M. Heughan, 'Furniture production', *Production Engineer*, 51 (November 1972), p. 381.

36 *History of Harris Lebus*, p. 29.

37 *Ibid.*, p. 52a.
38 Pritchard, *View from a Long Chair*, p. 150.
39 'Planning the mill', *Machine Woodworker* (1912).
40 The development of the Lea Valley area of Greater London is a good example. It was this area, with its road and canal connections to the docks of London, as well as the outer districts and main sales areas, that saw a rapid growth in the inter-war years.
41 This applies to Britain. In the United States the fit was deliberately looser to obviate the need for skilled fitting.
42 W. Birch Ltd, *Directors Minute Book*, 30.6.23, Aylesbury Record Office.
43 The example of the Lebus company – once the largest furniture factory in the world – can be cited.
44 L. J. Mayes, *The History of Chairmaking in High Wycombe* (London, Routledge, 1960), p. 125.
45 'The new factory of Castle Brothers (Furniture) Ltd.', *Metropolitan-Vickers Gazette* (February 1939), pp. 42–8.
46 BFM, Private Papers: Report of Mr Kindel of US National Association of Furniture Manufacturers, 1949.
47 A. Gale, 'Schreiber furniture factory Runcorn', *Architects Journal*, 172 (November 1980).
48 *Encyclopedia of Social Sciences* (Macmillan, 1931).
49 *Furniture and Decoration* (January 1895).
50 *Cabinet Maker* (18 January 1908).
51 'Planning the mill', *Machine Woodworker* (1912).
52 *History of Harris Lebus*, p. 18.
53 Although see J. Rudd who recommends electric motors for just this purpose as early as 1912: *Practical Cabinet Making and Draughting.*
54 *History of Harris Lebus*, p. 43.
55 *Ibid.*, pp. 21–2.
56 *Art and Industry* (April 1956), p. 132.
57 L. Weaver, 'Tradition and modernity in craftsmanship, IV, furniture at High Wycombe', *Architectural Review* (January 1929).
58 *History of Harris Lebus*, p. 43.
59 J. L. Oliver, *The Development and Structure of the Furniture Industry* (Oxford, Pergamon, 1966), p. 117.
60 W. P. Baermann, 'Furniture industry in transition', *Industrial Design*, 14 (May 1967), p. 28.
61 IEEE, *Spectrum* (January 1991).
62 J. C. Rogers, *Furniture and Furnishing* (Oxford, Oxford University Press, 1932).
63 D. Booth, 'Notes on the construction of cheap furniture', *Journal of the RIBA*, 42 (July 1935).
64 Of course this ignores the pioneering work of many architects and designers who developed completely new ways of working with a range of materials. Plywood, with its unique bending properties, was an especial favourite of the Modernist designers of the 1930s. But this is beyond the scope of this work.
65 Booth, 'Notes on the construction of cheap furniture'.
66 *Ibid.*, p. 965.
67 *Ibid.*, p. 970.
68 *Ibid.*, p. 965.

69 Tomkins, NAFTA Annual Report, quote in Reid, *Furniture Makers*, p. 157.
70 J. Hooper, *Modern Cabinet Work and Fitments* (London, Batsford, 1952), ply frame construction.
71 Kape, *Cabinet Maker* (28 November 1953), p. 808.
72 WPR, pp. 101–8.
73 British Standard 1960, Parts 1–5 (1953).
74 Pritchard, *View from a Long Chair*, p. 160.
75 Consumer Council, *Furniture Trade and Consumer* (1965).
76 Furniture Development Council (FDC), *A Design Manual* for Cabinet Furniture (London, 1958).
77 Pritchard, *View from a Long Chair*, p. 164.
78 Trippe, 'Mass production methods in a craft industry', pp. 58–60.
79 *Ibid.*, p. 55.
80 *Woodworking and Furniture Digest* (April 1978), pp. 52–6.
81 John Massey quoted in M. Duckett, 'New furniture: the domestic market', *Design*, 242 (February 1969).
82 For a description of the polishers trade see Arthur Harding, in P. Kirkham, R. Mace and J. Porter, *Furnishing the World, The East End Furniture Trade 1830–1980* (London, Journeyman, 1987), p. 108.
83 *History of Harris Lebus*, pp. 23–4.
84 Reid, *Furniture Makers*, p. 145.
85 *History of Harris Lebus*, p. 47.
86 For an account of spray polishing see the reminiscences of Sissy Lewis in Kirkham, Mace and Porter, *Furnishing the World*, pp. 119–20.
87 London School of Economics, *The New Survey of London Life and Labour* (1931), p. 225.
88 British Furniture Trade Productivity Team, *Report on a Visit to the USA in 1951*, Furniture (1952).
89 This uses chalk as a grain-filler, popular for deep grain woods such as oak and walnut.
90 A good example of this sort of business is Maxine & Co. Their trade catalogues in the National Art Library (Victoria and Albert Museum, London) illustrate a great variety of these decorative accessories.
91 C. G. Tomrley, 'Contemporary decoration for furniture', *Design*, 47 (November 1952).
92 M. Farr, *Design in British Industry* (Cambridge, Cambridge University Press, 1955), p. 13.
93 Pye in D. Bonnett, *Contemporary Cabinet Design And Construction* (London, Batsford, 1956), p. 175.
94 *Ibid.*
95 Tomrley, 'Contemporary decoration for furniture', p. 7.
96 *Ibid.*, p. 7.
97 Fineline veneer is made up from a series of veneers that are glued together in a 'sandwich' form, and then sliced vertically to produce a veneer made up of very thin wood sections. The principle is similar to Tonbridge ware, in which a bundle of coloured wood sticks are assembled in a pre-determined way, glued together and then sliced vertically to give a decoratively designed veneer.
98 The application of the hand and pneumatic staple gun has also had enormous implications for the continuing de-skilling in the upholstery craft.

99 D. A. Braddell, 'Common sense in furniture design', *Journal of the Royal Society of Arts*, 90 (3 April 1942), pp. 312–13.

100 G. Logie, *Furniture from Machines* (London, Allen and Unwin, 1947), p. 142.

101 The exception might be the many copies of the Sacco chair designated under the heading of bean bags.

102 J. Heskett, *Industrial Design* (London, Thames and Hudson, 1980), p. 74.

103 K. Sembach, G. Leuthauser and P. Gössel, *20th Century Furniture Design* (Cologne, Taschen, n.d., *c.* 1988), p. 75.

104 *Ibid.*, pp. 75–7.

105 See T. Benton, Open University, *A305, History of Architecture and Design, 1890– 1939* (Milton Keynes, 1975), Unit 5–6, p. 62, The Deutsche Werkbund.

106 *Open University Course A305, Units 5–6, Europe 1990–1914*, p. 57.

107 D. Ostergard (ed.), *Bentwood and Metal Furniture: 1850–1946* (New York, University of Washington Press, 1987), p. 125.

108 *Die Form*, 4 (1929), quoted in B. Campbell-Cole (ed.), *Tubular Steel Furniture* (London, The Art Bock Company, 1979), p. 12.

109 W. Lotz, 'Suites of furniture and standard furniture design', *Die Form*, 2 (1927), pp. 161–9 and pp. 229–30, quoted in T. and C. Benton and D. Sharp, *Form and Function, A Source Book for the History of Architecture and Design 1890–1939* (London, 1975), p. 118.

110 Le Corbusier, *The Decorative Art of Today* (1925; translated by J. Dunnett, The Architectural Press, London, 1987), p. 79.

111 Typenmobel exhibition, Gewerbemuseum, Basle, 2.6.1929–2.7.1929. Examples of the work of Breuer, Kramer, Thonet, and Embru were shown.

112 B. Tilson, 'Plan Furniture 1932–1938: the German connection', *Journal of Design History*, 2:3 (1990).

113 Logie, *Furniture from Machines*, p. 36.

114 *Ibid.*

115 Although see the Neo-craft sectional bedroom furniture by Minty produced *c.* 1935.

116 Hooper, *Modern Cabinet Work and Fitments*, p. 275.

117 Farr, *Design in British Industry*, Addenda, p. 307.

118 Trippe, 'Mass production methods in a craft industry', p. 53. G-Plan was still offered in suites for the lounge, bedroom and dining room; its novelty was that each item could be bought separately and at various times. See catalogue, *G-Plan – newest idea in home furnishing*, 1954.

119 *Design*, 98 (February 1957), p. 35.

120 M. Hartland-Thomas, 'Unit furniture, built-in furniture and modular co-ordination', *Design*, 68 (August 1954).

121 See Ercol wartime production of pre-built and fitted walls.

4 The furniture industry

The whole furniture trade from factory to second-hand store is a pit of infamy, extortion, rascality and lying, compared with which Thieves Corner [Stock Exchange] is the very Mercy Seat itself [1]

'A Maker of Homes sounds quite a good passport to offer the Ferry-man when he at last holds out his hand.' In this simple sentence written by a gifted and modest craftsman, there is focussed the complete picture of our duty and responsibilities as trustees of a legacy of fine conceptions inherited and cherished in this great traditional industry. [2]

In the history of furniture, as with any other objects, an understanding of the socio-economic system within which the products are created is essential in understanding the influences that make objects look how they are. This work has been looking at furniture production within a capitalist system and therefore this chapter will deal with the structure and organisation of the industry, its attitudes to design and research, its distribution policies and methods, and lastly, any restrictions that have interrupted the free market.

The furniture manufacturing industry is characterised by segmentation and diversity. Although other industries may also make this claim, what makes the furniture industry different is the lack of integration, the multiplicity of trades involved, the relatively large numbers of small enterprises, and attitudes to research, design, marketing, and management.

A number of difficult problems have affected the industry over the century; some are of its own making, others imposed. The first of the most serious influences on the operation of the industry are the cyclical fluctuations: recessions occurring regularly since World War II were met by short-time working whilst the contrary boom times meant extended lead times. In addition to these cyclical problems, the fluctuating seasonal element of the trade has always had an effect on planning and investment.

Secondly, the dichotomy between the notion of a craft enterprise and a full blown business has been at the heart of the furniture industry's problems for much of the last one hundred years. From early in the century until recently, many commentators have asked why the trade held on to old working practices, whilst at the same time trying to introduce the latest materials and technology. One reason may be that it is an old-established craft, with a long tradition of practices that have worked well for many decades, combined with little history of capital investment. In comparison, the motor car industry had the advantage of starting from scratch.[3] Additionally, the furniture trade is torn between producing a necessity as well as a fashion item, and therefore is subject to the vagaries that this brings in its wake. For much of the century, the furniture business was poorly organised in terms of management and location, and to make matters worse, a professional attitude to design and product research was hardly extant. This meant that competition was rampant and most efforts were directed towards survival and solvency. All these problems existed up to and beyond World War II.

The third major problem has been the relatively poor reputation that the furniture business has experienced since mid-Victorian times, both in terms of service and design. This problem has tended to marginalise furniture in the public's mind and it has often been seen as simply a necessity, rather than a desirable competitor to motor cars, holidays, and leisure equipment.

One of the first commentators within the trade to point out the necessity of getting furniture back in the mainstream was Hamilton Smith. In his article 'On taking furniture seriously' (1926) he made apposite comparisons with the car industry. He thought that new techniques such as artificial seasoning, plywoods, built up boards, and machinery, that were 'capable of radically different results from hand work, have simply been squeezed into the old moulds' leaving all the more exciting possibilities unexplored.[4] He rightly suggested that this would not have happened in the motor car industry.

After the experience of World War II and the Utility scheme, it was clear that dramatic changes would have to occur post-war. The Working Party, set up by the Board of Trade in 1946, rang a clear warning bell when they saw that the new conditions would be very different from those pre-war. They were proved right in as much as between 1950 and 1957 the number of businesses fell from 3,148 to

1,987. The changed conditions not only reduced the number of businesses.

Firstly, it was recognised that timber supplies were a problem and this would have to lead to the continuing development of substitute materials. Secondly, new ways of living would alter people's concept of furniture and how they wanted it to function. These changes included the concept of open-plan which, in its turn, would require furniture that was portable, dual purpose, or built-in, which promoted a trend towards even less furniture. The Report saw that the demands on the trade would be great, and if they sought new solutions rather than relying on the old traditions, they would not find their trade taken over by the 'younger industries which are busily engaged in finding uses in the domestic field for techniques evolved for war production'. Finally, it was again pointed out that the major difficulty for the trade post-war, was to be the increasing competition from consumer durables, such as the motor car, washing machine, and refrigerator.[5]

A positive result of this close critical analysis was the birth of the Furniture Development Council in January 1949. The Government had established the Industrial Organisation and Development Act in 1947 with the express aim of establishing development councils for any industry 'with the object of assisting it to increase its efficiency and productivity and to improve the service rendered to the community'. Despite many initiatives from within and without the trade, the difficulties that Hamilton Smith recognised in the 1920s have continued.

The furniture industry gradually slipped behind as more businesses closed, imports grew, and public disinterest continued. By the early 1990s the issues of the viability of the British furniture industry were clearly spelt out by the Design Council. Gone into the background were the well-meaning attempts to raise a public consciousness about design: rather there was a hard-headed business attitude which was little less than a plan for survival. The key issues that were highlighted included the introduction of new materials and the embracing of new technology. In particular CAD/CAM was identified as an important innovation that would be beneficial to the industry by reducing the need for prototypes, which would decrease lead times for new designs. The opportunities for export were emphasised; they were currently hampered by ignorance of an international range of

tastes, standards, and conditions. Finally. the increasing impact of international standards was recognised as being of growing importance in the future.[6] The structure of the industry was partly responsible for its own weaknesses.

Structure

At the turn of the century, *The Times* (1901) was surprisingly optimistic in its report on the furniture trade. It commented that:

> the small makers, turning out a few articles per week in their own homes with the help of their wives and children, have given place to large factories where goods are produced in great quantities by means of every mechanical device that human ingenuity has yet invented for the making of furniture.[7]

The changes that are implied in *The Times* piece were in fact piecemeal and very varied in their effect. There were indeed large factory concerns in the main centres of production, but there were equally many remaining 'small makers' scraping a living in the trade. The optimism was somewhat misplaced. However, there were attempts at integration and product development and of course restructuring of existing businesses.

One example of re-structuring was the vertical integration of parts of the production process. For example, William Birch and Company of High Wycombe purchased a saw mill and plant in 1919, so as to secure their own sawing premises and to react to the 'independent attitude adopted towards the trade of the sawmills in the town'.[8] Other examples might include manufacturers who developed their own timber importing businesses or who became wholesalers of other manufacturers' products. A later, less successful example of horizontal integration was in the firm of E. Gomme. Following the example of some German companies, Gomme tried to set up a chipboard plant as an attempt to use the waste wood from the factory. It was discovered, nearly too late, that good chipboard needed a constant mix of timbers, so the chopping up of any available wood waste and trying to convert it to boards was impractical.[9]

In some cases there were examples of exchange between retailing and manufacturing, and a number of retail businesses operated or were closely linked to their own factories.[10] Whatever the method of

integration or structuring, the main aim was inevitably to make a profitable enterprise. Indeed the level of profitability achieved by some parts of the industry sometimes seemed more than comfortable.

In 1919 the trade was the subject of an investigation into allegations of profiteering, out of which came some very revealing evidence as to the state of the trade. The Committee appointed to investigate, classified the industrial organisation of the trade into three groups. The first group were large factories with trade union labour, the second were small workshops with a majority of free labour, and the third were back-yard workshops and rooms. Their comments on this third category are especially interesting when related to the supposed diminution of small masters reported some eighteen years previously in *The Times* (see above).

The report noted that a revival of small workshops had been caused by the following factors:
i. The shortage of furniture during the war and big prices realised by its sale.
ii. The fact that longer hours can be worked.
iii. More concentration in work.
iv. Employers supplying material to small workers, thus causing the 'out-worker' system.

They continued by pointing out that although it was assumed that greater concentration would give higher efficiency,

> the economic unit in furniture manufacturing still remains the small master, who in his turn has to compete with the independent worker producing on his own account in the back-yard of his own dwelling.[11]

This reflects a recurring theme in the industry which shows how easy it was to open a business making furniture.

The Committee's comments on the economics of the industry are worth quoting at length as they clearly show what were then considered to be the two main possibilities of industrial expansion:

> The furnishing industry, indeed, is, in effect, an illustration of the theory now generally accepted that there is a growth of specialisation no less striking than the growth of standardisation, and that while the latter tends to centralisation and mass production, the former retains the subdivided form of industry, and affords scope for the small master and individual producer. Certain economic factors aid this development, as

for instance the increasing availability of electric power in the small workshop.[12]

The remit of the Committee was clearly aimed at investigating the popular furniture market, and it is their choice of objects that helps to give a clear idea of what were considered to be standard furnishings in 1919–20. Enquiries were made into the production of 'cheaper furniture'. This group included the common or Windsor chairs which were made at High Wycombe and its environs.[13] Seven-piece suites of furniture covered with American cloth, which were made in London and the provinces, were also selected as being representative. These suites included a sofa, two easy chairs, and four dining chairs. Oak or satin walnut bedroom suites, which were made all over the country, were considered standard furnishings, while wooden bedsteads were selected as being a product that was universally required. The 5ft (1.52 m) sideboards in oak or walnut were seen as representative of the storage needs of the time but they were difficult to make price comparisons about, owing to the diversity of patterns, embellishments and quality. Finally, a category labelled as 'common deal furniture' was compared. An idea of these 'common deal' products can be gleaned from the report which said this was a completely different class of trade in which the men were paid piecework rates. The furniture was usually made from pine or spruce and painted white.

Although these items were selected for analysis of the costs involved in manufacture, to ascertain the level of profit being attained, they do represent the typical furnishings that would be purchased by the growing, lower to middle market in the beginning of the century. This furniture selection can also be confirmed by looking at the estimates supplied by most retail firms around this time.[14]

The nature of the trade was such that if there was a rise in prices, the result was that a number of individuals could exploit the subdivisions in the trade and set up business in their speciality by undercutting prices. The alleged iniquity of the division of labour in general, so abhorred by nineteenth-century reformers, was also remarked on by two dissenting members of the Committee in an additional statement:

The difficulty of obtaining sufficient skilled labour is due to the sectionalising processes introduced into many factories by employers,

which make it increasingly difficult to develop craftsmen, and constitute a somewhat alarming menace to the prestige and stability of British production.[15]

This gripe was combined with a more general statement by the same two members who considered that the invidious conditions for workers and the enormous public need for furniture 'proves that private control of the production and distribution of furniture is inimical to the public interests'. They considered that manufacturers and retailers were charging too high prices for furniture, especially with profit margins being taken on the cost of the production stage plus the profit for subsequent stages in the distribution process, the retailer allegedly being the worst offender. The majority of the Committee, however, found no evidence of profiteering or price rings and judged that open competition was the best way to continue to ensure fair prices.

Profiteering concerns also existed in the United States. In 1923 the Federal Trade Commission revealed that four major furniture manufacturers' associations, whose members between them produced 30 per cent of household furniture sold, tended to fix prices. The manufacturers concerned apparently made an average *net* profit of 28 per cent in 1920.[16] These profits were based on some theoretical selling prices that were seemingly arrived at without any costing system.[17]

The 1920 Profiteering Acts investigation had referred to a trade organisation that seemed ripe for rationalisation. However, even by 1939, it seems as if little had changed. In that year the British Furniture Trades' Joint Industrial Council was set up and one of its duties was to send an independent investigator to examine trade conditions in London. After fieldwork, mainly in the East End, he reported there was 'an inordinate number of small firms, extreme competition, constant changes in the ownership of premises and some dubious practices by the less reputable firms'.[18]

This clearly reflected the results of the 1919 investigation which had found that as soon as prices rose, a number of individuals set up as small one-person businesses. Other developments in other parts of the country and indeed world-wide, were not commented on as that investigation concentrated on the East End of London. Nevertheless, it seems clear that although many changes had occurred in

the intervening twenty years, they were still piece-meal. Even after World War II changes seem few.

Dunnett (1951) considered that 'The furniture industry is curious in two respects, for it conforms to almost the same pattern throughout the world'. He suggested that this pattern showed that 80 per cent of the production is devoted to the making of antique reproductions or a semi-reproduction type which left only a small capacity for modern designs. Secondly, he commented that the scale of the industry, world-wide, with few exceptions, was still small.[19]

More dramatic changes had to occur in the second half of the century. Some sixteen years after Dunnett's pronouncements, Walter Baermann saw a very clear-cut trend towards 'bigness' in the industry in America. According to Baermann (1967) this tendency 'will result in an expansion of the capital base which will assist in expansion, growth of management talent, finance and research and development', and 'it will eventually change the industry from a craft-orientated one to an industrial-products one, speaking solely from a technological point of view.'[20] Even in 1967, that author had to say 'eventually change', surely an indicator of the lethargic state of mind of the furniture industry, and that in the biggest economy in the West. According to other American commentators writing in the same year, 'much of the activity in the industry continues to be guided by the traditions of prior years',[21] and in 1968 it was observed that 'in an age of mass production for mass consumption most of the 5,350 companies (90 per cent employing less than 100 people) that make up the [American] industry are still insignificant in size, inbred in management, inefficient in production and inherently opposed to technological change'.[22] A damning indictment indeed, but changes were to occur in the following decade.

For example, in 1970, a suggestion was made that with the growth of business take-overs and integrations the idea of selling complete rooms rather than specific items of furniture would be quite likely. Carpet, bedding, and cabinet interests were all merging in this era, and the take-over of furniture companies by conglomerates was common.[23]

The trend towards integration in manufacturing did not last long, and a number of businesses were shed from the conglomerate's portfolio. By 1983 a report prepared for the Design Council could reveal that:

113

Manufacturers supplying the retail sector now find themselves in the unenviable position of being sandwiched between relatively few powerful suppliers of raw materials and relatively few outlets for the finished product.[24]

The Times (1969) summed up the situation and encapsulated the problem:

> In spite of the mergers, no one firm has yet emerged as a really dominant force in the industry. In the long run this is probably the industries greatest need – one or two companies which would be strong enough to assert themselves against the retailers and set new trends.[25]

This lack of strength seemed to be an inevitable result of years of neglect that had been noticed by critics but largely ignored by the industry itself:

> Most commentators would agree that these misfortunes are largely a function of the resistance and/or inability of the industry to invest in plant, technology, and in particular, marketing and design skills over many years.[26]

The apparent failure of the idea that furniture-making could be treated like many other consumer product businesses seems to have given financial experts a jolt. The erratic nature of the trade, as well as the subtle combination of entrepreneurial skills combined with the 'art' of designing and selling, caused many to pull out. Between 1979 and 1984 profit levels fell from 21 per cent to 7 per cent on capital invested, and furniture shares suffered as a result. The consequence was a reduction in capital expenditure as a percentage of output from 9 per cent in 1979 to 5 per cent in 1984.[27]

The other major economic factor has been that there are only a few economies of scale that can be applied to the industry. These are mainly in the panel conversion and plastic sectors. This again results in an industry based on conversion and assembly: designed to cope with wild fluctuations by having a flexible organisation but with few financial reserves to fund the lean years.

Nevertheless there were some who thought that there were economies of scale to be achieved by growing into larger operations. This may seem to be so on the surface. In 1949 there were forty or so factories responsible for 15 per cent of turnover. By 1954 this group had increased their percentage of the total to 37 per cent.

However, there was still a grand total of 2,300 firms of which 845 had a turnover of less than £50,000. By 1962 the total had been reduced to 1,525.[28]

The economic reality seems to be that economies of scale fail to offer a higher return beyond a modest size in furniture-making. 'It has been estimated [in 1966] that the most profitable kind of firm is probably one only in the 50–100 worker range'.[29] This brief analysis of the industry's structure has shown up a number of problems, the nature of its management and organisation being a prime example.

Organisation, entrepreneurship, and management

As has been shown above, the flexibility that comes with the simple requirements of a small enterprise has encouraged many to set up as furniture-makers with little knowledge of business or of the trade. The ownership of such businesses was often invested in one person or family which in some cases grew to become a large public enterprise, or on the other hand to remain a small private business. The expansion of furniture businesses requires capital investment and in a family-run business this may be difficult to develop. Attitudes to change within the hierarchy vary considerably and the uncertain economic basis of the furniture trade during the century has never encouraged speculative investment.

One of the most successful approaches to furniture-making seems to have been the idea of market segmentation and the consequent establishment of a niche, which was likely to provide a more reliable return on investment due to careful marketing. Many businesses have come and gone through the century, but the long-lasting organisations seem to have survived by a mix of entrepreneurial skills, judicious investment, and customer loyalty. Criticism of the furniture industry, its organisation, and management must therefore be qualified by the fact that there are, and have been, many successful and responsible enterprises that have succeeded in helping to furnish the nation.

The growth in the furnishing market brought about by new conditions in the twentieth century was the stimulus to expansion in the furniture-making trades, and it was therefore in response to these conditions that new enterprises arose or existing ones grew. The

example of the firm of Harris Lebus is instructive in illustrating this development.

Lebus had started business as long ago as the 1840s and by 1899 had become the largest furniture manufacturer in Britain, employing nearly 1,000 persons. After World War I, Lebus shrewdly realised that the best potential for growth was in the mass market. Having visited the United States, they were encouraged to harness the new production and management skills that were being used in factories there. A boardroom minute from 1920 clearly shows the way forward that the company envisaged. They saw the furniture trade divided between five groups. First was the very high-class trade, of which the firm had done little; the second class was where the bulk of its business had come from, along with a little bit of the third class, but of the lower fourth and fifth classes, no trade had been done. They realised that the balance of business had shifted away from the higher quality and price to the less expensive types, and that was where the growth was to come from.

> The firm, therefore has decided to attempt the manufacture of, not the lowest class of furniture, but of the fourth class; it is not its intention to make anything that is not likely to wear well.[30]

The company recognised that the organisation of the industry at the beginning of the 1920s was such that it would be potentially difficult for a large manufacturer to break into a market that was served by the sweated section of the trade:

> The difficulties are great in the way of the new adventure, as up to the present time [1920] the makers of fourth grade of furniture have been of the 'Garret' class, and no factory so-called, has succeeded in competing with such. On the other hand, in America large factories are making this class of furniture with great profit.[31]

The reasons for this lack of financial success by the factory producers were found in the extremely low prices for which the garret class of maker could supply his products, due to his very low overheads and small margins. Lebus's answer was to meet price competition by investment in machines, quality control, and scientific management. This led the firm to invest in apparatus to enable it to operate on the American factory model. To cut costs, shallower wardrobes were made with veneered plywood and were constructed with larger drawer and door tolerances, in the American way, to avoid

the time-consuming process of individually fitting doors and drawers.[32] The products that resulted were well assembled but light in construction. The strategy was successful and by the 1950s Harris Lebus was known as 'the largest furniture factory in the world'.[33]

In contrast to this example of expansion and growth which also occurred in a number of other enterprises, there is a continual theme of the individual craftsperson or entrepreneur 'setting up shop' and making a living in the furniture business.[34] George Nelson (1947) noted that one of the appealing factors for those considering setting up a business was that furniture-making was seen to be one of the few remaining industries in which individuals could make a place for themselves. Factories could be small, clean, and relatively quiet, and they were perfect for small town decentralisation. However, the obvious pitfalls for small-scale manufacturers included lack of capital for research into new materials and technology, as well as advertising, design, and marketing.[35] In addition, Nelson pointed out that the reliance on the drive and enthusiasm of one family or generation may or may not be sufficient to guarantee continuation and expansion.[36]

In Britain the same point was made by the Board of Trade *Working Party Report* on *Furniture* (1946). They considered that the success of a business or even its very existence depended too much on the founder, who may have had no training, whilst having all the management roles, including design, vested in him.[37] In addition to this management problem the Report also commented on a lack of market research, and the scarcity of reliable statistics which might have allowed more informed management decisions to be made.[38]

The experience of one American woodworking company, Mengel, that decided to turn to furniture-making in the post-war years, is instructive. The chance to rethink and develop an entire operation resulted in the business being based on four factors to bring it into line with the thinking of other industries. These factors consisted of the mechanisation of the production process, aiming for a segment of the market based on income group, a merchandising policy that used advertising and promotion in a big way, and a style that would offend as few people as possible.[39] These were very similar to the successful ingredients that Harris Lebus had introduced in the 1920s.

A similar analysis can be seen in a post-war example from Britain. E. Gomme, a well-established High Wycombe firm, introduced a new range of furniture under the title of G-Plan in 1952. Leslie

Gomme is quoted as saying 'Can we, by some new marketing tech-nique, restore the mass-production efficiency of the Utility days?' The result was the famous G-Plan range which was promoted on an extraordinary level by advertising and branding along with 'tied' retail displays and G-Plan centres. The whole design concept was based on a limited number of related units that customers could choose to make their own groups, instead of purchasing ready-made suites. The combination of niche marketing, positive advertising, retailer support, and mechanised factory processes were successful. Their decision resulted in a six-fold profits increase between 1952 and 1958. However, the perennial problems associated with the in-dustry befell the company in the shape of an end to the consumer spending spree, and a restrictive Government Budget that led to a loss in 1961 of over £100,000.[40] Eventually, the company had to in-troduce other designs and 'tastes' to enable the business to remain profitable. As the company grew it was unable to maintain its fac-tories on one particular 'style'.

Despite many examples of successful products, the standard of design in the furniture industry has been continuously criticised. The retail trade's demand for at least an annual change of designs re-sulted in many superficial alterations to basic shapes. It was not until a better understanding of marketing that ranges were developed to suit particular customer profiles.

Design-management and the flexibility that comes from it was often most successful in small-scale businesses. In these cases small-scale production is still feasible and in many cases is a viable eco-nomic alternative in the face of the demand for annual changes, particularly if the product falls in to the reproduction category.[41]

Important changes in management had begun with the new younger generation who were rising into senior positions in business during the 1960s. They were more in touch with their own younger generation market, and were responsible for a number of changes in various company directions. Greater profitability was not always the main consideration. Leslie Julius, managing director of Hille, is quoted as saying that having overheard a chance remark to the effect that no decent modern furniture was made in Britain, he decided to prove that idea wrong. It is worth bearing in mind that at the time, Hille were profitably producing a range of high quality reproductions, and this side of the business subsidised the new 'modern' venture.

The change-of-heart of the new post-war generation is well expressed by Leslie Layton of L. Lazarus, makers of Uniflex furniture:

> When freedom of design came in, a lot of firms went the wrong way and I must admit that we started making the same sort of juke-box stuff that everybody else was making. The change came when the younger members of the family came into the business.[42]

In recent years, design and design management have featured highly in critiques of the industry; therefore, in the next section the industry's attitude to design will be charted.

Attitudes to design, research, and development

Throughout the century most reports on and analyses of ordinary furniture have suggested that design has not been used as a tool for changing ideas or introducing new ones. Design in the furniture industry has more often than not been a matter of stylistic adaptation, rather than conceptual change. This is not surprising, considering the public's demand for furniture that reflects images and lifestyles. For much of the century, if designs were not based on examples of the past, they were diluted copies of either historical examples or modern architectural concepts. In both cases they often bore very little resemblance to either original.[43]

The historicism, as well as the search for novel styles, was rooted in the taste for middle-class furnishings, first established in the nineteenth century. It should not be surprising then that makers would continue with these successful designs as they filtered down the social scale. As first-time buyers emulated the taste of their social superiors, the styles of the sixteenth, seventeenth, and eighteenth centuries were adapted to early twentieth-century living.

However, just as in the nineteenth century there were some calls for designs to fit the times, so there were in the twentieth. During World War I, the *Cabinet Maker* (1916), suggested that: 'it is somewhat difficult to find in any of the Wycombe showrooms, furniture which the historian of the future will assign without hesitation to the twentieth century'. The article continued by decrying the continual copying that the trade was plagued with, and then said:

> If we were asked to indicate the lines along which a twentieth century type of cabinet work might develop, we should advise the designer to

forget for the moment the details of the historical styles and concentrate his whole attention on choice of material and the utility of every pattern he purposes to make.[44]

Choice of material and utility were not very new concepts for design reformers grounded in the writings of the nineteenth century, but their championing was a not inconsiderable step for the organ of the commercial furniture trade.

Regardless of the magazine's comments, most manufacturers continued to produce a wide range of products whose styles changed on a regular basis. For example, Harris Lebus's trade catalogues were produced 'in house' because new designs were being continuously introduced and the catalogue was updated every month.[45]

Throughout the history of commercial furniture an argument has bubbled around whose responsibility it is to improve design. Inevitably it has become a circular argument. Depending upon your position on the circle, whether a retailer, consumer, manufacturer, or 'interested party', your point of view will vary. The issue of responsibility was raised at a conference on house furnishing in 1920. Charles Tennyson speaking for the Federation of British Industries said:

> the blame in the matter lay not with the manufacturers but with the public. The manufacturer was tied hand and foot by the public in two ways. First of all, the shares in manufacturing companies were held largely by the public; in the second place the manufacturer had to persuade the public to buy his goods.[46]

The representative of the London Cabinet and Upholstery Trades Federation also considered the public to be at fault but put the blame on the lack of education: 'Manufacturers would supply what the public asked for if the public was taught to ask for the right thing'. He continued by saying that cabinet shops employed

> very large staffs and very expensive design departments so that the accusation which had been made that manufacturers neglected that side of their business was entirely unfounded.[47]

To support the argument that manufacturers' designs had improved, S. D. Bianco, a cabinet maker, suggested that the improvements were so great that in recent years American firms had been tempting English designers to cross over to the USA for large salaries. This straightforward commercial approach contrasted directly with a rather

unorthodox suggestion. James Smellie suggested that the Government be responsible for design under a master designer for furniture. Individual manufacturers would then deal with their own categories. The idea then was that the retailer would order goods from various makers to furnish a room being assured that the goods would match as they had the same design ethic.

In contrast to this idea of imposed taste, further reports considered that manufacturers simply gave the consumers what they wanted, or put another way, what the retailer could sell.

In 1927 the Committee on Trade and Industry could report that:

all the higher class furniture manufacturers employ designers trained in the historical styles of furniture. The training is, however, seldom used as the foundation for modern design.

The reasons given for this lack of initiative were the timidity of the trade in introducing something that was not proven in sales, and secondly the divorce of the designer from the manufacturing process.[48]

Further reasons are given in the same report to try and explain the nature of 'taste' in furniture:

Some commercial furniture-makers realise that most of their work is in bad taste, but they consider that they have found by experience what the public wants. The criteria are cheapness, as much ornament as can be applied for the money, and conformity to the prevailing fashion and to a certain established idea of proportion learnt by experience of popular taste.[49]

Most of these criteria are still in evidence in popular furniture in the 1990s.

The 1927 report also found that the majority of firms employed no designer, so design ideas had to come from other sources.[50] Firstly, they came from suggestions or designs made by the large houses which bought the furniture. Secondly, designs came from the verbal instructions of the manager to the shop foreman. The ideas of the former were often gleaned from other people's catalogues and from salerooms. A common method of working was to compare photographs or impressions of a particular type of chair, and to see if there was any aspect in which the design could be improved and the cost reduced. This often resulted in complaints about design copying, and was clearly a common cause of frustration. Thirdly, designs

25 Convertible table/sofa, *c*. 1929. A good example of the response to a space-saving requirement

were obtained from outside designers. As a rule it was the designs
for the cheaper class of furniture which came from this source. These
outside designers had little control over the methods of production,
and in the opinion of one manager 'the more divorced the artist was
from the factory the better'.[51]

Changes in popular taste, which was beginning to emulate the
'moderne' fashions, began to be evident at the 1929 Ideal Home
Exhibition held in London. The Design and Industries Association
considered it almost a revolution and noted in their journal that: 'At
many of the larger stands representing the general furnishing trade,
hardly an antique or a reproduction was to be seen. I noticed how
the crowd was decidedly drawn towards the modern.'[52] The attitude
of the design establishment to these modern products, which were
mainly made in the East End of London, was predictable:

> It is an unsatisfying and largely Semitic attempt to imitate the confident
> creative work of contemporary French Designers of the calibre of Jacques
> Ruhlmann, and to some extent it has been supported by retail furnishers.[53]

In 1931, *The New Survey of London Life and Labour* echoed the
sentiments of the *Cabinet Maker* article from 1916, quoted above:

> The demand for period furniture shows signs of giving place to a craving
> for ultra-modern forms of severe and simple type, which wholly ignore
> tradition and claim the fulfilment of function as their only object.[54]

This aim towards function, which it was thought would help to sat-
isfy a wider market by supplying democratic type-furniture, was
echoed in a speech given in February 1935, by the Prince of Wales.
Addressing the Burlington House Exhibition, London, he exhorted
the trade to 'give consideration to another greater and far more
important ideal, designing and working for the majority instead of
the needs of the minority'.[55]

Whether or not the manufacturers took any notice of these re-
quests, some were at least aware of their power in making the market.
In one particular case of a mass-production factory, one of the man-
aging directors said with some pride that their 'production is so
overwhelmingly extensive' that they are able 'to create the popular
taste'.[56]

The fact that this popular taste was denigrated by nearly all
the commentators of the century had little influence on the actual

products of the industry. Throughout the period, the apparent lack of progress or even any serious concern with 'good design' was what attracted the attention of critics. The thorny question of who was responsible for the 'shameless display at the British Industries Fair [that] reveals the decadence of our furniture industry' was one that many thought they were able to answer.[57] Abercrombie (1939) thought that:

> [a] greater part of the blame clearly lies with the manufacturers, who can exert enormous influence in swaying the public demand. There is little truth in the contention, made by many manufacturers that the public likes its furniture 'with knobs on' and will not buy good design.[58]

Abercrombie goes on to chastise the makers of well-designed furniture for their practice of limiting their output so that their products remain exclusive. He conveniently forgets that in many cases there just was not the sophisticated market available for extended production, although much of the inter-war modern furniture designs appeared to be ideal candidates for bulk production, if not sale.

The hesitation of the trade in the production of well designed modern furniture was not surprising to R. D. (Dick) Russell. What he was appalled at, was the unscrupulous price-cutting that occurred between the wars which seemed to put contemporary furniture at a great disadvantage in terms of price. Russell talked a deal of common sense when he advised young designers to make contact with the customer to find out what they wanted:

> They [designers] must resist the natural reaction to recoil in horror from the worst examples of popular taste and, instead, when confronted by some really terrible piece of furniture, understand that this grisly, depraved exhibit may contain the secret formula they are searching [for].[59]

He further suggested that the new generation of designers should be prepared to work for their customers rather than for each other and the design press. These elements of the design world as a mutual admiration society are gradually being diminished.

An interesting sidelight on Russell's career which involved attempts to improve large-scale production design occurred during 1947–49. Jack Pritchard, at that time working for Harris Lebus, had employed Russell with the aim of introducing some contemporary designs into the firm's range, following the lifting of the Utility controls. Unfortunately, due to the apathetic attitude of Herman Lebus

towards Dick Russell's retail designs, as well as his plans for built-in furniture and contracts for school furniture, the exercise came to nothing.[60] The introduction of mass-produced, well-designed furniture had to wait a little longer.

Things seemed little different in the United States. George Nelson (1947) commented on the lack of design progress, which he saw reflected in the continuing demand for historic designs:

> Thus the deeply rooted insistence on century-old prototypes in the industry, however understandable or justifiable it may be, has been a major element in prolonging an already impressive technological gap.[61]

Discussing 'borax' furniture[62], Nelson found that the manufacturers evaded the question of design responsibility, and passed the blame on to the dealers and the public, which the manufacturers thought 'needs to be educated'.[63] Indeed a theme not unheard of in the British industry.

In 1946, the British Board of Trade *Working Party Report* took the opportunity to address the question of design. Sensibly, design was seen as a part of a series of areas requiring investigation and recommendation. One of the most innovative suggestions was the need for a research establishment that would help the trade to relate to the changed circumstances of the post-war scene.[64] The position of the committee on design was quite clear:

> We must emphasise that whether industrial design is deemed good, bad, or merely indifferent is not merely a matter of opinion. It is a matter on which all those who have a trained aesthetic sensibility the world over will agree, in broad principle.[65]

According to the Report, the industry's pre-war problems had originated in the nineteenth century because in that period 'Production and consumption were separated by channels of distribution'.[66] The inference seems to be that as the makers lost touch with the customers' requirements, design standards fell. It is then only a short step to blaming the distributor-retailer for this situation.

In addition to this separation of design from sales, the Report thought that the possibilities of the machine had been ignored as far as improving products were concerned, and were only employed to increase business turnover.[67] Design also suffered due to a number of other factors.

Firstly, the Report suggested that although there had been a change in materials use, it had not created a new attitude to design. This was reflected in the traditional cabinet-making designs applied to plywoods and blockboards for example. Secondly, longer production runs and a reduction in the range of designs carried, resulted in the 'demand for an endless variety of superficially different variants of the same design and resulted in the application of all sorts of decorative features as a means of creating this variety'. The success of manufacturers supplying decorative parts attests to this. Thirdly, the idea of a 'suite' not only remained a valuable sales aid but also operated as a 'symbol of respectability' for the customer[68] (see further in consumer section below). Fourthly, the Report suspected that the retailer's search for novelty to increase turnover and avoid comparisons was behind the frequent design changes. They were correct, as the essence of furniture retailing, when it was not competing on price, was to offer something different. Finally, the divorce of the designer from the production process resulted in drawings or pictures being adapted to fit the production facilities of the maker in question, with no real understanding between the design and the maker. It seems as if not much had changed since the 1927 Report.

The Working Party were also clear that the failure to employ designers before the war resulted in low standards of furniture design. The situation in 1946 found that a majority of manufacturers still did not employ full-time designers whilst others combined various functions with that of designer. Yet others used freelance designers. Interestingly, the employment of architects as designers was apparently unsuccessful, due to the notion that the architect was too academic in approach by creating designs without reference to production or function.

To improve the situation the Report made certain recommendations regarding the training of designers, retailers, and consumers. These recommendations included training designers to relate furniture to interiors, to relate to the techniques and materials used in production, and to be trained on a proper course of instruction away from the factory. In addition, a Design Centre for the industry should be established, as well as a programme of information to schools. Finally, the training of retail staff in matters of design should be a priority. Many of these recommendations have been carried out in

one form or another, although the training of retail staff still seems to cause problems.[69]

The Council of Industrial Design gave evidence to the Working Party in response to the requirement to try and advise on improvements that would strengthen and improve the industry. Their first point was that 'improved design can play a large part in the future prosperity and stability of the furniture industry'.[70] Not surprisingly perhaps, the evidence was damning of the trade as it stood. The industry was thought to be feeding on the past, ignorant of new trends and uncaring about progressiveness in design. The Council thought this resulted in flashiness, copying, and price cutting, which thus debased the industry. In particular they criticised suites of furniture, triple mirror dressing tables, and heavy upholstery frames.[71] The Council seemed to think that it was the retailer who was partly responsible for all these ills, especially as the furniture industry itself was disorganised as a body:

> A disorganised industry is bound, in the matter of design, to be as much at the mercy of retailers' prejudices and short term interests as it is at the mercy of the less responsible and efficient section of its membership.[72]

One of the Council's first comments was how the trade was in danger of losing sales due to the attractiveness of other demands. They pointed out that little research had been undertaken to discover latent needs or demands, but in the trades where this had happened the results were profitable. Yet again it was made clear that the major post-war changes would have to come from within the industry. Improvements in design and attitudes towards it would help exports as well as the home market, while the use of new and different materials would demand new approaches to furniture design and making. The Council suggested that by encouraging training and education, as well as maintaining an open-minded attitude to technology and customers' wants, the industry should be improved and strengthened.

On the other hand, the Council felt obliged to tackle the 'problem' of taste in furniture design head-on. Paul Reilly, one-time director of the Design Council, suggested that modern design had a long way to go before it reigned supreme over bad taste. 'We can claim little progress so long as gin-and-French Modernism jostles Repro-Jaco for pride of place in the multiple shop windows. Facadism

and dodoism are still successful formulae in the furniture industry.'[73] This disdainful approach to popular furniture was challenged by Jack Pritchard.

In an address to the Royal Society of Arts in 1952, Pritchard, discussing the difference of opinion about furniture design, makes the important point that:

> there is in this country, a very wide difference of opinion on the design of furniture between those who form the chief market for it and those who have studied it: the architects; the historians; the experts and the highbrows.[74]

The retail furnishing bogey-man can still be found not far below his comments. Discussing the historical differences, Pritchard pointed out that the two-way process between maker and user no longer existed; buyers were still inexperienced even though standards of living had gone up: purchases were only made very infrequently; and retailers were now the makers' customers. Allegedly, the development of mass distribution which had to put a middleman between the designer/maker and the user, resulted in the retailers' perception of public taste supplanting that which had previously existed.

According to Pritchard, the way to overcome this was to encourage the public to establish closer links with furniture designers and makers. This, he thought, could be done by (i) market research projects, (ii) using the education system to promote images of design through schools with home-craft flats, (iii) furnishing Government offices in different ways, 'in particular employment exchanges', the idea being that if they were furnished in 'say, half a dozen different characters [they] would give the public a very good idea of what can be done'.[75] Few of these initiatives were exploited, as the main driving force of the industry was, and remains, its key theme – 'does it sell?'.

Ten years after the *Working Party Report* little seemed to have changed. Surveying the industry in 1955, Michael Farr was told by one furniture manufacturer that:

> Design for mass production, consists in juggling with a number of standardised parts, so that mouldings and fittings can be changed round.[76]

Although this may be a matter of fact, it indicates the lack of progress in design since the 1920s. When Michael Farr investigated the industry in 1955 he still found that in many cases the manufacturer did the

designing. In the case of large concerns, Farr gives examples of a manufacturer whose understanding of design was such that he required his designers to have a 'decorative flair', whilst another wanted his designer to get ' a few ideas from magazines'.[77]

Attitudes amongst the large manufacturers that Farr talked to, reveal a blinkered approach to design policy. One called his furniture 'damned ugly' and said that it was directed at a new market, 'the uneducated masses'. In several other cases it was pointed out that shareholders would not support a design policy which might involve financial risk. It was considered unwise to 'rock the boat', if a design was selling well, 'don't upset the sales curve'.

Farr also suggests that no manufacturer that he met 'felt himself to be morally involved in his business'. 'We are not in business for the sake of our health', was apparently the favourite phrase.[78] Although certain standards must be maintained, it is this uninvited role of agent for wider reforms that sits uneasily on the mantle of furniture-makers (and retailers), just as much as it does for architects, for example, who are blamed for poor housing projects.

By 1965, the problems had still not gone away. Oliver Lebus discussed the well-known dilemma of the multiplicity of designs that conflicted with the need for long production runs in a mechanised factory. He thought this might be solved

> on the one hand by the design discipline one imposes on oneself and, on the other hand, by the ingenuity one can exercise in one's planning – so that one *maximises the apparent flexibility through a minimum of basic parts* [my italics].[79]

Here we see exactly the same approach to mass market design that Farr had noted ten years earlier.

One leading member of the trade in the 1960s suggested that furniture factories were already out of date because the designed environment would soon be completely different. Leslie Julius's predictions concluded that plastics and disposable materials were to be the products of the future. He suggested that 'furniture will be foam-moulded as part of the walls, and the walls themselves will be manufactured in such a way as to be movable and changeable according to the family requirements'.[80]

Commenting on the acceptance of modern design using clean lines and honesty of materials in the international contract market, Julius

compares this furniture with the domestic retail market. He unwittingly demolished his own argument about the future of furniture mentioned above:

> Domestically the situation is different, and in my opinion is likely in the immediate future to change for the worse, as the desire of those who have hitherto not had the opportunity of expressing their growing living standards will be able to do so in a more ornate manner; since such people, because of the very nature of the education they have received, tend to be visually insensitive.[81]

At least this honest assessment, which takes into account human nature, more accurately reflects the reasons why furniture-makers produced designs that were based on the past, rather than culturally alien 'modern' designs.

This does not mean that improved design was not better business in the retail sector. The example of Schreiber, a little-known manufacturer of cabinets in the 1950s, clearly shows that a conscious effort to improve design, and incidentally, delivery times, could be successful. By the early 1970s they were market leaders.[82]

Rather than growing in some organic way as new developments occurred, the industry seemed to be trying to portray an image of a craft-worked traditional design, whilst still using sophisticated machinery. Paul McCobb (1967) put it thus:

> Technologically speaking the furniture industry has become expert in imitation. As compared to other industries, the furniture industry has chosen the road of exploitation of the most basic tastes displayed by the public today. The fashion industry, whose products depend on the whim of the season, has an intellectual capacity and a desire to interpret better taste and the creativity of the designer.[83]

McCobb also has some harsh home truths about the use of decoration and the role of traditional design. He pin-points the circular nature of attitudes to design and explains why the design sources tend to remain the same:

> The industry does not understand the word design. The industry thinks of decoration but not the meaning of decoration. Decoration becomes a selling tool, rationalized by the term environment. The great consumer public is offered an array of meaningless style environments appealing to a false sense of security or tradition. Since this same public simply has no opportunity to select good design (for it isn't offered except in very

rare circumstances), it is assumed by the industry that the public doesn't want good design and that it is seeking satisfaction in instant heritage'.[84]

The concern for some morality in business that Farr identified as missing in Britain was also commented on in relation to the United States. Baermann (1967) considered that the industry 'does not indicate any sense of obligation to the consumer as a member of a rapidly changing society'.[85]

At this point it must be remembered that the furniture industry is a business with a volatile market that is susceptible to many outside influences: therefore it is not surprising that design initiatives are often kept within the bounds of the known. Even when everything seems right for a new design, it can often be unsuccessful. An example can be found in the story of the Limba range by Gomme. To respond to a drop in sales, Gomme introduced a new range of cabinet furniture called Limba. From a design point of view it was 'uncluttered and functional, veneered with an unusually straight grained wood which made matching easy'. The trade loved it, but unfortunately the public did not take to it at all. The timing had been wrong and the reason for its introduction wrong.[86]

One of the main problems associated with furniture design and manufacture in the 1970s and 1980s in Britain was that many cabinet firms began to make panel products based on the same simple modules. The same carcases simply had changes of veneer or foil finish, different hardware or other detail. The main distinction was whether it was aimed at the higher or lower market segments. The problem of bulk production versus individual requirements remains as it did in 1955, it was still a matter of juggling with a number of standardised parts. Indeed, the concept of producing a range of basic furniture alongside a range of decorative furniture both designed for the two distinct uses in each market, is quite an attractive one. For example, kitchen units are based on uniform modules and designs controlled by technique and performance standards. On the other hand, individual pieces can be provided on a mix-and-match basis to provide an individual decorative scheme.[87]

More recently, manufacturers have begun to direct their products to the retailers who furnish particular niches in the market. The example of the Christie-Tyler group who have a variety of subsidiary companies, each supplying various particular sectors of the market, demonstrates this point.[88]

These developments clearly affect the distribution policies of manufacturing companies and these will now be examined.

Distribution policies, sales, and marketing

As has already been intimated, fluctuations in demand, either due to social factors (e.g. the habit of many couples arranging marriages at Easter: the ritual of spring cleaning with its refurnishing opportunities), or more importantly economic or government pressure, often made it difficult to achieve long-term continuity and stability. The economic factors are partly based on retail buying programmes. Retailers created variations in demand either by stocking up for Easter or Christmas trade or conversely in the case of department stores, by the release of furniture showroom space for Christmas trade. Retailers also have a habit of reducing stocks prior to their annual stock take. The government's influences on sales and marketing policy are usually related to controls of credit, interest rates, sales taxes, or extraordinary economic conditions.

Manufacturers' policies on distribution and marketing have mainly been related to overcoming and trying to iron out the disorientating fluctuations in business, that, incidentally, seem to follow the general economic climate with some precision.

Marketing and advertising

One of the most important changes in the attitude to marketing and its effect on design was the recognition by major manufacturers that the market was segmented. Successful firms post-war were unable and unwilling to be 'all things to all men'. In addition to greater targeting of markets, a fashion element in furniture was beginning to be recognised. In 1969, Peter Liley of Meredew said in *The Times*:

> We are now predominantly a fashion industry and have learnt from experience in the past few years that public taste follows a strict pattern in which top design for a minority group soon flows into a majority market area.[89]

The significance of these principles based on Veblen's *Theory of the Leisure Class*, shows the first stirrings of an understanding of the true nature of the later twentieth-century furniture industry. Speaking for one of the biggest cabinet-making concerns of the time, Kenneth Dean of Lebus remarked:

We now produce furniture for three separate taste markets. Our Europa range is aimed at the top third sales area and includes decorator-style furniture as well as one or two trend-setting designs. The middle market is covered by the Furniture Circle range introduced recently and aimed mostly at young married couples, who are buying furniture for the first time. Lastly we produce basic storage and seating units for the lower end of the trade at the cheapest possible price commensurate with quality.[90]

These remarks echo those of the president of the American Drexel Furniture company when he commented on the application of General Motors' principles to the furniture business: 'The Heritage line will be our equivalent of Cadillac, Drexel will be our Buick-Oldsmobile and Morganton our Pontiac'.[91]

The segmentation principle has allowed not only large companies with a variety of lines to survive but also for a range of smaller specialist companies to exist alongside.

Another important distinction is between those manufacturers who tie themselves to large-scale retailers and produce 'own brands', usually relying on the retailer to promote the goods, and the manufacturers of branded ranges who sell to independents as well as large multiples. They then take on the role of promotion of the brand direct to the customer.[92] Some retailers often discouraged indiscriminate branding and frequently removed all manufacturers' labelling in order to avoid price comparisons with competitors. This led some manufacturers to apply fixed labels or to literally brand the firm's name into wooden parts.[93] On the other hand, branding has often developed along with programmes of exclusive dealerships, staff training, and joint retail-maker promotions which have benefits for all parties. The exclusive dealerships require a retailer to devote a specific amount of display floor space in his branches to a certain product range, to maintain a high quality display and offer advice from trained staff. These relationships are often connected with a priority delivery service.

Perhaps the most famous example of branding, based on customer awareness, is E. Gomme's G-Plan brand, launched at the 1953 London Furniture Exhibition. The timing was impeccable as it broke away from government restrictions, and caught the public imagination with its guarantee of availability of additional pieces, thus allowing customers to buy piece by piece rather than in suites. Furniture branding reached its peak in 1960 with over 60 per cent of

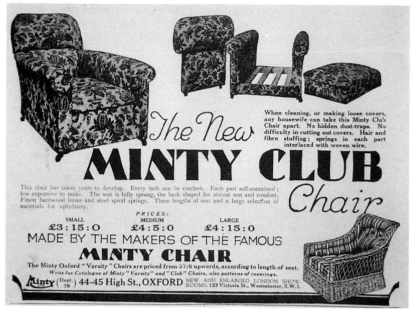

26 Minty 'Club' chair, *c.* 1930. Designed to be dismantled for easy cleaning and fitting of covers

the turnover of such retailers as Times Furnishing being branded. Indeed their slogan was 'if it's famous it's here'.

Although there have been industry-wide attempts to promote furniture sales such as the 'old furniture must go' campaign and more recently the 'touch-wood' campaign, it is clear that centrally organised and paid for promotion is going to be limited, owing to the continuing fragmentation of the industry.

Showrooms and exhibitions

The distribution of furniture from manufacturer to retailer has for the entire century relied on a system of exhibitions and showrooms in which a market place can be created. In the United Kingdom, exhibitions have been held since 1881 at various venues around the country. The publicity and educative value were expressed as early as 1883:

The interchange of ideas has been most beneficial to the trade and the public, for both have been educated up to a knowledge of art in the home, and that in a most agreeable manner.[94]

The main objective has been to introduce new lines and improved models as well as to show a full range of a manufacturer's products. In the competitive atmosphere it is not surprising that efforts would be made to attract attention with outlandish designs, but these were not always welcome by the retailer. One retailer comment emphasises this: 'I am glad to see that there is less inclination on the part of the manufacturer to indulge in freakishness'.[95] In recent years many manufacturers have dissociated themselves from the annual exhibitions and occupied space in alternative venues at the show time: a degree of exclusivity has thus been maintained.

These have usually been trade-only shows but there have been occasions when the public have been admitted. Slightly different are the annual Ideal Home Exhibitions, showing a wide variety of household products and associated objects. They have always been a successful and profitable market place for established furniture retailers who take space and set up shop each year. In this way it is a selling situation, in contrast to the Furniture Shows which were non-selling displays of a good cross-section of the trade. Apart from annual exhibitions, some manufacturers kept showrooms in major cities, often for purposes of public relations, but also to maintain a metropolitan presence.[96] Although many of these have subsequently been closed as a result of cost-cutting, some still remain.

The use of markets in North America, especially the Furniture Marts at Chicago and High Point, are indicative of a different way of doing business. The Chicago Furniture Mart, when established in 1924, had nearly 2,000,000 square feet (185,800 sq. m.) fully rented, housing 700 exhibitors from 31 states. The power of the mart can be seen in figures from 1928 when 90 per cent of the country's furniture-makers did 25 per cent of their total annual business there. Although Chicago has tended to be less influential in recent years, up to the mid-1960s it was still estimated that 75 per cent of the industry was represented at the Chicago fairs.[97]

Although there has been an international import-export of furniture for many years, since the 1950s the trade in furniture has become truly world-wide. International furniture fairs are held all over the world, with the two mighty European fairs being in Milan and

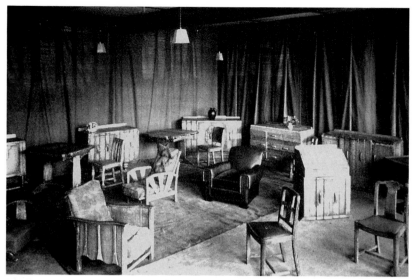

27 Castle Brothers' purpose-built furniture showroom at the factory in High Wycombe, *c.* 1937

Cologne. Over the years other countries have had exhibitions that have been favoured – Halsingborg in the 1950s, Copenhagen in the early 1960s, Brussels in the 1970s and Valencia in the 1980s. An indication of the world-wide sourcing of furniture can also be seen in the importance of fairs in the Far East, especially in Malaysia and the Philippines.

Lastly, brief mention must be made of the wholesale function, which, although declining from an early twentieth-century peak, can still render service to both manufacturer and retailer. In fact in 1965, 15 per cent of the US manufacturers' production was taken by wholesalers for onward shipment. Clearly this continuation, which compares to a very small market in the United Kingdom, is related to the physical distribution problems in the United States.[98] In Britain the wholesaler's role has seen a revival in terms of being an agent for the import of European and Far Eastern products. The bulk import of items such as inexpensive metal dining sets from Italy or ramin 'colonial-look' dining suites from the Philippines has meant a new lease of life for these entrepreneurs.

Government restrictions

The British furniture industry has been affected in a number of ways by government activity. These have included the abolishment of resale price maintenance, the creation of consumer standards, numerous regulations about standards of materials, and the impact of a variety of credit controls, as well as general legislation affecting all trades and industries.[99] However, the most far-reaching and effective control of an industry was the government's activities during wartimes.

Hostilities affected supplies of materials and developments in techniques, and put pressure on manpower and altered the nature of demand. They also stifled import and export markets, which led to efforts to replace the imported designs. The popularity of Austrian bentwood chairs had been substantial before World War I, so the Board of Trade saw this branch of the industry as one that could benefit from the development of a similar trade in Britain. Consequently they set up an exhibition of German and Austrian articles that typified successful design, and encouraged manufacturers to develop these products for the home market.[100] High Wycombe chairmakers began to produce bentwood chairs, and William Bartlett and Sons, Joynson Holland and Co., and the Vulcan Electric Chair works were all engaged on bentwood chair production to replace the market left by the lack of imported chairs.[101]

The example above was a case of indirect influence and it was to be World War II that acted as the flux for a deeper and more direct involvement. The well-known Utility furniture scheme was a unique example of the complete governmental control of a particular industry.

From the outbreak of war strict controls on timber for furniture use were applied, and after July 1940 no new timber was released, so manufacturers had to rely on their own stocks. At the same time, the Ministry of Works published the simplest of designs for furniture which it considered should be the only ones produced, although at this stage there was no compulsion. Up to early 1942 there was little interest from the Board of Trade in controls of furniture apart from the orders applied by the Prices of Goods Act (June 1940). However, problems had developed due to the timber shortage and the lack of furniture available to meet demands. This had resulted in the growing use of poor substitutes which encouraged scamping on the part of makers, as well as a rapid rise in the price of second-hand

furniture. Combined with this increase in demand and a need to control production as well as prices, in May 1942 maximum prices were limited to the then current prices for new items, and the price of second-hand furniture was limited to its first-hand price.[102] This resulted in still poorer new products, so a full-blown control scheme was arranged.

The case history of the Utility scheme incorporates a number of useful examples to demonstrate the attitudes to, and from, the furniture industry in Britain. The problems for the furniture industry at that time were enormous: there existed an almost complete lack of new raw materials, a loss of labour and the turning to war work by requisition. All these, combined with public fears of profiteering and poor quality from what was made, meant that the Central Price Regulation Committee decided to control process, production, price, and more unusually specification and design.[103]

The Government considered that control of supply (production and distribution) and price were the most important objectives: production because of the need to save labour and to concentrate scarce resources, and price control (by standardisation) to stop any profiteering. The control of design, although not being just incidental, was dictated by the fact that the industry was fragmented and standards had to be able to be met by the lowest common denominator of factory size and ability. In other words 'Design had to be adapted to the simplest productive processes'.[104]

The detail of the application of the Utility scheme has been introduced elsewhere[105] but a brief description of the manufacturing processes will be included here, as the processes led the way to new thinking about materials and construction, even if design reform remained a limited influence. The first range, called the Chiltern, was designed to provide basic furniture which could be simply made to provide good service in use. The cabinets were built from hardwood frames with infills of veneered panels. The joints were pegged or mortised which allowed inexperienced machinists without craft skills to build furniture. The later range, the Cotswold, introduced in 1946, after the cessation of hostilities, was designed for mass production in larger works that had previously been employed on war work.[106] These models made use of some plywood and blockboard, which resulted in a more streamlined flush finish. In place of plinths, legs were used giving a lighter overall look.

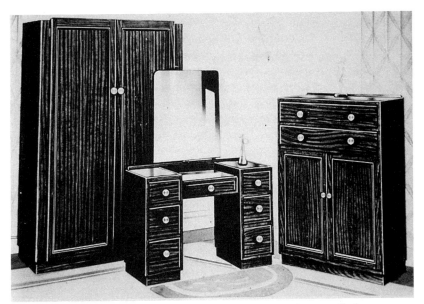

28 A Lebus Utility bedroom suite clearly showing the panelled construction that was a feature of many Utility designs, *c.* 1948

The importance of the techniques employed in the Utility range for future furniture production was soon recognised. In his introduction to a Utility furniture section in *Modern Cabinet Work* (1952), John Hooper noted that the chapter was prepared for the book at the

> special request of the publishers, as the technique of the early and later editions of Utility furniture embody sound principle of construction, combined with economy of materials and production, which are applicable over a wide range of work in the furniture and other woodworking trades.[107]

This seems to be the important point about the influence of the Utility scheme. It introduced new ways of thinking about production and construction processes, which manufacturers would not have been exposed to in normal circumstances.

Needless to say, opposing points of view ranged from points of principle to small details. For example, according to Hooper, the use of veneered hardboard for panelling bottoms and backs was a clear saving of material, although the *Architectural Review* considered that:

'hardboard, a comparatively new and not yet fully tried out material, limited the designers to the Arts and Crafts technique of frame and panel and to small panels at that'.[108]

The manufacturers' and retailers' natural dislike of standardised designs was argued from the point of view that the consumer would be unhappy with no choice. Michael Farr had noted that 'Utility was designed for service, not for selling, for useful work in people's homes and not for eye appeal in the shop window'. He perhaps rightly considered that this made the retailer antagonistic towards the Utility designs.[109]

To support its demands for design freedom, the trade argued that: 'over and above all questions of design there are a number of idiosyncrasies in the public taste in furniture which defy both rules of design and construction'.[110] However, the trade journal hoped that the Utility experiment would have a much deeper result: 'our guess is that, and our hope is, that the Committee will plump for sound, plain and functionally satisfactory furniture. If it does so, it will have left, after the war, a solid and nationally characteristic mark upon style'.[111]

It has been argued that this new style was achieved partly through necessity and partly through the ideals of the chairman of the design panel – Gordon Russell. Indeed Russell had anticipated his own work in 1933 when he said:

> I am saying that the taste of the consumer should be educated so that there will be a larger demand for well designed things, and the machine will then be used as it should be – to turn out cheaply and by tens of thousands examples within the reach of the slenderest purse.[112]

Not too much emphasis must be placed on Russell's altruistic role, as the Government clearly wanted designs that gave the consumer value for money combined with guaranteed standards. The designs were chosen for maximum economy of production, the ability to create precise specifications for price and quality control, as well as being able to respond to the urgent need to commence the programme. The designs were the most suited to the moment, and it was not surprising that they should reflect a degree of bare functionalism.

By the late 1940s and early 1950s the trade was clamouring for the return to normal conditions of trade, whilst the politicians were concerned about the political effect of ending the Utility scheme, as

value for money and controlled prices were seen as essential to a stable post-war society.[113] Nevertheless, the combined effects of the manufacturers' long-standing opposition to the scheme in principle, the stultifying effect of the scheme on design innovation, and by implication the export effort, and the fact that the Board of Trade saw the scheme as a distortion of the market, led to its eventual demise. The Douglas Committee recommended all Utility schemes be abolished from 17 March 1952, except in the case of furniture 'which should continue until such time as adequate safeguards for the public had been devised'.[114] The British Standard was established and the scheme was disbanded in December 1952; however, consumer protection remained on the political agenda.[115]

Overall it was acknowledged that 'most firms recognise that their experience of Utility furniture production contains useful lessons for the future'.[116] Although the Utility scheme provided some lessons for the trade, which included the advantages of a small range of good simple designs, long production runs, the benefits of plant modernisation and importantly for the smaller firm, the advantages of scientific costing methods, its impact on design awareness seems to have been small.

As for the impact of Utility furniture on the public's taste, Michael Farr (1955) was quite clear: 'the designs presupposed that the public had the ability, both financial and artistic, to furnish a living room or a bedroom with objects of a related standard'.[117] Contrary to this benign critique, a contemporary American report on the British industry considered that

the design of most British furniture is so bad that it would not be acceptable to the American public. Wartime controls known as Utility furniture scheme apparently are responsible for this stifling of creative designing.[118]

On 15 December 1952, the furniture Utility scheme ended along with price control and quality assurance. This was not the end of controls altogether. Immediately thereafter the 'D scheme' was introduced which set a price median for all production. Tax at 25 per cent was charged on the wholesale value over the tax-free limit, so that lower-priced goods remained tax free and higher-priced ones had a related differential. In October 1955, the D scheme was abolished and all furniture became subject to 5 per cent purchase tax.

The control of the economy by the 'stop-go' process hit the furniture trade hard. In February 1955, hire purchase restrictions were re-imposed. They stipulated a minimum deposit of 15 per cent and the maximum repayment period to be over two years and add-on agreements became illegal. By February 1956 the minimum deposit was raised to 20 per cent. These sort of stop-go controls plagued the industry for many years as the purchasing of furniture was often the first to be foregone when private spending had to be curtailed.

In addition, according to some, the sustaining of resale price maintenance over a growing area of merchandise resulted in hindering the development of new forms of furniture retailing:

> [resale price maintenance] discouraged price cuts as an effective method of competition; prevented the retailer from selecting the degree of service, stock assortment, advertising and pricing most suitable for his customers and helped to keep the inefficient retailer in existence.[119]

Whatever the case, the furniture trade did not apply for exemption from the 1964 Resale Prices Act, but paradoxically it has been one of the trades most affected by the abolition.

Although no more than 15 per cent of furniture sales were covered by resale price maintenance, there was a fear of the results of abolition. This resulted in manufacturers being apprehensive of the increased bargaining power of the retailer, whilst retailers themselves feared lower margins and hence service levels, due to price competition.

The effects of abolition were to stimulate widespread price-cutting by retailers stocking well-known brands and reducing prices which resulted in a rise of market share for nationally branded items. On the other hand, retailers began to stock unbranded goods in an effort to avoid comparison and maintain slender margins.[120]

Resulting uncertainty contributed to a rise in imports, which fuelled the stop-go cycle. More recent Government attempts have been directed to changing this balance.

In March 1986 the Furniture Economic Development Council sponsored an exhibition entitled the *Better Made in Britain Exhibition*. It was designed to show imported goods in a challenge to makers in Britain to match or outdo the importers.[121] Ironically, seventy years after the first Board of Trade initiative on similar lines, the criticisms of the British furniture still included a lack of quality, poor finish,

long lead times, unsuitability for today's lifestyle, poor marketing, and a lack of appeal to the young. Even more recently the government's Enterprise Initiative-Design Consulting Scheme has been used to fund design projects. Run by the Design Council, who have identified furniture as one of three individual sectors which would benefit, it encourages companies to seek assistance and funding for short-term design projects.[122]

None of these initiatives are before time, for since 1980 when import penetration accounted for 13 per cent they have risen to 19 per cent in 1989. All this growth occurred while exports remained static at around 6–7 per cent over the same period.[123]

Notes

1 N. Bell, *Tower of Darkness* (Collins, 1942).
2 Arthur Warne (Secretary of NFFT) in H. J. Schonfield (ed.), *The Book of British Industries*, (London, 1933).
3 The motor car industry soon shook off the carriage-building image and developed its own particular methods which were suited to the mass production of vehicles.
4 Hamilton Smith, 'On taking furniture seriously', published in the *Furniture Trades Yearbook* (1926).
5 Board of Trade, *Working Party Reports. Furniture* (HMSO, 1946), p. 132 (hereabter referred to as WPR).
6 Key facts for the industry as at 1990 were as follows: 6, 119 manufacturing units producing a total output valued at £3.8 billion in 1989. The industry employs 94,000 but is extremely fragmented with 86 per cent of manufacturers employing less than 20 people. Domestic furniture imports amounted to £584 million in 1989 representing a penetration of 19 per cent.
7 *The Times*, 27 December 1901.
8 Directors Minute Book, 19.6.1919, Bucks Country Record Office, Aylesbury.
9 'Good going at Gomme' s', *Management Today* (June 1970), p. 174.
10 The examples of Maple and Co. and Heal and Son are well known, but many provincial businesses continued a cabinet making and upholstery service well into the second half of the century.
11 *Profiteering Acts 1919 and 1920. Findings and Decisions of a Sub-Committee appointed by the standing Committee on the Investigation of Prices to investigate costs, profits, and prices at all stages in respect of furniture* (HMSO, 1920). Cmd. 983, p. 9.
12 *Ibid.*, p. 11.
13 This style of chair continued to reflect a minimum standard; it was recommended for the furnishing of a working-class home by the Council for Art and Industry in 1937.
14 See Clive Edwards, 'Furnishing a home at the turn of the century. The use of furnishing estimates 1875–1910', *Journal of Design History*, 4:4 (1991).
15 *Profiteering Acts*, p. 14, minority report.

16 Compare these figures with those found by the Sub-Committee investigating profiteering in the British industry, who noted net profits ranging from between 7.57 per cent for the bedroom suite to 15.68 per cent for a wooden kitchen table.

17 *Encyclopedia of the Social Sciences*, 5 (Macmillan, 1931), p. 540. The lack of costing systems is not surprising at this stage of the industry's development: the accountants attached to the British Profiteering Sub-Committee found in many cases that no cost accounts were kept.

18 J. E. Martin, *Greater London. an Industrial Geography* (London, Bell, 1966), p. 186.

19 H. Dunnett, 'Furniture since the War', *Architectural Review*, 109 (March 1951), pp. 150–66.

20 W. P. Baermann, 'Furniture industry in transition', *Industrial Design* (May 1967).

21 W. Skinner and D. Rogers, *Manufacturing Policy in the Furniture Industry* (Homewood, Illinois, 1968), p. 2.

22 'A review of the American household furniture industry', in Furniture Industry Research Assoc., *An Economic Review for the Furniture Industry 1968–9* (July 1970).

23 Furniture Industry Research Assoc., *An Economic Review for the Furniture Industry*. Apart from internal trade mergers and take-overs such as Silentnight, Bond Worth Holdings and the Duport Group etc., large institutions took an interest, albeit sometimes short lived, in the trade. Examples include GEC and Schreiber, Bowater Holdings and Beautility and Limelight; Lonrho and Homeworthy, Thomas Tilling and Rest Assured.

24 Design Council, *Report to the Design Council on the Design of British Consumer Goods* (London, 1983), p. 28.

25 *The Times*, 24 January 1969. It is clear that the retailer is still seen as the cause of many problems for manufacturers.

26 Design Council, *Report ... on the Design of British Consumer Goods*, p. 29.

27 Greater London Enterprise Board, *Turning the Tables: Towards a Strategy for the London Furniture Industry* (1985), p. 5.

28 Economist Intelligence Unit, *Retail Business*, No. 50 (April 1962).

29 Martin, *Greater London*, p. 185.

30 *A History of Harris Lebus 1840–1947*, typescript, 1965, Furniture Collection Archives, Victoria and Albert Museum, London, p. 38.

31 *Ibid.*, p. 39.

32 This process involved the assembler adjusting the door and drawer frames by planing until they fitted exactly. Hence drawers were not interchangeable under this old system.

33 *Cabinet Maker*, 1 July 1950, pp. 60–3.

34 See the example of T. R. Dennis, cabinet maker, in W. J. Burnett (ed.), *Useful Toil, Autobiographies of Working People*, 1974.

35 G. Nelson, 'The Furniture Industry', *Fortune* (January 1947).

36 Twenty-four public companies in 1941 out of 4,000 firms.

37 WPR, p. 64.

38 *Ibid.*, p. 70. One of the roles of the Furniture Development Council was to provide comparative statistics for the industry's use.

39 Nelson, 'Furniture Industry', p. 171.

40 *Management Today*, June 1970, pp. 164–76.

41 For a discussion about design and the small firm see J. Attfield, 'Then we were making furniture, and not money'; A case study of J. Clarke, Wycombe furniture-makers, *Oral History* (Autumn, 1990). Many innovative modern furniture companies have been small scale as well, e.g. Merrow Associates, Plush Kicker, Pieff.

42 M. Jay, 'Furniture: Autocracy versus Organisation', *Design*, 194 (February 1965).

43 On example from many, might be the No. 6 tubular steel chair produced in the 1930s by Horatio Myer's, better known for beds. This chair was available in cellulose sprayed finishes: gold, aluminium, blue, green or flame with a canvas seat – an example of a manufacturer trying to use his existing technology to benefit from a transient taste. The chair design bears no relation to its prestigious forebears. *Myer's First Century 1876–1976* (Horatio Myer and Co. Ltd, 1976), p. 28.

44 *Cabinet Maker*, 28 October 1916.

45 *History of Harris Lebus*, p. 51. They included price lists with either a 50 per cent or 100 per cent mark up for the appropriate customer.

46 'Conference on House Furnishings', *Journal of the Royal Society of Arts* (5 March 1920), p. 254.

47 *Ibid.*, H. E. Taylor, Secretary, London Cabinet and Upholstery Trades Federation.

48 Committee on Trade and Industry, *Factors in Industrial and Commercial Efficiency* (HMSO, 1927), p. 360.

49 *Ibid.*, p. 361.

50 Compare with the remarks above, expressed at the conference on house furnishings (1920).

51 Committee on Trade and Industry, p. 362.

52 *DIA Quarterly* (March 1929), quoted in T. Benton, 'Up and Down at Heal's: 1929–1935', *Architectural Review*, 972 (February 1978), pp. 109–16.

53 J. Gloag, 'Prophets and Profits', *Architectural Review* (April 1930), quoted in Benton, *ibid.*

54 London School of Economics, *The New Survey of London Life and Labour* (1931), p. 217.

55 Prince of Wales Speech to Burlington House Exhibition, *The Studio* (February 1935).

56 N. Pevsner, *An Enquiry into Industrial Art in England* (Cambridge, Cambridge University Press, 1937), p. 39.

57 P. Abercrombie, *The Book of the Modern House, A Panoramic Survey of Contemporary Domestic Design* (London, 1939), p. 362.

58 *Ibid.*

59 R. D. Russell, 'Furniture today, tuppence plain: penny coloured', *The Anatomy of Design*, A Series of Inaugural Lectures by Professors of the Royal College of Art, London (1951).

60 J. C. Pritchard, *View from a Long Chair* (London, Routledge, 1984) pp. 144–5.

61 Nelson, 'Furniture Industry', p. 111.

62 'Borax furniture' is a colloquial American term for furniture that is based on heavy forms with added ornament which tries to achieve its effect through stimulation of the eye.

63 Nelson, 'Furniture Industry', p. 111.

64 WPR, p. 132.

65 *Ibid.*, p. 111.
66 *Ibid.*, p. 112.
67 *Ibid.*, p. 112.
68 *Ibid.*, p. 113.
69 See for example, The Consumer Council, *Furniture Trade and the Consumer* (HMSO 1965), pp. 39–45.
70 WPR, p. 181.
71 It is interesting to see that in the late 1980s the Design Council had moved some way away from this sort of criticism and had begun to be more constructive in their deliberations. Specific advice on design related matters such as standards, CAD/CAM, materials, and the international market were clearly more helpful than negative criticism that was still being fired at the industry.
72 WPR, p. 183. For a discussion on the role of the retailer see below in distribution section.
73 Paul Reilly, in D. Joel, *Furniture Design Set Free* (London, Dent, 1969), p. 99.
74 J. C. Pritchard, 'The changing character of furniture', *Journal of the Royal Society of Arts*, 100 (February 1952), pp. 237–56.
75 *Ibid.*, p. 252.
76 M. Farr, *Design in British Industry* (Cambridge, Cambridge University Press, 1955), p. 12.
77 *Ibid.*
78 In 1946 Gordon Russell had encountered something similar. A manufacturer was annoyed at the insistence of the Utility Committee that a moulding had to be produced to the exact contour on the drawing. He apparently blurted out 'we have never had time to worry about little things like that. We're too busy making money here!'. Russell commented that this had 'all unconsciously, expressed with perfect clarity the deep-seated disease of the furniture trade', *Architectural Review*, 100 (December 1946), p. 184.
79 Jay, 'Furniture: Autocracy versus Organisation'.
80 L. Julius, 'The Furniture Industry', *Journal of the Royal Society of arts* (May 1967), p. 463.
81 *Ibid.*, p. 438.
82 P. W. Sizer, *Structure of the British Furniture Industry,* University of Aston Management Centre, Working Papers Series No. 31 (November 1974), p. 4.
83 McCobb interviewed by Baermann, 'Furniture industry in transition', p. 33.
84 *Ibid.*
85 *Ibid.*, p. 35.
86 *Management Today*, June 1970. For a more recent documented example of an innovative design failing see: J. Manser, 'You can lead a horse to water', *Design*, 455 (November 1986), p. 36.
87 Dr F. Ullmann. Report of a Lecture given by Dr Ullmann to the Worshipful Company of Furniture Makers, at the Royal Society of Arts, 6 April 1970, p. 11.
88 In 1988, Christie-Tyler plc had a turnover of £200 million, employed 4,800 people and made a profit of £10.3 million.
89 *The Times*, 24 January 1969.
90 K. Dean, quoted in P. Varley, 'Lebus introduce new techniques in the furniture industry', *Design* (February 1968).

91 Skinner and Rogers, *Manufacturing Policy*, p. 2.
92 Economist Intelligence Unit, *Retail Business*, 1964, p. 14.
93 See Parker Knoll chairs for example.
94 Quoted in *Cabinet Maker*, July 1955.
95 *Cabinet Maker*, 19 January 1935, p. 125.
96 This certainly applied if the manufacturer's base was situated in the provinces. Greaves and Thomas had showrooms in Bond Street, London, and Manchester and Bristol: Harris Lebus, Gomme, Parker Knoll, all have or have had showrooms in major cities.
97 Skinner and Rogers, *Manufacturing Policy*, p. 6.
98 *Ibid.*, p. 12.
99 Some of these are examined below.
100 *Exhibit of German and Austrian Articles typifying Successful Design*, 6 April 1915. Also see *Cabinet Maker*, 17 October 1917.
101 *Cabinet Maker*, 17 October 1917.
102 This was the *Price Controls of Second-hand Furniture Order*, July 1942. It applied to shops and auction rooms.
103 WPR, p. 68.
104 E. Hargreaves and M. Gowing, *Civil Industry and Trade* (HMSO, 1952), p. 515.
105 G. D. N. Worswick and P. Ady, *The British Economy 1945–50* (Oxford, Clarendon, 1952), section on Direct Controls; Hargreaves and Gowing, *Civil Industry and Trade*; Geffrye Museum, *CC41 Utility Furniture and Fashion, 1941– 1951* (ILEA, 1974).
106 The initial designated manufacturers were all of small scale and numbered about one hundred in total.
107 P. Wells and J. Hooper, *Modern Cabinet Work, Furniture and Fitments*, 6th edn (Batsford, 1952).
108 'Utility or austerity', *Architectural Review*, 93 (January 1943), p. 4.
109 Farr, *Design in British Industry*, p. 6.
110 Hargreaves and Gowing, *Civil Industry and Trade*, p. 516.
111 Geffrye Museum, *Utility Furniture and Fashion*, p. 28.
112 Gordon Russell, BBC programme discussion – Design in Modern Life, *The Listener*, 3 May 1933, pp. 695–8. Reprinted in Open University, *A305 History of Art and Design 1890–1939* (Milton Keynes, Open University, 1975), p. 69.
113 Clearly the work of the Profiteering Acts 1919–20 and the various Sub-Committees it set up were aiming for the same stability.
114 F. Longworth, 'Furniture under controls', *Cabinet Maker* (July 1955), p. 58.
115 For further discussion about the Utility scheme and the various attitudes to its introduction and disbandment see P. Maguire, Book Reviews, *Journal of Design History*, 5:2 (1992), pp. 160–3. Also see P. Maguire, 'Designs on reconstruction: British business, market structures and the role of design in post-war recovery', *Journal of Design History*, 4:1 (1991).
116 WPR, p. 69.
117 Farr, *Design in British Industry*, p. 5.
118 Private Papers; Kindel Report to NAFM BRFM 38/49, July 1949.
119 C. Fulop and T. March, 'The effects of the abolition of resale price maintenance in two trades', *European Journal of Marketing*, 13:7 (1979).
120 *Ibid.*

121 Refer back to previous Board of Trade assistance during World War I for a similar example.
122 'How to finance good furniture design', *Cabinet Maker* (5 June 1992).
123 *Business Monitor* MQ12.

5 Distribution

I still maintain that retailers, with great, notable and noble exceptions
have failed the public and the industry miserably.[1]

Introduction

The role of the retailer in the distribution cycle is both clear-cut and
vague at the same time. Whilst it is clear that retailers act as the
pivot between the manufacturer and the consumer and perform a
distributive role, the ambiguity of that role is seen in the mantle of
taste arbiter and educator that is sometimes imposed upon them.
This theme will be returned to later. The complexity of their rela-
tionships with others is also notable. Relationships between retailer
and manufacturer can vary from the simple contractual obligations
of buying and selling to a high degree of involvement in mutual
concerns, such as specifications of products, staff training, in-store
displays, and so on. The relationship between the retailer and the
consumer is much more transient. Although many customers relate
to a particular shop which they can identify with, and feel comfort-
able in, ultimately customers will purchase where the conditions of
their needs are best met.

The retail furniture trade has long suffered from a bad press from
many quarters. Some manufacturers have thought that the retailers
have had too much power in the pivotal position of intermediary
between the maker and the consumer.[2] The consumer has often con-
sidered the retailer a profiteer with no interest other than to sell a
product for an inflated price, whilst the design reformers and critics
have seen the retailer as a brake on the diffusion of better design
(see below in this section). Yet others have criticised the trade's pro-
fessionalism in terms of retail practice.

In 1964, a respected financial report[3] found that 'Retailers tend to

regard themselves as sellers of furniture and seem little concerned with the efficient, economic, and profitable retailing of consumer goods'.[4] More specifically they were criticised for tending to keep too narrow a range, for a lack of merchandising, for cramming all available space with unattractive displays, and for offering long delivery dates.[5] More recent reports have criticised retailers for selling goods in 'an uninteresting way',[6] and because the 'product on offer is frequently unadventurous in design, and of poor quality'.[7]

There is no excuse for poor professionalism in retailing, but it must be borne in mind that the companies' managers and buyers have a responsibility to the shareholders and staff to make a profit. If experience has shown that a certain item will sell at a reasonable rate of stock turn, it will be stocked: if experimental goods are having to be cleared at cost or below in sales there is little incentive in restocking them. This is not to say that retailers should always play safe, indeed they do not, as not every line can ever be expected to be a 'winner', but they must have a majority of lines that are profitable in order to survive. Often in debates about furniture in the twentieth century, the role of retailer has featured as one of the keys to change: in this chapter this role will be addressed first. An analysis of the structure of the trade and the various organisations and their ways of doing business will follow.

The role of the retailer

The venting of one's anger at the furniture retailer is nothing new. In the nineteenth century, Charles Eastlake asked his readers not to rely on the taste of furniture salesmen. Of the salesman he wrote:

> his business is simply to sell it ... in other words he will praise each article in turn, exactly as he considers your attention is attracted to it with a view to purchase. His principles of selection are based on price and who else buys the item.[8]

Critics have been continuing this mode of attack in various forms ever since. Some have had strong, deeply entrenched feelings about design, including thoughts about the retailer and his attitudes to design which were nothing short of abusive. In 1934, John Gloag, quoted from a radio programme of the late twenties in which an anonymous critic had said 'somebody ought to write a guide called

"How to buy furniture in spite of the salesman"'.[9] This was mild compared to Gloag's own remarks in which he castigated the retail furnisher for his lack of knowledge of design: '[he] is not even passively ignorant of design; he is aggressively ignorant'.[10]

Twenty years later, Michael Farr could write, without tongue in cheek, that 'If there were no retailer, no middlemen between the manufacturer and the public, the design standards of industrial products would undoubtedly improve'.[11] Farr justifies this remark by comparing the retail trade to the architect-led contract furnishing industry, which has no middlemen.[12] Farr seems not to have considered that many parts of the contract trade were based on hard-headed commercial considerations, rather than exciting architect-designed projects.

To back his argument further, Farr reported that when manufacturers were discussing design standards with him they complained that: 'We are entirely in the hands of the retail buyer, [who] constantly demands variety'.[13]

To compensate for this demolition job, Farr generously noted the reasons why post-war retailers embraced pre-war designs. Firstly, it appeared to them that the public did not want modern furniture, the example of Utility had shown that. Secondly, there were financial risks involved in changes that were unproven in an extremely difficult economic situation. Thirdly, a rate of stock-turn of at least 4–5 per annum was required to run profitably, therefore proven selling lines were required.[14] Some forty years later the last two factors still remain relevant to retailers' purchasing decisions.

Similar criticisms about the retailer and his impact on design were made of the American trade. George Nelson, writing about 'The Furniture Industry' in *Fortune* (1947), thought that 'The retailer is the man who stands between the progressive manufacturer and the public'. Nelson then criticises the manufacturer for falling in with this. The tone then becomes even more derogatory when he considers 'this is unfortunate, because the incompetence of the average retailer in matters of design is breath-taking.' Ultimately though, he comes to the same conclusion as many other commentators; the lack of education of the public is the main draw-back to further developments: 'The real difficulty of the consumer lies in the absence of an accepted series of value standards on which he can base his judgements.'[15]

Two conflicting views of the trade, one from outside and one

from inside, show how wide the gap was between them. Whilst Nikolaus Pevsner indicated that 'many of the shopkeepers realize the bad taste of their cheap goods'[16] but, by inference, were happy to go on selling them, Gordon Russell suggested that the retailer's responsibility as far as design was concerned was to introduce new ideas to the public. This was not to be at the expense of profitable 'bread and butter' lines, but with an enthusiasm for feeding the constantly-changing public taste. In addition, Russell considered that the retailer was required to have buyers who were aware and enthusiastic for contemporary lines, that the goods should be displayed in their context, and thirdly that the sales staff needed the education to enthuse.[17] Yet again it seems as if public education was the only way forward for improvements in design.

> Something was badly needed to jolt people out of the acceptance of the dreary furnishing conventions which have gripped the public for so many years. Once people find out, and see for themselves, different ways of composing their home surroundings, the trade will no longer be able to impose its slovenly standards on them.[18]

Of course, some retailers were aware of the commercial benefits of good display, trained staff, and a variety of merchandise. In 1949, Sir Ralph Perring made a valid point when he said 'that the furniture trade is one of the few retail trades in which there is no counter'.[19] Although this definition may be less valid in the 1990s, the sentiment behind it still seems applicable. Perring meant that the true furniture seller takes on the role of adviser rather than an order-taker, and it is this distinction that still separates the home furnishings expert from the furniture trader.

Others were quick to discuss the problem of the retailer's role. In 1948 the trade magazine, *Furnishing*, had a lively debate undertaken in its letter columns.[20] Needless to say, the arguments centred on a number of features. The first was the difficult role of the buyer who had to satisfy two masters, the profit-related employer and the design-related customer; secondly, it was argued that it was the responsibility of the customer to be selective and this would only be learnt through education; thirdly, why should there be a dictation of design by a few pundits who were not in touch with the grass-roots of public taste?

The example of Richard Hoggart's description of the duping of

the working classes through the skills of a salesman, who approached in a friendly and homely manner, particularly in areas where they have little or no experience, is worth quoting as it not only illustrates the physical details of some post-war stores, but also comments on the psychological problems sometimes associated with furniture buying:

> The louder furniture stores are of unusual interest, especially because of an apparent paradox. At first glance these are surely the most hideously tasteless of all modern shops. Every known value in decoration has been discarded: there is no evident design or pattern; the colours fight with one another; anything new is thrown in simply because it is new. There is strip-lighting together with imitation chandelier lighting; plastics, wood, and glass are all glued and stuck and blown together; notice after notice winks, glows or blushes luminously. Hardly a homely setting. Nor do the superficially elegant men who stand inside the doorway, and alternately tuck their hankies up their cuffs or adjust their ties, appear to belong to 'us'. They are not meant to. With their neat clothing, shiny though cheap, shoes, well creamed hair and ready smiles they are meant (like the equally harassed but flashier motor-salesmen) to represent an ethos. One buys the suggestion of education and elegance with the furniture.[21]

The other aspect of the equation was that in many cases, customers' decisions about what to buy were based on an item taking the fancy immediately it was seen, rather than any process of careful comparative shopping.[22] When the customer was ignorant of what choices were available this was often the easiest decision. In addition, the store with the most favourable terms would often receive the order. The *Financial Times* (1954) appears to have recognised this when it suggested that 'It can now almost be said that in furniture retailing a good hire-purchase organisation is as – or more – important than a wide range of designs'.[23]

Hoggart's descriptions above reflected a widespread suspicion of the trade, its products, and its methods. The reputation of the trade was clearly in jeopardy at this time so it is no surprise that the retail furniture trade association published its own guide-lines for its members. The trade association,[24] supported by many of the well-known retail businesses, encouraged high standards of shop-keeping, customer service, manufacturer relations and staff training and education. The association introduced the National Furnishing Diploma, which was awarded to students who had successfully completed a

rigorous part-time training scheme in all aspects of home furnishings and their retailing. An indication of how seriously they took their role as furniture retailers is clear from the following:

> The retailers function therefore includes guiding public demand and this is a privilege which he should jealously guard. As soon as he delegates to others – whether to journalists or to national advertisers of branded products – the task of determining what is to be bought, he has handed over one of his most creative and rewarding functions.[25]

The lack of attention that some furniture retailers paid to these basics, resulted in the decline of once well-established stores as they ceased to function as true house furnishers. Various companies had the same furniture, the same advertisements, and the same approach to selling credit, rather than service. Most importantly, 'they fell down on the job of watching a changing population and economy'.[26]

There were isolated examples of the wider and positive contributions that a retailer could make. One such example could be found in an exhibition at the London Bedding Centre, which made a case for standardised dimensions for bedroom storage. It was worthy of comment by *Design* magazine, who said with a degree of surprise, that: 'It is equally strange that the stimulus, should come from a retailer, for the view has been widely canvassed that the standard of British furniture design would be a good deal higher if it were not for the resistance of store buyers.'[27]

The distinction between the cheap stores who sell credit terms rather than design, and those better-class stores who sell environment continues. In the former they ask the customer how much can they afford to put down as a first instalment and then show a range that fits that price bracket. These are the ranges that are often subject to cosmetic changes each season, so that the store looks as if it has something new.

On the other hand, companies who sell furnishings for an environment, point to 'the continuity and stability in co-related groups [that] is the antithesis of irresponsibly created obsolescence'. More importantly they say that, 'we have never considered ourselves in the furniture business because what we sell is environment not furniture'.[28]

This home environment issue was not only considered in the United States. T. Fry, one-time central furniture buyer for the John

Lewis Partnership, remarked that: 'Once we have really grasped the idea that we are selling home atmosphere – not factory processed lumps of wood or plastic – our share of the total consumer market will begin to get larger.'[29] He emphasised the need to 'sell the sizzle even more than the steak', and suggested that a combination of quality display and 'stockiness' would assist in this development.[30] The role of the retailer was to provide inspiration, and the development of co-ordinated furnishing packages, often, it must be said, originated by the manufacturers, showed how successful this could be.

This idea developed in other store groups and many were to follow suit and create individual room settings. In the period 1960–70, these ideas were innovative: nowadays, there are many businesses attempting to sell lifestyle or environment rather than just a product. The co-ordinated look is inescapable whether it be in a mail-order catalogue or a fashionable store. The visualisations go as far as selling houses complete with ready decorated and furnished interiors, landscaped gardens, in fact a complete way of life and its environment.

Despite these changes, by the 1980s the polarity between the design establishment and the trade had not moved much and it seemed as if little had been learned on either side. A report prepared by the Design Council concluded that:

> In spite of the shrinking numbers, there has been a rapid increase in the strength and power of the retailers as arbiters of public taste during the last few years, with more and more of them initiating products themselves. This together with their advertising muscle, *could* allow them a substantial influence in terms of design and quality. What seems to be happening however, and particularly at the lower end of the market, is that the initiation takes the form of global sourcing of cheap copies of existing products.[31]

The role of the retailer as an arbiter of design was yet again being posited. But even the guru of 'good design', Terence Conran, was clear as to the retail role. In the early 1980s he pointed out that

> as retailers we are not educators, it is not our responsibility to increase design awareness or put on design exhibitions. There would be more successful modern design if there was a greater demand from the buying public and that would happen with better education'.[32]

Despite the common sense of Conran's argument, over one hundred years after Eastlake, the knocking was still going on. In 1989 it was

said that 'British furniture and product designers are unanimous that the problem with British furniture begins with myopic reactionary retailers'.[33]

Organisation and structure of the trade

Like the manufacturing industry, the retail trade is made up from a disparate variety of enterprises. These have ranged from the 'largest furnishing store in the world' (Maples) to the once-only fly-by-night three-piece suite 'sales' held in local halls. Of course, many trustworthy and respectable names have been associated with furniture retailing and some high street names have been familiar to many over the century.

To prepare a satisfactory analysis of the infrastructure of furniture retailing, it has been necessary to divide the trade into store types, as follows: Specialist furnishing retailers; Concept stores; Multiple furniture stores; Superstores; Others including department stores and Co-operative stores.

Before discussing these businesses and their various roles, it is worth recognising that the variety of store types is related to the segmented nature of the market. One interesting analysis of store types made in 1955 demonstrates this. The top range store catered for the upper middle class and offered no hire purchase whilst displaying mostly reproduction designs with nothing contemporary. Second was the specialist store type supplying interior design services, antiques, Persian carpets and contemporary design to the middle and upper classes. Here again the payment was all cash. It was in these sorts of stores that parents, continuing a nineteenth-century tradition, often bought all the furnishings for newly weds. Next was the department store, with its middle-class trade and credit accounts. The department stores claimed that their customers preferred flashy, brightly-polished furniture and anything with a novel design. This type was followed by the multiple store businesses having a mix of clientele, but with nearly all the transactions financed by hire purchase. Interestingly, stores catering for the lower middle class and working class, claimed that their customers were interested in appearance and were appreciative of modern simple furniture.[34]

The fact that as stores supplied particular class groups they had

an influence on the purchasing decisions has been noticed by other writers. Penny Sparke (1982) has said that: 'class differences are the basis of the marketing decisions which determine the nature of the furniture that retailers supply'.[35] It is after all only common sense that a store established in a working-class district will supply goods that are immediately identifiable and acceptable to those customers in that area. What has become evident in the last few decades is the fact that the most successful retailer of home furnishings in the last quarter of the century – IKEA – has had a marketing approach that is categorically democratic. By providing well-designed furniture at low prices whilst at the same time providing good value merchandise, they have become the biggest furniture retailers in the world (see further below).

Specialist furnishing retailers

Under this heading can be found businesses that still make their own furniture, offer a full service of furnishings and repairs, as well as being able to meet all the demands of a customer's home furnishing requirements. Often these stores had only one branch but were known throughout the design world. Dunns of Bromley, Heals of Tottenham Court Road, Bowmans of Camden Town are names that feature in the pages of architectural and design magazines. Often these stores have been in the vanguard of the promotion of 'good design'. The impact of their influence has often been wider than their size would indicate. Importantly these businesses have often been run by later generations of the founding family so there was a sense of service as well as a pleasure in the business. Others were well known in the county localities they served. Interestingly, many of these stores have promoted European and American designed products and have remained elitist to a degree. The fate of these stores has been variable. Due to the high costs of supplying the services that are associated with this business, many have been forced to close; some have been through changes of ownership, while others still remain as family-run businesses. Their survival has been based on moves to up-market trading which often combine interior decoration and contract work. They maintain exclusivity and interest by careful merchandise selection and co-ordination, but above all they continue to offer a personal service.[36]

29 Habitat upholstery group in Swedish pine with cotton covers, 1989

Concept stores

Under this heading can be found stores such as Habitat, Next Interiors, Laura Ashley or in the United States, Ralph Lauren, or the Ethan Allen chain. These businesses ideally operate in a niche market that they have established for themselves.

The stores usually operate in a fairly narrow band of customer profiles and in terms of industry penetration they are not large. However, the notion of being the right business, providing the right goods, for the right time is clearly part of their success. By selling a 'package' and a wide choice of services, they became a success story. The sustaining of this success has been more problematic. Habitat, for example, were acknowledged masters in creating an atmosphere

30 A sophisticated interior image projected by Habitat for their 1989 catalogue cover. Compare with more homely pine furniture

in-store that appealed to middle-class younger customers who were able to purchase a form of instant 'good taste'. The chain was successful to the extent that they had over fifty branches. However, by the late 1980s the business had begun to lose its appeal and was being challenged on many sides by newer concepts. In 1992 it was purchased by an erstwhile rival, IKEA.

Multiples

At the turn of the century and until World War I, the retail furniture trade was firmly in the hands of the small-scale or independent retailer. Whilst the department stores in the large towns, and the Co-operative retail societies, sold some furniture, practically nine-tenths of the total sales were undertaken by the independent trader. The only multiple organisations of any significance were Jacksons Stores Ltd, the Warwickshire Furniture Co. Ltd, and Smart Brothers, all totalling only some one hundred branches in all.

It was the years between the wars that saw the rapid development of multiple shop trading and the estimated increase was from under

31 An interior view of Courts Bros furnishing showroom at Folkestone, *c.* 1948

two hundred branches in 1920 to around eight hundred in 1939, a fourfold increase. The value of sales by the multiples in the total furniture and furnishings market also rose more than fourfold from about 4 per cent in 1920 to about 18–20 per cent in 1939 – a pattern that reflected the growing purchasing power of a new group of consumers.[37]

The field of popular retailing, boosted as it was by the growing need to furnish urban homes, meant that there were opportunities for rapid growth. An example was the Times Furniture Company, founded by John Jacobs in the last quarter of the nineteenth century (*c.* 1880) which was one of the first specialist multiple furnishing businesses. The company were also one of the first to use instalment payments as a natural way to buy furniture. In the 1920s they published a guide to their business for potential customers which offers a fascinating insight into trading methods. The inducements used to promote the Times service over other retailers were very varied. Some are recognisable today, whilst others have been long forgotten. For example, customers were strongly advised not to be

guided by credit terms alone, but rather to study them in relation to the quality of the furniture being supplied. However, incentives were often connected to the credit terms, as, for example, a scheme of free insurance to cover eventualities such as death, fire, and misfortune. Other 'free' services were the storage of purchased goods until required, and the fitting of carpets and linoleum if bought with furniture. Customers from out of town were even reimbursed with rail fares if they spent over £20 on goods from the store. But perhaps the most significant of all was the Times's policy of a guarantee for all goods purchased. The 'Green Disc' guarantee was against 'fault in material or workmanship for all time'.[38] Surely a scheme that had very strong customer appeal, especially when much furniture was considered to be 'cheap and nasty'.

World War II saw few changes in the structure of the trade, but the outstanding feature was the emergence, through purchases and amalgamations, of one very large and well-known firm, which, at the end of the war, controlled over two-thirds of all the multiple shop branches in the trade.[39] The post-war period, once the immediate shortages had passed, had been a period of boom for all types of retailers in the trade, though again there is some evidence to suggest that the multiples further increased their share of the trade; in 1954 they undertook some 26–28 per cent, while department stores were responsible for about 16 per cent and the Co-operative societies for 7–8 per cent, leaving the independent retailer with about 50 per cent of the trade.

The advantage of size in multiple trading in the furniture trade was mainly due to strong hire purchase financing, the economics of administration from a central head office, and influential purchasing power with manufacturers. In the case of privately-run multiple groups, such as Cantors, Times or Perrings, the power of individual directors, many of whom were second generation family, was often a potent driving force in these companies.[40]

In the 1980s further amalgamations and closures changed the multiples into even larger groups like Waring and Gillow (with 100 retail outlets in 1987), Harris-Queensway, and Maples.[41] The power of some of these groups can be seen in the example of Harris-Queensway who at the height of the 1980s boom controlled over seven hundred and fifty outlets, controlling an estimated 13 per cent of the domestic furniture market.[42]

Other multiple store types have been interested in entering the market, especially in the middle segment. The successful entrance of Marks and Spencer into full furniture retailing is one example, whereas Argos's attempt at an up-market furnishings group – Chestermans – was an economic failure.[43]

Credit selling

Much of the success of the multiples has been based on their use of credit selling which was made respectable during the century. The euphemism 'furnishing out of income' was no doubt intended to appeal to the sensibilities of the middle classes. The intense competition between retailers in this sector and the way some businesses sought trade, 'by advertising that they do not seek references, that no deposit is required and even that no payment need be made until thirty days have elapsed' caused some consternation. The fear was expressed that 'it may lead to furnishing by improvident people, increase the bad debts on the part of the firms concerned, and consequent prejudice to the genuine buyer of furniture'.[44]

Early in the century, the use of credit to finance home furnishings was seen by one writer as a degenerate step. Sparrow considered that:

> Thrift was looked upon as a foe to business: and we are now beginning to see that an over-stimulated demand in trade weakens the national character and begets an unrest of mind without will-power.[45]

Some firms seem to have relinquished the responsibility for selling furniture in a proper manner, as they became more interested in money-lending. The deposit and the weekly payment became more important than the goods, and this approach to retailing certainly encouraged the concentration on price that still persists in some parts of the trade. Furthermore, some practices associated with credit selling increased the low public opinion of parts of the trade. Indeed, at various times during the century legislation had to be introduced to curb dubious practices such as the 'snatch back' of goods if payments were not kept up. Apparently, even legislation such as the 1939 Hire Purchase Act did not cover such activities as the substitution or switching of goods seen by the customer in the showroom, for inferior ones from a stock. In addition to this, retailers were castigated for varying the mark-up on credit sales according to the

customer, as well as putting on a mark-up far in excess of the normal profit margin.[46]

Despite these criticisms, many multiples ran satisfactory credit schemes and it was through the benefits of hire purchase financing that growth really came. The public confidence in hire purchase was clearly a great incentive for other retail sectors to introduce it with vigour, and in the post-war era hire purchase was part of every retailer's sales repertoire. The days when hire purchase was looked down upon, and 'delivery in a plain van' was necessary, rapidly passed after the war.

However, the benefits of hire purchase were sometimes checked by circumstances beyond the control of the trade. In 1964 it was noted that:

> the importance of credit trading, together with the fact that furniture purchases tend to be of a capital nature, have made this a trade vulnerable to government credit policy and to the general economic outlook. Perhaps the most important factor which triggers off the consumer purchasing decision is the amount of cash deposit, and the monthly repayments required on furniture.[47]

This factor, along with the growing cost of financing hire purchase trade, has led many retailers to contract out their credit business, and the proportion of hire purchase trade financed by the stores has gradually gone down. This is not to say that credit is not used to finance furniture purchases, rather that the finance comes from other sources often in the form of a personal loan.[48]

Superstores

The nature of the trade in the 1960s was delineated by three clear factors that were to spawn another retailing style. The first was long delivery times for customers. They had to wait due to the high cost of stock holding, the batch production of cabinet furniture, and the custom upholstering business. Secondly, floor areas in stores were often small and therefore this discouraged room-setting merchandising methods, as well as offering a small selection. Thirdly, there was relatively little price competition, partly due to resale price maintenance.

The 'out of town' discount stores which developed in the 1960s began by offering warehouse prices and limited service. They

originally reduced prices by up to 20 per cent but this differential with the high street was gradually narrowed. Their operating expenses were lower, display areas were greater and car parking facilities encouraged visits from the public, so they seemed set for success. In addition some stores were able to offer delivery from stock. The example of Queensway which started business selling mainly end-of-lines in 1966, is instructive. After the abolition of resale price maintenance they moved away from selling ends of ranges and odds and ends, and began to sell well-known names from stock at reduced prices.[49]

More recently the MFI flat-pack discount-selling method has been very successful. Combined with 'brand names' such as Schreiber and Hygena they show massive discounts off the prices of these well-known furniture brands. MFI, which specialised initially in self-assembly furniture, saw phenomenal growth as sales rose between 1977 and 1987 from £15 million to £334 million. The attitude of the MFI company towards design in 1986 was clear in their response to questioning. The company did not have a creative design team, rather they said 'We want to reach the British buying public. We want to make products at prices they are prepared to pay'.[50]

By the early 1970s the idea of furniture superstores was well established in the United States and was becoming a force in Britain. The concepts were different in each country. In the United States, the warehouse, which in one example boasted 246 'show-rooms', was able to offer customers instant delivery of anything from a range of 52,000 items. Alternatively a slightly higher price would buy the same product delivered, assembled, and fitted into the home.[51]

In Britain, the operations tended to be on a much smaller scale and more price conscious. Rarely having co-ordinated displays, these warehouses were based on self-selection but company delivery. At one time, Queensway Warehouses operated self-service purchase cards which were attached to goods. Customers then filled in their details and waited for the store to arrange delivery.

By the mid-1980s, the no-frills approach was disappearing into a more sophisticated marketing set-up. Following the lead of the American retailers, and the more innovative British furnishers, these warehouse operations moved up-market by displaying merchandise in 'vignettes' which allowed them to expand the product range to include soft furnishings and accessories. Although much emphasis

remains on price and credit terms, co-ordinated style is now a major ingredient of success.

Furniture supermarkets, where the ethos was to 'pile them high and sell them cheap' were also developed in the 1960s. The idea was to create a high turnover which would allow bulk buying. This in turn would reduce unit costs and allow cheaper retail prices. Needless to say the level of service would also be reduced. An example of this approach was the Williams Furniture Supermarket Group, which operated a massive central warehouse servicing the twenty-seven stores in the south-east of England. The furniture was not discounted in the sense of reductions on branded goods with maintained resale prices; rather it was purchased in bulk to gain savings in costs. The emphasis was always on price rather than quality or service.

The success of the superstores was also bolstered by the flat-pack cabinet business, which enables instant gratification for the customer. Flat-pack furniture was often cheap and usually of good value, achieved by placing large orders with companies who specialised in one or two lines. In addition, the retail buyers were acutely aware of the new generation of customers who were more fashion conscious but at the same time wanted to emulate high-style furnishings. This was particularly apparent in upholstery styles and cover designs.

The most successful multiple superstore operation is perhaps the IKEA company. Originating in Sweden in the 1950s and taking the decision to concentrate on self-assembly furniture, they have grown to become a world-wide retailing force. They are selling Scandinavian design, which may be manufactured in Scandinavia or Eastern Europe of elsewhere, through catalogues and showrooms. Indeed the main promotional tool is the catalogue, of which some 44 million are printed each year in ten different languages. Working from the premise that the company can make 'a valuable contribution to the democratization process at home and abroad',[52] they aim to offer value for money, on the basis that what is good for the customer is good for the company. In 1993 the company operated 111 stores in twenty-four countries, including five in Britain. With 20,000 employees and world-wide sales of £2.2 billion, IKEA is the world's largest furniture retailer. A long way from the 'pile it high' warehouse concept, IKEA produces classless furnishings which are supposed to appeal to all customer profiles. The selection of furnishings is enormous, ranging from the basic essentials to reasonable copies of

fashionable ideas. This seems to compare with the fashion trade who produce copies of *haute couture* and sell them in the high street.

The third development in the superstore category has been the expansion of the DIY businesses into furniture. The Texas and B&Q companies are the market leaders in the United Kingdom. Originally starting out as comprehensive and accessible builders' merchants and DIY suppliers, they soon moved into self-assembly furniture, kitchens and bathrooms. The DIY stores have entered the full furniture market at the lower levels, as the once-lower strata trade up to another level of business.

Although Texas say they aim for co-ordinated ranges to achieve their design ideas, the competition was clearly a source of ideas. The furniture buyer said they 'go into the market place and look around at what the competition is doing; I always like looking at IKEA's catalogue.'[53] Whilst some commentators see the success of IKEA and the like as the 'triumph of the proles over the middle order',[54] it is clear that traditional retailers have been able to hold much of their original market. By introducing their own brands or house lines, banding together as buying groups, or trading up into more exclusive merchandise or offering more services, they seem set to retain their niche.[55]

Other store types

The department store has always been associated with one-stop town centre shopping built around the twin themes of fashion and the home. The early involvement in furnishings can be seen in the catalogues of the later nineteenth-century stores, and since then the department stores have maintained furniture sections. The emphasis has often been on selling branded goods at the middle to upper price ranges, but in more recent years own brands have become more important. The various store groups such as the House of Fraser, John Lewis Partnership, Sears, and others now wield considerable buying power, but their image is still unexciting.

The development of the Co-operative store system during the period 1880–1920 was phenomenal. In 1881 there were 971 societies and by 1903 this number had risen to 1,455. Membership rose from 350,000 in 1873 to 2,878,000 in 1913. This store group is something of a special case as the Co-operative societies were often supplied with furniture made by the factories of the wholesale division.

Obviously not all stores dealt in furniture but an indication of the size of the trade in furniture can be found in the growth of the furniture factories within the wholesale section of the organisation. The CWS established factories in Broughton 1893, Pelaw in Newcastle in 1903, Bristol in 1919, and Birmingham in 1920.[56] Although in 1964 some 380 stores produced £17 million turnover, in recent years the importance of the Co-operative Society has waned.[57] Once considered as the 'sleeping giant' of retailing, they still have a following.

A number of other sub-categories of retailer have entered the furniture market at various times. These have often taken the form of weekly payment clubs either by mail order or by canvassing. In the late 1930s the so-called 'club trade' which dealt especially in fireside and adjustable chairs began to be another channel of distribution. The clubs were run by middlemen who dealt with procured orders from catalogues supplied to salespeople. The idea was for customers to pay a shilling a week for twenty weeks. On receipt of the first payment the club notified the contracting chair-maker who then arranged to dispatch the chair. As Mayes points out:

This trade had an effect on Wycombe's reputation. Out of one pound there had to be found the costs of advertising and commission, the normal overheads and profits of the club firms plus a generous allowance for bad debts, and what was left was available for paying the manufacturer for the chair.[58]

Clearly there was little left to produce a quality item.

Another example of distribution was through catalogues. These took the form of true mail-order companies with one thousand pages of 'everything for the home' to the specialist dealers selling one or a few items. Although these avenues have not seriously usurped more regular retailing processes they have become more of a force. In 1986, 7 per cent of furniture sales were made by mail order.[59] These figures perhaps indicate the customers' reliance on weekly payment schemes even above seeing the goods before purchasing.

In terms of the economics of furniture retailing, one of the most serious problems was the loss of important markets to other trades. This process is clearly evident in the example of the fitted kitchen furniture business, and in some cases the fitted bedroom business and other types of built-in work. The most recent example of a non-traditional furniture retailer entering the market is the successful

intervention of Marks and Spencer. Effective marketing based on niche establishment and the trading upon an established brand name, combined with proficient purchasing, has meant that Marks and Spencer have become serious competition for the middle to upper market.

The specialisation of aspects of the furniture market should not be surprising and the other major market that was gradually eroded was the contract furnishing business. According to Leslie Julius (1967):

> Retailers opposed the manufacturers in exploring and opening up the modern contract furniture market and then, when this was created, tried, naturally enough and using every trick in the book, to pull the trade back entirely to themselves. They failed.[60]

As the various product ranges become more specialised on the one hand, and more co-ordinated on the other, retailers will have to re-evaluate their role. As customers finally begin to become more educated and discriminating, retailers will have to gain and maintain a reputation for quality and service within their own sphere of influence.

Notes

1 L. Julius, 'The Furniture Industry', *Journal of the Royal Society of Arts* (May 1967), p. 443.
2 The Greater London Enterprise Board (GLEB) report, *Turning the Tables: Towards a Strategy for the London Furniture Industry* (1985), suggested that obstacles to change, included the power of the retailer due to concentration of ownership, often combined with a buying strategy using exclusive retailer manufacturers relations.
3 Economist Intelligence Unit, *Retail Business* (November 1964).
4 Compare with similar remarks related to manufacturers in the industry section.
5 Economist Intelligence Unit, *Retail Business* (November 1964), p. 17.
6 R. Kelehar, 'Furniture starts to polish up its act', *Marketing Week* (19 August 1988), p. 38.
7 Design Council, *Key Themes in the UK Furniture Industry* (n.d., c. 1990).
8 C. Eastlake, *Hints on Household Taste* (London, 1872).
9 J. Gloag, *English Furniture* (London, A & C Black [1934], 1952), p. 166.
10 *Ibid.*, p. 156.
11 M. Farr, *Design in British Industry* (Cambridge, Cambridge University Press, 1955), p. 151.
12 *Ibid.*, p. 152.
13 *Ibid.*, p. 11.
14 *Ibid.*, p. 153.

15 G. Nelson, 'The Furniture Industry', *Fortune* (1947).
16 N. Pevsner, *An Enquiry into Industrial Art in England* (Cambridge, Cambridge University Press, 1937), p. 38.
17 Russell in M. Sheridan (ed.), *The Furnisher's Encyclopaedia* (London, 1955), pp. 202–3.
18 C. G. Tomrley, *Furnishing Your Home* (London, 1940), p. 198.
19 R. Perring, 'Retail Distribution – Popular', CoID, *Report of a Conference on Furniture Design* (RIBA, 1949), p. 147.
20 *Furnishing* magazine, 4:56 (1948), p. 235.
21 R. Hoggart, *The Uses of Literacy* (Harmondsworth, Penguin, 1957), p. 90.
22 Associated Rediffusion, *London Profiles No. 14, Women and Furniture* (London 1962/3), p. 16.
23 *Financial Times*, 31 December 1954.
24 National Association of Retail Furnishers.
25 National Association of Retail Furnishers Report of NARF sub-committee on 'Better Retailing', A Guide for Furnishers, n.d., *c.* 1966.
26 S. H. Slom, *Profitable Furniture Retailing* (New York, 1967), p. 19.
27 *Design* (February 1964), p. 19.
28 Ethan Allen line by the Baumritter Corp., 'The Furniture Industry in Transition', *Industrial Design* (May 1967), p. 32.
29 T. Fry in Council of Industrial Design, *Selling Modern Furniture* (1971).
30 *Ibid.*
31 *Report to the Design Council on the Design of British Consumer Goods* (London, 1983), p. 29.
32 B. Phillips, *Conran and the Habitat Story* (1984), p. 144.
33 J. Woudhuysen, *Blueprint* (May 1989), p. 46.
34 D. Chapman, *The Home and Social Status* (London, 1955), pp. 44–5.
35 P. Sparke, *Did Britain Make It? British Design in Context 1946–1986* (London, Design Council, 1982).
36 See Hugh Joscelyne, 'Has the retailers job really changed?', *Cabinet Maker* (19 September 1980).
37 J. B. Jeffreys, *Retail Trading in Britain 1850–1950* (Cambridge, 1954).
38 *Times Furnishing Company* brochure, n.d. (*c.* 1935).
39 In 1955 Great Universal Stores controlled Cavendish, Jay and Campbell, Jacksons, British and Colonial furniture, Smart Brothers, Godfrey, James Broderick. Also Manufacturers, Universal Furn. Productions, Gill and Reigate, Joseph Johnstone, Northern Bedding, Tyne Furniture, Tyne Plywood.
40 Multiple groups have included: Cantors, Cavendish-Woodhouse, Colliers, Courts, Grange, Hardys, Harrison Gibson, Jacksons, Kentons, Maples, New Day, Phillips, Smart Brothers, Times, Williams, Perrings.
41 H. Barty-King, *Maples, Fine Furnishers* (London, Quiller, 1992). In 1980 Waring and Gillow took over Maples. Manny Cussins group then comprised Waring and Gillow, Harrison Gibson, Wolfe and Hollander, John Peters Furnishing Stores, 42 in all. In January 1987 they absorbed Wades, Kingsbury and Homestore, making them the fourth largest retailer of furniture with 150 branches. In 1989, the company divided between Allied Maples and Gillow plc (Saxon Hawk plc).
42 Alice Rawsthorn, 'Awakening may be rude for some', *Financial Times*, 19 April 1988.
43 *Cabinet Maker* (28 February 1992 and March 1993).

44 London School of Economics, *The New Survey of London Life and Labour* (1931), p. 216.

45 S. W. Sparrow, *Hints on House Furnishing* (1909), p. 30.

46 Tomrley, *furnishing Your Home*, p. 203.

47 EIU, *Retail Business* (1964), p. 18.

48 In a hire purchase transaction, the title to the goods remains the property of the seller until they are paid for. In a credit sale the ownership passes immediately to the buyer.

49 C. Fulop and T. March, 'The effects of the abolition of resale price maintenance in two Trades', *European Journal of Marketing*, 13:7 (1979), p. 235, consider that the abolition of RPM has resulted in radical changes in the marketing of furniture, the most important being the 'out of town' store.

50 R. Brown, 'The Furniture Oligarchy', *Design*, 449 (May 1986), pp. 44–7.

51 The example quoted is from the United States: Wickes Furniture Warehouse and Showroom, *c.* 1972.

52 IKEA company internal training manual.

53 Brown, 'The Furniture Oligarchy'.

54 H. Pearman, *Sunday Times*, 1 November 1992.

55 Buying Groups. The Good Furnishing Group in 1953 included Dunn & Sons Ltd, David Elder Ltd, Findlater Smith Ltd, P. E. Gane Ltd, Hemmings Bros. (Nottingham) Ltd, Holmes The Furnishers Ltd, Lee Longland & Co. Ltd and York Tenn (Farr, *Design in British Industry*, p. 307). More recent groups include the Green Group, and Floreat.

56 W. H. Fraser, *The Coming of the Mass Market 1850–1914* (London, 1981), p. 124.

57 This accounted for approximately 6 per cent of total furniture sales. Since 1961 the percentage of total market share has fallen from 9 per cent to 4 per cent. See the Economist Intelligence Unit 1964 report and the Office of Fair Trading Report.

58 L. J. Mayes, *The History of Chairmaking in High Wycombe* (London, Routledge, 1960).

59 Office of Fair Trading, *Report on Furniture and Carpets* (1990).

60 Julius, 'The Furniture Industry', p. 443.

6 Patterns of consumption

Introduction

The final result of the economic process of furniture production and distribution is the consumption of the products of the industry by home-makers. There has been much research recently into what constitutes a 'home' but as this work is concentrating on furniture, this research will only be referred to in passing. Although the century has seen furniture become an important but undervalued (by consumers) part of home furnishings, the consumption patterns of furniture have developed gradually over the century. In the early part of the century there were many examples of first-time furniture buyers entering the market, who were benefiting from improved housing and an improved economic situation. These people required furniture as a basic proposition. By the mid-century a second and third generation were furnishing homes and they demanded more than just the essentials: objects were now selected not simply for utilitarian purposes but also as symbols of home. Even these consumers had difficulties with choice, as many people were still inexperienced in the purchase of a major product.

It was in an attempt to assist these people, and at the same time to try to establish an image of 'good furnishing', that consumer advice proliferated. It had been a feature of the nineteenth century, but during the twentieth century the concerted efforts of organised groups to spread a particular type of furnishing was far more pernicious than the lady-like publications produced for middle-class Victorian homes.

The difficulty for many of these advisers was that they did not understand the needs of the new generation of home-makers. The expectations of many consumers did not coincide with the notions of fitness of purpose, truth to materials and simple elegance that many advisers suggested. Furniture had a different role in these homes.

32 The market for furniture demanded choice. Habitat offered a range of sofa-beds, sofas and chairs which were supplied with a paper pattern so customers could make their own covers, 1989.

Historically, furniture over and above the strictly utilitarian has always been a mark of one's position in a social hierarchy. It was no different for the middle and lower status groups of the twentieth century. It is therefore no surprise to find that there was a demand for furniture that emulated past styles, and by inference, conferred some respectability on the owners. The three-piece suite, which had originated in the nineteenth century, played the same role.[1]

There was a gradual move away from the historical bias and this became apparent during the late 1950s and early 1960s. A number of variables came together to encourage an enlargement of the pluralist approach to furniture which allowed for a growing range of tastes that retailers recognised as market niches. These factors included a marriage bulge of a post-war generation, an increase in housing completions, the growth of conspicuous spending, and a rise in replacement demand. In conjunction with these consumption factors were better marketing, a wider range of designs, and the introduction of new types of furniture.

These changes promoted segmentation of the market place and further encouraged home owners to choose furniture that

demonstrated their status and lifestyle. Whilst this choice included reproductions (which have continued in popularity) there were other possibilities. The so-called Contemporary furniture met the growing demand of a younger furnishing generation who constituted a wide band of purchasers. In a more limited segment, developments including pop, had a passing effect on modern post-war furniture design and consumption, but whilst much of the buying public indulged in design fads for some furniture types, other types remained fairly constant.[2]

The social changes that have occurred in the past century have been immense, and whilst the interest in the home and interiors has grown just as rapidly, the furniture industry has often been criticised for not engaging with these changes. As recently as 1989 it was said that 'Behind the dilatory nature of British furniture retailing, however, lies the unwillingness of manufacturers to capitalise on the social dynamics of the British interior'.[3] These social dynamics are in part the history of changing attitudes to homes and their furnishing.

The rise of the popular market 1900–25

The period of growth between 1900 and 1925 saw the beginnings of choice for a population which had previously been unable to significantly enter the market. These changes were brought about by buyers who were able to afford new furniture, planned housing programmes which encouraged new furnishing purchases, and a rise in disposable income, leading to design differentiation and emulation, which in turn led to greater expectations and a demand for choice. In conjunction with these factors there was a growth in the scope and influence of the media which encouraged an interest in all aspects of the home. The impact of these changes on the industry were noted by *The Times* in 1920:

> Without doubt the greatly increased spending power of the industrial classes has had a direct effect on the furniture trade. The newspapers have played an important part in educating the people in domestic art, and even the lower middle-classes today furnish with intelligence and good taste. All this is good for the trade, because it encourages the designer and craftsmen. Future prospects in the furniture trade are good. The volume of trade is assured, and there are grounds for believing that increased attention will be devoted to the study of domestic art. It may

be said without fear of contradiction that beautiful homes make for a contented people.[4]

The comments on the role of the media in educating the public (as well as earning advertising revenue) and thereby encouraging purchases, and the last phrase of the passage reflect the foresight of Lord Northcliffe and the *Daily Mail*. His instigation of the Ideal Home Exhibition sponsored by the *Daily Mail* was clever, since it not only produced a market place for the nation's furnishers, but also provided advertising revenue for the newspaper. The slogan chosen for the Ideal Home Exhibition, which was a quotation from King George V, made the same point as *The Times* (see above): 'The Foundations of the National Glory are set in the Homes of the People'. The political agenda which encouraged people to become home-makers, and to spend and invest in the home-making process was clearly aimed at providing a bulwark against the social unrest evident in post-World War I Europe.

In this context of the political emphasis on quality homes, the debate concerning the furnishings of the working-class home began to be considered in depth. Immediately after World War I, the Design and Industries Association's Journal aired a number of views about the need to supply 'Good and cheap' furniture. Interestingly, compared to some European designers, the correspondents were aware of the importance of avoiding standardisation, so as to maintain some idea of freedom of choice, whilst at the same time providing good value in furnishings for small homes. Alfred Simon recognised that even the 'poorest living room has some pretension to taste', and considered that in order to improve standards, it was necessary to educate the taste leaders from whom the majority took their lead.[5] This Veblenian idea of the filtering down of styles was agreed with by Baillie Scott, though he considered that the answer to providing good and cheap furniture was firstly not to produce the gaudy and tasteless items that were generally available. Scott suggested that 'as long as people can get cheap and flashy smart-looking things to put in their houses they will choose such things.'[6] The corollary was that whilst the 'commercial system of labour and capital pulling in opposite directions persists, so long will it be impossible to produce good work'.[7] His second point was that the organisation of the industry should be based on some Utopian guild system which was free of

the profit motive. According to Scott, this would then naturally encourage good work. These ideals, rooted as they were in the Arts and Crafts Movement, were a long way from the realities of producing furniture for working-class homes.

It is clear that one of the main problems for consumers of furniture was, and indeed is, that they have little experience of the furniture-buying process during a lifetime. It was partly in response to this that many articles and books were published to help in the process of devising tasteful environments. Throughout the century a range of critics continued the nineteenth-century habit of advising how to furnish your home. Whether it was periodicals such as *The House Beautiful* or *Ideal Home*, books with titles such as *Our homes and how to beautify them*, or even *Make Yourself at Home*, they all had the same aim of assisting in the establishment of comfortably furnished homes. The value of them was sometimes doubted:

> it is true that there is plenty of idealism and scores of pretty furnishing platitudes to be had for a shilling or two, in various art-at-home manuals, but I doubt whether the economical seeker after tasteful furniture is much informed after perusing scores of dreary sentences as to what should constitute the 'House Beautiful'.[8]

However, it seems that the readers of such magazines did not doubt their efficacy, and the illustrated journal and book continued in importance as a home furnishing guide.

In addition to journalists, retailers often published estimates for a variety of room-types and costings that were aimed at assisting the would-be furniture buyer to select the 'proper' items for the various rooms in the home.

The popularity of estimates prepared by retailers as guide-lines for their customers was an important feature of the retail trade during the first third of the twentieth century. An analysis of these estimates shows how there was a consistency of styles that were deemed appropriate to the various rooms within the house across the social scale. They have also shown how the supply of furniture to meet these demands was often based on a selection of high-style objects that were progressively simplified as they descended the scale, so that the image of the style remained identifiable, even if only symbolically. In this way the consumer's tasteful furnishing would be recognised.[9] The dining room was invariably recommended to be

33 A fashionable Maples 'art nouveau' mahogany sideboard, *c.* 1900

furnished with oak, whilst the main bedroom and the hall also had oak as a preferred furniture finish. It was only in the living or drawing room that the choice was between mahogany, the most favoured, and walnut. These estimates and recommendations were used from the late nineteenth century to well into the 1930s, with the same preferences expressed.[10]

The method of purchase was also subject to advice. In one publication from 1909, there was a whole chapter relating to the

'Systems or Methods of Furnishing'. The review began with a deprecation of the hire purchase system. The readers were urged to buy only that which could be afforded outright, as well as to furnish according to their needs, not wants. For Sparrow, the reasons were as much ethical as commercial: not only was it foolish to pay extra for the privilege of spreading payments, but 'purchase without payment dulls self-respect'.[11]

Accordingly, the author suggested the much more satisfactory 'stock system', whereby customers were exhorted to visit a reputable firm, to choose wisely and ask for a discount for cash. Yet again, the warnings were to be wary of buying too much under persuasion. Other systems that were recognised included the 'collector's system' which involved careful scrutiny of the second-hand or antique markets; the craftsmen system whereby articles of furniture are commissioned, and lastly, the 'reproduction method' in which 'you commission a reputable firm to make your furniture in accordance with certain old styles and models'.[12] Sparrow was clearly writing for a middle-class audience, but for the growing working-class demands, forms of credit were to be essential. To overcome the stigma of credit purchase which clearly existed, stores went to some lengths to legitimise the process. The middle-range company, Drages Ltd, used a testimonial by the Countess of Oxford and Asquith to praise the use of hire purchase. In advertising copy it was written that she was 'amazed to think that a man of moderate means can furnish for £100.00 on a payment of only £2.00'.[13]

It was clear that credit encouraged purchases and with the retail trade offering terms over three to four years and often with no deposit, it meant that the vast majority had access to new furnishings. This freedom led to even more vociferous arguments about style and taste in the ensuing years.

Between the wars 1925–40

The continual rise of a suburban culture, influenced in its furnishing tastes by the upper classes, meant that the demand for reproduction antique furniture was high. The evidence of furnishing estimates, mentioned above, clearly shows what people expected particular rooms to look like. It really should be no surprise to find that any

177

design changes that occurred in high-style furniture during this period should remain at best a source to be plundered rather than a new direction. Art Deco was one such style which gave rise to a whole range of images that were very freely adapted to both cabinets and upholstery at all levels. In retrospect, the best efforts of reformers, designers, and architects to impose a particular ethic for furniture were wasted as the consumer appeared happy to take whatever was offered. However, at the time, some thought the day for standardised 'design' was not far off.

Aldous Huxley, writing some Notes on Decoration (1930), concluded that when furnishing, 'people of moderate means' have to choose between 'affectedly refined cottage decoration' or 'the sort of decoration they can buy at the big shops – some of it fairly good (and dear), but most of it either dear and bad, or cheap and bad'. Huxley then cites the example of a third alternative which was available to German home-makers. This was the modern, standardised, utilitarian furniture mainly in metal, which seemed destined to become the 'domestic bliss of all but a very few rich people in the future. The time I am sure is not far off when we shall go for our furniture to the nearest Ford or Morris agent'.[14] In fact standardised utilitarian furniture was just what the majority wanted to avoid as many found that the 'refined cottage decoration' went very well with the Tudorbethan semis that were so common in the 1930s.

Whilst it found some acceptance at an institutional level, the ideal of machine-made democratic furniture was in direct conflict with the cultural values which were being adopted by the British working classes. The attacks on Victorian reproduction design and interiors, effectively attacked the working-class structure; and whilst good modern design could be economic, stylish and functional, and therefore considered suitable for the working class, it ignored the issue of respectability and differentiation within class sub-groups that remained the mainstay of those design choices for many years.

The virulence of some critics towards the taste of others seemed to be unnecessarily harsh. In 1935, L. Yakobson wrote disparagingly of the suite:

> Mental laziness, the lack of independent judgement, these it is that lead to the purchase of complete suites of furniture, and the quasi-individualism of the petit bourgeois triumphs.[15]

34 A Lebus Walnut bedroom suite, demonstrating the use of highly figured veneers

For a generation that had only known the second-hand and the home-spun, the three-piece suite represented the height of respectability and social prestige.

Whilst the standardisation process was clearly perceived as being the most useful for the lowest income groups, the design of products in this class was questioned. In 1937 an exhibition was held by the British Council for Art and Industry, entitled 'Home: Its Furniture and Equipment'. The objects on display included stove-enamelled metal bedsteads, a suite comprising a sideboard, chest of drawers and a table made from oak-veneered plywood, and dining chairs of polished oak wood. Other chairs included unpolished Windsor wheel-back or stick-back chairs and rush-seated chairs. The upholstery was recommended to be small scale and wooden framed rather than fully upholstered. Apart from normal sofas and chairs, bed-settees were shown along with reclining chairs and extending bed-chairs. All very laudable one would have thought. However, one critic commented that:

> Assuming that the exhibition accurately reflects what is to be had at the moment in this, the cheapest end of the mass-production market, it is

35 'Soft inviting curves impart an air of comfort'; advertisement for Waring and Gillow's 'Ashburton' three-piece suite, *c.* 1935

remarkable what a difference there is between the minimum suite (i.e. affordable by families with an income of £3.00 per week) and the other rooms on exhibition furnished up to the (£5 a week income) maximum standard.[16]

It was clear that the cheapest end of the market was least well served and the report recognised this by saying that 'the planning of mass-produced furniture seems to call for fresh study'.

Fresh study did not really interest the industry, as it was thought that the furniture trade's existing products were able to meet a wide variety of demands that covered the whole spectrum of taste. In addition to the minimum standards mentioned above for small flats or houses, it was apparently clear that a Jacobean style was appropriate for residents of 'suburban tudor' semi-detached homes, although the advice was that ease and comfort should come before strict period conformity. For an image of 'taste and distinction', walnut was the recommended finish, whilst those with a feel for the 'modern' could select bedroom or dining suites made from the new range of Empire woods,[17] or even polished metals.

Although the trade was unconcerned with matters of education in design and planning, much consumer advice of the period was often

36 A 1935 interior showing the use of unit furniture, comprising cupboard, bookcase and writing table

trying to direct people away from the large-scale furniture that was available towards things considered more suitable. Indeed the whole question of space-saving kept appearing. The notion was the subject of an article in the *Woman's Journal* of May 1935. It is of more than passing interest as the article makes the point that whilst the general public prefer conservatively designed furniture on the whole, the new smaller homes would benefit greatly from the modern styles of furniture. By modern style was meant the more restrained designs which were well scaled with plain finishes. What is even more revealing though, is the advice given to make furnishing easier:

> It is so much easier to make out a list of furniture, say, for the dining room, copied from the dining rooms of one's friends, which included the usual table, chairs and sideboard – far more easy than to plan an individual room, using new materials and incorporating new ideas.[18]

Clearly the furnishing of the homes of friends and relatives was both an inspiration and a leveller.

There was still a suspicion that modern furniture was outlandish, so the same article extolled the virtues of unit furniture in terms of

cost, adaptability, and style, and emphasised that units were a modern solution, 'without in any way approaching "freak" furniture'.[19]

The sort of freakish suggestion that might have frightened some was offered by the architect, Wells Coates. Talking on BBC radio in 1933, he considered the possibility when,

> The dwelling house of tomorrow must contain as part of its structure all that today is carried about for the purpose of furnishing one house after another. Very soon it will be realised that it is as fantastic to move from house to house accompanied by an enormous van, filled with wardrobes, chairs, tables, beds, chests, and whatnots, as it would seem today to remove the bath and the heating system complete.[20]

Wartime to prosperity 1940–60

Although this period was one which saw the harnessing of new materials, the development of new technologies and the introduction of new styles, its impact was patchy. The difficulties in supply during the period 1940–52 meant that consumers remained broadly disinterested in furniture, beyond seeing it as a necessity. After 1952 the situation did not improve and the Consumer Council clearly identified the problem – it was the attraction of other consumer goods:

> Between 1948 and 1964 the proportion of total consumer spending, taken up by all consumer durable goods – including furniture, motor cars, radios and electrical goods – *nearly doubled but the proportion spent on furniture and floorcoverings remained fairly static* [my italics].[21]

Although the problem of competition with other consumer goods had a regular airing, the fragmented nature of the British trade denied many collective attempts at change. By 1956, the chairman of the Furniture Development Council pointed out that 'the volume of furniture bought measured against size of population, has during the last few years averaged less than 75 per cent of the pre-war (1938) figure.'[22] The attitude to furniture can perhaps be most clearly seen in the British consumer's furniture life expectancy. In 1964 the average replacement period for a three-piece suite was nineteen years and a bedroom suite an astonishing thirty-seven years.[23] Comparing these with the same figures from the 1950s in the United States, where purchase rates then were on a sixteen year interval for a

living room, and an eighteen year interval for a bedroom,[24] an assessment of the relative importance given by the two markets can be made.

Everyone seemed to be confused; the customer, the retailer and the manufacturer. The Utility scheme had done little to help. Hailed by some as the great opportunity to once and for all change the course of furniture design, by others as bureaucratic interference in an industry quite capable of looking after itself, and received with ambivalence by the customers it was designed for, it is little wonder that it did not survive much beyond the emergency period. The furniture produced under the scheme was ultimately the response to a peculiar situation and could not be expected to act as a catalyst for major changes in attitudes to furnishing. The problem for Utility was clearly expressed in a contemporary article. In the *Architectural Review* (January 1943), a comparison between Utility furniture and council housing was interestingly made. It was pointed out that even if the council houses were well made and equipped, well above jerry-built standards, the stigma adhering to a council house remained. The article suggests that it is the bare institutional look of the houses that 'spoiled its chances'. It feared the same for furniture. Developing the idea further, the article went on to discuss honesty in design. The author noted that:

> the public at large has never accepted this tenet [honesty in design], and so long as furniture looks austere and institutional as the Board of Trade's, the majority of the forced purchasers will, at their very first opportunity, return to the wildly-grained H.P. walnut suite with stuck-on moulded ornaments.[25]

Richard Hoggart in *The Uses of Literacy*, identified the same idea retrospectively, when he said 'It was not difficult to guess that working-class people would go back, as soon as they no longer had to buy Utility furniture, to the highly polished and elaborate stuff the neon-strip stores sell'.[26]

This did not mean that interest in improving the design of furniture for consumers had been exhausted. The Board of Trade report of 1946 commented quite sincerely that:

> we accept the view that a very large proportion of the furniture made in this country before the war was of poor design and we cannot say too strongly that we feel that the inhabitants of our industrial towns should

not be fobbed off with ugly things because they live in squalid surroundings, and because for the moment many will accept such things as natural.[27]

Interest also took the form of market research and analysis to discover why 'ugly things' were considered natural and why certain styles were popular. When the Social Survey (1945) conducted an investigation on behalf of the Council of Industrial Design to gauge public taste (a crude experiment using four photographs of a plain, fairly-modern wardrobe, an old-fashioned model and two ultra modern items to offer a choice), they found that the old-fashioned model was liked by 45 per cent of the sample because it looked strong and was an attractive colour – dark oak.[28] They also suggested that modern Utility-like designs were preferred by the generation up to age 34 as well as higher wage-earners.

The *Working Party Report* (1946) tried to analyse the consumer's requirements in a slightly more rigorous way. Based on a very small sample, they found that criticism of pre-war furniture was not surprisingly related to (a) design, (b) quality, (c) size and weight, (d) function, and (e) the use of built-in furniture. In the case of design, over a third of those questioned (116 returns out of 350) criticised pre-war furniture for 'too many frilly bits, too much carving, too much fancy work, too ornate, over-embellished, too many twists, showy meaningless decoration'.[29] Whereas quality was not generally criticised, except in the case of 'cheap furniture', the bulky nature of many pre-war items were. The Report perceptively saw that there was to be 'considerable scope for the introduction of lighter furniture'. Clearly then, the trade had been advised that there was to be a probable demand for lighter, more modern furniture once some normality had returned to the situation.

Whilst there was an obvious liking for suites as symbols, their use also revealed a desire for harmony in furnishing schemes, which was perhaps difficult to achieve with no prior knowledge of composition using colour and pattern. Again the Report suggested that the development of unit furniture might enable a harmonious look to be achieved without necessarily buying a suite. Indeed, this must have been the case when individual upholstery and cabinet pieces could be harmonised, often from the same supplier.

The operation of the Veblenian filtering of taste meant that the new modern styles were to become high style as traditional styles

The 'Helson' three-piece Lounge Suite is a real favourite among lovers of contemporary furniture. It can be supplied in plain moquette or in tapestry or in two-tone effects as illustrated. This suite, combined with the Bureau, Coffee Table and three-tier Sidetable, strikes a most pleasing note, at an extremely moderate cost

The contents of this delightful and comfortable-looking room can be obtained for a really modest outlay. The 'Parkstone' three-piece Suite with interior sprung cushions is available in various moquettes or tapestries according to taste. Note the interesting nest of tables and coffee table with attractive pie-crust edges

37 A page from a 1954 Maples catalogue showing the comparison between the traditional three-piece suite and a lighter more 'Contemporary' design

trickled downward. By the early 1950s Contemporary or Modern styles were to be seen in many stores and the success of unitised ranges such as G-Plan and Meredew, etc., illustrate how market research could be useful to furniture-makers and consumers alike.

Despite the common sense approach of the *Working Party Report*, there were design pundits who considered that the 'general public think that an article with a lot of carving and elaborate work on it must be more valuable than something that is plainer and simpler.'[30] R. D. Russell was one designer who brought a rare sense of understanding to the question of the public's attitude to design:

> The development of a contemporary vernacular depends first upon finding out what people want and like in the broadest sense. I think they like warm colour and a certain solidity, and although Jacobean reproductions give them these there must be dozens of alternatives, for it is not really Jacobean furniture that people want but furniture that is warm and cosy.[31]

38 An example of the 'Contemporary' style used in a bedroom range by Meredew, *c.* 1949

This notion of the 'warm and cosy', with its overtones of human occupancy over time, was clearly more popular than a rigidly defined and designed look, and indeed remains so.

An interesting example of a kind of market research which reflects Russell's comments was carried out by the DIA. In 1953 they set up two room-sets for the public to judge. Although both were furnished with current furniture, one was in a conventional style while the other was in a contemporary look. Paul Reilly, commenting on the exhibition which was called 'Register your choice', made a number of interesting points which illustrate the distinction between the cosy and the stylish. He noted how although both rooms were furnished with furniture and fittings that were available at the same time, the more contemporary look had a 'designed' feel about it, whilst he saw the other room as an 'assemblage'. This does perhaps reflect the distinction between the reality of many homes that are based on accretions of objects compared to the designerly ideal of new and complete schemes that are furnished in one go.

A revealing sidelight on the exhibition, and one that Reilly considered significant, was the identification of the National Association

of Retail Furnishers with the exhibition[32] – an early example of the recognition that public relations efforts were of great importance in giving consumers more confidence in furniture shops and stores.

During the post-war period the design establishment had an uncomfortable time charting the difficult waters of domestic home furnishings. On the one hand they wanted to maintain the gains made in the public taste since the 1951 Festival of Britain; on the other, they were aware that only by reforms in the trade and industry could real advances come. One example of the positive approach that could arise from these attempts was the furnishing of a show flat by the Council of Industrial Design at the 1955 Ideal Home Exhibition. They used furniture supplied by a high street retailer, chosen by ballot, in this case Williams Furniture Galleries of Kilburn. The selection of items, all of restrained contemporary design, included Stag and Loughborough Cabinet Company bedroom furniture, the Jason chair by Kandya, and Goodearl dining chairs combined with Reynolds Woodware sideboard and table.[33] This compares interestingly with the selection made for the Whitechapel Art Gallery's 'Setting up Home for Bill and Betty' exhibition of 1952. In that show the organisers used products from Hille, Finmar, HK, Meredew, and R. S. Stevens. All these suppliers were from a more costly bracket than those selected by the Council three years later.

Although perhaps more usefully published in home interest magazines rather than *Design*, crusading articles which demanded more responsible attitudes to design continued. In 1957 Meade wrote a clear attack on unscrupulous salesmen and high pressure methods of selling furniture to families that could not afford it and for whom it was usually unsuitable. The case of a family persuaded to buy a cocktail cabinet (with an automatic light in the lid although the house had no electricity) who then kept bread in the cabinet, is admittedly extreme but it helped to prove Meade's point.[34] Rather more naively she deplored the fact that furniture was mass produced especially for this market and was designed for show: 'ostentatious, ornate and polished to a mirror finish'.[35] Home-making advice never understood that the propounded image of modern interiors seemed like improvisation to many families. The furniture made like orange boxes, the hessian fabric on the walls, the scrubbed plain wood floors, all seemed temporary and makeshift compared to real 'proper' furniture.[36]

This attitude was clearly understood by Richard Hoggart. His perception of the working-class taste of the mid-1950s showed how

> they are nearest of all, though, to the prosperous, nineteenth century middle-class style; the richness showing well and undisguisedly in an abundance of odds-and-ends in squiggles and carvings in bold patterns, a melange whose unifying principle is the sense of an elaborate and colourful sufficiency.[37]

The skill of designers was to offer modern furniture which may use new materials, but which should embody the same assumptions about the furnishing of a 'really homely' room as the older things bought by the customers' grandparents.

It was thought that in the 1950s the democratising role of 'good design' would have a levelling effect on society. One of the most important influences in trying to achieve this was the continuing support of women's magazines. The change from the wartime 'make do and mend' attitudes to an educational role for the new generation of purchasers was provided by magazines in articles and features that discussed the purchase of new furniture on a low budget. Chapman (1949) noted that salespeople remarked on young couples' taste, which they thought had come from women's magazines. This is to some extent confirmed by the market research and subsequent editorial material published by women's magazines. McDermott (1982) quotes Mary Grieve, editor of *Woman*, who claimed the kudos of public acceptance of a modern look for the home editors of magazines such as her own.[38]

The emphasis on ordinary couples helped the buyers to identify themselves and to begin to relate to the experiences described, rather than read the advice of erudite pundits. The role of the BBC had been important in promoting design matters in the 1930s; it continued to do so in the post-war period. The Corporation supported the CoID index and often used approved furniture for studio settings. Bearing in mind 9 per cent of the populace had access to TV by 1959 this was a good medium through which to deliver the message. However, a research survey carried out in 1962 showed that in response to the question 'Have you ever noticed any furniture you liked on television, either in the programme or on the advertising', only 30 per cent said 'yes'.[39] On the other side of the screen there

was a rise in a TV culture evidenced by TV dinners, and special TV viewing furniture. This would include adjustable-height tables for eating or occasional use, and tele-viewing upholstery as well as cabinets for the TV itself.[40]

The most obvious method of attempting to show the public how to begin to make informed purchasing decisions was to frame the choices in opposing terms which were inevitably divided between good and bad. Ironically, it was often the case that all the qualities were desirable to the consumer. However, the mass market had definite ideas of its own as to how to furnish.

The world of working-class aspirations registered the notion of respectability as an important issue and notions of good and bad design rarely entered the discussion. The role of 'proper' furniture was indicative of appropriateness, with a specific function or at least a dual and often disguised secondary function, i.e. a bed-settee. In addition, the ritual of furnishing with brand new items, especially with a three-piece suite, was seen as a marker of the setting up of a new home. Furniture such as unit and add-on systems were not so successful as suites as they were often seen as 'ambiguous pieces, of changeable function and therefore of uncertain identity'.[41] Old furniture was often seen as second-hand, whilst hand-downs were used only until new could be purchased, because they were seen as 'de-valued' in the sense that new furniture was seen as an important marker in the establishment of a home. The lack of any serious planning of interiors and an indication of the spontaneous nature of purchases, was reported in one research programme that found that seven in ten of those purchasers interviewed had 'taken a fancy to an item' rather than coming to like it after having seen it a few times.[42]

In 1955, newly-weds' priorities were for furnishing the bedroom (a third to half of resources), then the dining room (less than one third), followed, if affordable, by the lounge. This research was first reported in 1949 and emphasises the first consideration of making a home in an emotional sense rather than a functional one. This idea was of course completely at odds with the Council of Industrial Design's advice, which was to always emphasise the functional.

By the early 1960s some critics had caught up with the popular mood and began to denounce the Council's attitudes. Reyner Banham for example, declared that the Council approved 'rubbish' and

Stephen Spender pointed out the impersonal nature of serious, simple, functional design.[43]

One important development in this period was the growth of interest in the nature of the home exhibited by social scientists. Dennis Chapman's *Home and Social Status* (1955) commented on the 'immense variety and complexity of our common domestic material culture.'[44] Chapman declared that:

> there has been an important change towards lighter, brighter and simpler furnishing which is in part a reaction from the styles of a previous generation. Interest in performance is however, little developed, as is shown by the small proportion of the total resources spent on equipping the kitchen.[45]

Chapman's data suggested that furniture was not bought with specific function in mind, but selected in terms of style. He thought that this suggested that performance in a mechanical sense is less important than the social and emotional function of furniture,[46] something that retailers had been intuitively aware of for many years. Chapman thought:

> Perhaps it may be said that the main achievement of the contemporary movement in design is that it has separated the elements of fantasy and performance so that the conflict between them, evident in the work of even the greatest Victorian designers, is resolved.[47]

Although not true for the designs of a committed functionalist, much of the furniture of the period displays a degree of whimsy along with underlying performance capability.

Other social science research of the period analysed the processes adopted by consumers in the furnishing of their homes. Lippit's *Determinants of Demand for House Furnishings and Equipment* (1959) was an attempt to analyse the structure and nature of furnishing purchasing decisions. Although these appear to be common sense categories, they are useful as evaluation tools. The major determinant is clearly income and assets. Secondly, the family type and the stage in the cycle of family life will have a great bearing on buying attitudes. Thirdly, the place of residence, nature of the home tenure, and the interval since a move are important variables. The social group associated with the purchasers will affect their aspirations, as will their existing stock of durables. In the latter case there is a saturation point. These analyses began to help make the process of

manufacturing and distributing furniture something more than making decisions by the seat of one's pants or at best, based simply on previous performance. Unfortunately it seems that they were ignored by much of the trade.

Clearly social scientists saw that improvements in home furnishings were part of a wider programme of change rooted in educational improvements. Of course, for many years domestic science classes had trained girls in the basics of housewifery, but by the postwar period there were additional considerations. For example, Chapman (1949) urged that education for family living should include the aesthetic and functional elements of domestic life to overcome the 'intuition and a debased tradition' that formed judgements about the home.[48] In practical terms, Jack Pritchard floated the idea of a pool of furniture designs that would be offered to about 350 schools with domestic science rooms. These would be equipped as sitting rooms which students could furnish as they chose, from the pool. The idea was that this selection could be renewed every six months. The Furniture Development Council accepted the idea but it was opposed by educationalists as it gave a free choice rather than offering just the expertly chosen designs![49]

Pluralism 1960-92

The recent past has seen an even greater concentration of attention on domestic furnishings and interiors than before. The awareness occurs in the form of a plethora of magazines, part works, radio and television coverage, as well as academic interest in the social, political, economic and technological aspects of furniture and home design. As was seen in the chapter on materials, there has been an enormous growth in the range of choices or options that are now available to the consumer. This has included advice as well as objects themselves. Ultimately however, furnishing decisions have to be made by individuals and the interior then becomes a statement of the owner. The difficulty this caused was recognised when the problem of remote designers was highlighted by the *Architectural Review*. They insisted that some form of co-operation was the only successful way forward so that consumers and designers would be able to co-operate. It was hopeless to expect the customer, who had very limited experience to use skills such as specification, value

analysis, visual judgement, wear estimation, and ageing characteristics, to make accurate decisions.[50]

This problem was reflected on a larger scale for many during this period, which was not always one of great excitement and opportunity as it is sometimes portrayed. The image of the 1960s as being one long period of never having had it so good was not universal. Although there were many more opportunities to furnish in an ever-increasing range of styles, the difficulties that had been recognised in the 1930s still remained. In a revealing survey of furnishing problems on new housing estates in Manchester, it was found that space and incompatible furniture sizes were still a major impediment: 'we found that bedroom suites were frequently split up because the bedrooms were so small, with the bed and dressing table in one room and the wardrobe in another'.[51] The real concern of the inquiry was to demonstrate the harmful effects (or otherwise) of hire purchase on family life. The contrasts in attitude revealed are not surprising. One respondent had a 'sparsely furnished home with nothing in the living room except two armchairs but they said they would not take on hire purchase because they were afraid of getting into debt.' Conversely another 'family admitted they had "to go into a lot of debt" over furniture and a neighbour said their home was "like a palace" but she often "comes begging for a cup of tea".'[52]

On the other hand, the 1960s was partly based on a 'throwaway culture' and on the rise of a youth market that was anxious for a new and exciting approach to home furnishings. It was also a period of a wide variety of stylistic ranges offered to the various markets that had begun to be identified. Taste became a matter of age as well as class. To satisfy this new market with its eclectic tastes and heightened design awareness, the rise of Habitat seems in retrospect as an inevitable response to the furnishing needs of the new youth. The combination of pine and tubular steel, bentwood and Victorian revivals with the rise of bright colour and stain as well as the more exotic paper and plastic furniture, created a style that was clearly of its time. However, the Habitat niche was not everyone's aspiration: in 1970 marketing consultants had estimated that 47 per cent of the population seem to have wanted G-Plan in their home.[53]

What was clear was that a new generation were interested in furniture and home design and had the money to pay for what they wanted. It seemed like the right moment for the trade in general to

39 Habitat were later to offer ranges that appealed to a section of population who wanted the 'country look' in their suburban kitchen or dining room, 1989

revive attempts to increase sales through advertising by using joint promotions such as the 'Put Furniture First' campaign of the 1950s and the 'Old Furniture Must Go' of the mid 1960s. Although interest and awareness of furniture and furnishings continued to grow steadily in comparison with other goods, it was still losing ground. The problem that had been identified in the 1920s and again in the 1950s was still there.

40 The G-Plan Fresco range, one of the most successful teak finish
ranges of the 1960–70s

In 1983 the Design Council commissioned a report on the state
of design in consumer goods. The conclusions drawn about furniture
make dismal reading for anyone who thought that there had been
any progress in the development of design. Needless to say, the
roots of the 'problem' lay in the attitudes of the past:

> A contemporary interior has never been seen in this country as a status
> symbol worth having – unlike Italy, Scandinavia, Germany or US – and
> this historical fact still holds true. However vehemently denied, the class
> structure is still influential and most people given a choice would buy
> 'antique' rather than 'contemporary' – arguing that it would be a safer
> investment, but in fact acknowledging that we still look to our peers for
> guidance.[54]

It is clear that at various times during the twentieth century, the
furniture industry has had to fight for attention in an increasingly
competitive market, and other needs have continually taken preced-
ence in the priorities of consumers. The 1983 Report found that:

> Most people nurture some conception of the 'ideal home' interior, but
> are prepared to let furniture give way to more immediate needs such as

white goods or high performance products like hi-fi or motor cars, and make do with what furniture they already have. For many households, paying for furniture can be difficult, as borrowing money for durables other than furniture is seen to be less self-indulgent.[55]

The average householder often has a greater understanding of technical matters than aesthetic ones, therefore money will be spent on those areas where results and performance are obvious. The 1983 Report reiterated that the purchasing of furniture tends to become an emotional rather than a rational process.[56]

This comparison between the technical knowledge of customers and their ignorance of aesthetics was demonstrated some years before in the advice given to the fictional couple, Bill and Betty, in 1952. Making the point that consumers must know what they want it was suggested that Bill would not

> dream of buying a motor car which had bad workmanship disguised by window boxes, a half timbered chassis and chromium knobs all over it, but [he] jolly nearly bought a bedroom suite which was just as dishonest in exactly that way.[57]

The increasing consumer interest in automobiles, hi-fi, and home electronics demonstrate that this is an enduring matter which has serious consequences for the furniture business. The continuing decline in the real value of spending on furniture can be seen when between 1980 and 1988 the percentage of consumer durable expenditure on furniture went from 27 per cent to 19 per cent. Expressed as a percentage of total consumer expenditure furnishings fell from 3.3 per cent to 2.5 per cent in the period.[58]

As recently as 1990 a report by the Director of the Office of Fair Trading found that there was still much for consumers to find fault with. Interestingly, furniture ranked third in the scale of problems relating to purchase; first came cars, then appliances, followed by furniture. As furniture was not people's first priority, the result was that many people put off the furniture buying decisions until they became really necessary. The Report discussed the quality of advice and information available, order payment and delivery problems, questions of quality, and any redress available for breaches of promise or contract. Worryingly, half of all purchases made gave rise to some problems for the consumers interviewed.[59]

The customers' understanding of the nature of furniture buying is clearly shown in research. In the case of self-assembly furniture good

value was considered to be the most important attribute closely followed by satisfactory strength. In the case of cabinets, appearance was put first, followed by value, and for upholstery, comfort was again followed by value for money. It is clear that the combination of appropriate function was closely followed by price considerations while design and colour were not considered as so important.

The research also found that some 84 per cent of the respondents thought that 'you really get what you pay for', presumably related to the high response (76 per cent) that 'A lot of furniture is very poorly made these days'. Clearly confirming the problem of customer education was a figure of 61 per cent who thought that 'people have problems because they choose something unsuitable for their needs'.[60]

With customer attitudes like these on existing and past experience, what will happen in the future when further demands such as the office at home, the growing older market, and concerns over safety and ecology become high priorities?

Notes

1 The market research of Odhams in the 1960s showed that socio-economic groups C1 and C2 and D were purchasing three-piece suites in greater quantity, while groups AB purchased many more single easy chairs. Odhams Press, *Woman and the National Market: Furniture and Furnishings* (1964), p. 10.

2 Examples of fashion in furniture might include vinyl upholstery, fur fabric corner groups, chrome and glass, whilst teak-finish cabinets and white painted bedroom furniture have remained fairly constantly available over a long period.

3 J. Woudhuysen, *Blueprint* (May 1989), p. 46.

4 *The Times* Trade Supplement, 28 February 1920.

5 Quoted in T. and C. Benton and D. Sharp (eds), *Form and Function: A Source Book for the History of Architecture and Design 1890–1939* (London, 1975), p. 192.

6 Baillie Scott, 'Good and cheap – a reply', *Journal of the Design and Industries Association*, 9 (1918), pp. 23–5. Reprinted in Benton and Sharp, *Form and Function*, p. 25. Compare results of the Consumer Council report, *Furniture Trade and Consumer* (July 1965) giving reasons for choice which showed that 80–88 per cent gave appearance as the dominant factor. Questions about well-made and comfortable or easy to use were in single figures, only price (ranging from 28–48 per cent of respondents) was another major consideration.

7 Baillie Scott, 'Good and cheap'.

8 *The House*, 5 (1899), p. 52.

9 C. Edwards, 'Furnishing a home at the turn of the century, the use of furnishing estimates, 1875–1910', *Journal of Design History*, 4:4 (1991).

10 *Woman's Journal Book of Furnishing and Decorating* (May 1935), Waring and Gillow estimates.
11 S. W. Sparrow, *Hints on Home Furnishing* (1909), pp. 29–39.
12 *Ibid.*
13 Good Housekeeping (1932), in B. Braithwaite, N. Walsh and G. Davies, *Ragtime to Wartime* (London, 1986), p. 136.
14 A. Huxley, Notes on Decoration, *The Studio* (October 1930).
15 L. Yakobson, 'Standard furniture', *Design for Today* (1935).
16 Minimum Standard: furnishing design and economics for the mass, *Art and Industry*, 23 (1937), p. 66.
17 Empire woods were introduced by timber merchants from the Far East, India, Australia, and New Zealand during the 1920s and 1930s.
18 *Woman's Journal*, p. 8.
19 *Ibid.*
20 Wells Coates, in Modern dwellings for modern needs, taken from BBC programmes Design in Modern Life (24 May 1933), published in *The Listener*, reprinted in Open University, *A305 History of Art and Design, 1890–1939* (Milton Keynes, 1975), p. 73.
21 Consumer Council, *Furniture Trade and Consumer.*
22 J. C. Pritchard, 'An old industry develops technically', *Engineering* (18 May 1956).
23 *Furniture Industry and the Consumer* (1965), p. 8.
24 W. Skinner and D. Rogers, *Manufacturing Policy in the Furniture Industry* (Homewood, Illinois, 1968), figure 24.
25 'Utility or austerity', *Architectural Review*, 93 (January 1943), p. 4.
26 R. Hoggart, *The Uses of Literacy* (Harmondsworth, Penguin, 1957), p. 144.
27 Board of Trade, *Working Party Reports, Furniture* (HMSO, 1946), p. 111 (hereafter referred to as WPR).
28 *Social Survey Report – Furniture* (May 1945), p. 20.
29 WPR, p. 199.
30 *Journal of the Royal Society of Arts* (3 April 1942), p. 312.
31 R. D. Russell, 'People want furniture that is warm and cosy', *Design*, 42 (June 1952), p. 21, See also Russell, 'Furniture today, tuppence plain: penny coloured', *The Anatomy of Design* (London, 1951). In 1993 furniture designer Drew Bennett still considered the sense of warmth provided by particular timbers as an important factor in influencing his furniture designs.
32 P. Reilly, 'Same room same cost', *Design*, 52 (April 1953).
33 'Home for Four', *Design*, 75 (March 1955).
34 Hoggart: 'Young couples like to go out and buy everything new when they "set-up" and the furniture salesmen often do their best to persuade them to buy, by hire purchase, more new furniture than they need': *Uses of Literacy.*
35 D. Meade, 'Furnishing by hire purchase', *Design*, 104 (August 1957).
36 See Morley, 'Homemakers and design advice in the postwar period' in T. Putnam and C. Newton (eds), *Household Choices* (London, 1990), p. 92.
37 Hoggart, *Uses of Literacy*, p. 123.
38 C. McDermott, 'Popular taste and contemporary design', in P. Sparke, *Did Britain Make It? British Design in Context 1946–1986* (London, Design Council, 1982), p. 21.
39 *Ibid.*

Twentieth-century furniture

40 The Tele-circle Unit Upholstery Company made units specially shaped to make curved units.
41 Putnam and Newton, *Household Choices*, p. 92.
42 Associated Rediffusion, *London Profiles No. 14, Women and Furniture* (London, 1962/3), p. 16.
43 N. Whiteley, 'Semi-works of Art', *Furniture History* (1987), p. 110.
44 D. Chapman, *The Home and Social Status* (London, 1955), p. 91.
45 *Ibid.*, p. 47.
46 *Ibid.*, p. 41.
47 *Ibid.*, p. 93.
48 D. Chapman, 'Families, their needs and preferences in the home', *Report of a Conference held at RIBA* (July 1949), p. 34.
49 J. C. Pritchard, *View from a Long Chair* (London, Routledge, 1984), p. 149.
50 *Architectural Review*, 141 (February 1967), p. 158.
51 Manchester and Salford Council of Social Service, *Setting up House, Furnishing Problems on New Housing Estates* (1960).
52 *Ibid.*, p. 24.
53 *Management Today* (June 1970), p. 166.
54 Design Council, *Report to the Design Council on the Design of British Consumer Goods* (London, 1983), p. 30.
55 *Ibid.*, p. 31.
56 *Ibid.*
57 Whitechapel Art Gallery, '*Setting up Home for Bill and Betty*', Exhibition Handbook (London, 1952).
58 Design Council, *Domestic Furniture*, n.d., c. 1990.
59 Office of Fair Trading, *Report on Furniture and Carpets* (1990).
60 *Ibid.*

7 Conclusion

This account of the history of the changes surrounding the production, distribution, and consumption of furniture during the twentieth century has tried to produce a narrative which links the many and various aspects into a coherent system.

An emphasis on business, technology, and a social science approach has created certain limitations and constraints (i.e. no mention of the craft movement or contract furnishings) but the approach has allowed a number of aspects of the business of 'ordinary' furniture to be related. It is this approach that has been used to try and illuminate the nature of furniture and its use in the twentieth century.

This dissection, based as it is on a model which follows the economic process of furniture-making from raw material to the use in the home, is designed to show interactions between the various parts as well as show their own history. Each major division has reflected the duality of the furniture business and its products during the century. This has majored on the dilemma of innovation versus tradition which has been at the root of much of the changes that have occurred.

In the case of the materials used, the ever-growing range of choice and the subsequent cause and effect on design, manufacture, and sale has meant that changes in this field have been amongst the most important. They have meant that changes in the appearance of furniture could be made very drastically or hardly at all. The change in materials has also meant that some manufacturers have developed into 'furniture engineers', whilst others have diminished into assemblers of prepared parts. The greatest paradox is perhaps when new and innovative materials are simply used as substitutes for more costly natural materials and processes rather than in their own right.

Technology and changes in production method which have alleg-
edly resulted in a change from craft to industry have also been
affected by the dilemma of innovation versus tradition. Whilst in the
late twentieth century furniture is still made in small craft work-
shops with a limited range of powered tools, it is also produced on
a large scale in purpose-built factories for an international market.
The existence of both extremes illustrates the nature of the market
as much as the attitudes of the industry. Whilst there has clearly
been a contraction in the number of businesses, and a stubborn con-
servatism towards change, the carefully selective adaptation of new
ideas has led to a number of exciting innovations being developed.

It has been claimed in this work that the retail distributor is the
pivot of the trade. Not only is the retailer a physical go-between, he
or she is also a channel of choice. This role has been acknowledged
by design pundits as well as retailers themselves, and has been the
source of almost constant discussion for the last one hundred years.
In recent years the so-called retail revolution has helped to polarise
the various parts of the trade so that they can be more easily iden-
tified by customers who wish to pursue any particular lifestyle.

At the beginning of the century the consumption of furniture was
often a question of purchasing the simple necessities: as changes
in the spending power of the population gradually increased, so the
nature of demand changed. Greater disposable income meant that
furniture and furnishings had to compete with other merchandise.
The furniture trade had developed a poor reputation for service,
quality and value, so much of the new money was used to purchase
seemingly more desirable products, notably motor cars, electrical
goods, and holidays. Nevertheless, the increased demand meant a
wider choice which often resulted in confusion in the consumer's
mind. Design advice and media attention to furniture and the home
generally has increased through the century and shows no signs of
slowing down.

Indeed the education of consumers remains one of the priorities
facing the furniture business. It has been traditional to expect the
retailer to educate the public in matters of taste, design, and style,
but this seems to interfere with the business of retailing. The teaching
of visual literacy must begin in schools and colleges; only in this way
will the consumers of the future be in a position to make judgements
and demand the designs they want. However, it must be borne in

mind that many consumers bring particular demands with them when making choices about their furnishings, so there will always be a degree of customer pull, however much the industry pushes for change.

The design of twentieth-century furniture has not been discussed as a separate issue as it seems clear that materials, technology, concepts, and ideas (tastes and style), are all part of the process of design. What has been seen is that although there have been immense changes to many aspects of furniture in terms of technology, manufacture and sales, it still remains a Cinderella industry which will have to address even more changes in the next few decades.

Apart from the continuing need to improve customer interest in domestic furniture, other concerns will need to be addressed by the trade in the near future. These new demands include, for example, the office at home, the older market, the bedroom as a room, as well as increasing health and safety and ecology demands from the public.

Glossary

American cloth A leather substitute produced from enamelled oilcloth introduced into England in the mid-nineteenth century.

anodising A protective oxide film applied by electrolysis on to metals. Coloured anodising has often been used on aluminium.

bagasse board A man-made timber substitute produced from the pulpy residue of sugar cane after extraction.

batch production A method of manufacture that limits the quantity of items to be made to batches. This enables a variety of objects to be produced in a changing sequence, often dependent on demand.

battenboard A man-made board product that has its inner part made from core strips up to 76 mm wide.

blockboard A man-made board product that has its inner part made from core strips not to exceed 25 mm.

cantilever In reference to chairs, the method whereby a chair is designed without the conventional legs, often with the frame made in a zig-zag shape.

coir fibre Fibrous material from the husks of the coconut palm. Used as an upholstery filling.

curtain-coating The process of finishing prepared panels by passing them through a continual curtain of lacquer or paint.

deal Originally referred to pine or fir sawn boards, usually more than 9 in. (228 mm) wide but not more than 3 in. (76 mm) thick. Many coniferous softwoods have now been brought together under this general title and the size is no longer relevant. Broadly speaking these timbers have a pale yellow colour and clear annual rings.

densified wood Laminated wood veneers that are impregnated with phenolic glue and then sandwiched together under pressure and cured.

flat-pack Another name for the knock-down method of furniture construction. It is designed for customer assembly and is often available to be taken away from a store.

flow-line A system of manufacture that is based on the conveyorised progression of parts and assemblies through the factory from raw material to finished product.

flush-framing A method of construction that applied board materials to a frame without any mouldings.

foil A finishing material that is either paper or PVC based and which is often printed with a wood grain effect.

four-point platform An upholstery suspension system that uses a diaphragm of flexible rubber with clips on each corner. This enables a seat to be supported with very little loss of depth in the frame.

french polish A furniture finish introduced in the early nineteenth century. Made from a mixture of shellac and methylated spirits it needed a skilful hand to apply it to produce the required result. Now mainly used for repair work.

fumed oak A popular timber finish in the late nineteenth and early twentieth centuries. It worked by exposing oak to the fumes of ammonia in airtight containers. The greyish brown colour that was obtained faded to yellowish brown, and is mostly associated with the 'quaint style'.

glass fibre Glass filaments that are embedded into a plastic resin. The great flexibility that the building up process allows gives scope for sculptural shapes.

gutta-percha A tough plastic like substance, similar to latex, that was used to make imitation carved parts for furniture in the nineteenth century.

hardwood A term that does *not* refer to the weight of particular timbers. Rather it is a definition of the botanical nature of the tree, in this case it refers to the deciduous or broad-leaved trees.

jig A finely crafted master support or guide, which enables multiple copies of a part to be fabricated with a great degree of accuracy.

kilning The scientifically based drying or seasoning of wood. The word derives from the kilns that the prepared timbers are placed in for treatment.

knock-down (see also flat-pack) The term commonly used for the design and manufacture of furniture made in such a way that it is simply put together from prepared components. The success of this method of manufacture relies on the accurate cutting of parts and the development of special fittings to join the parts together to produce a rigid piece of furniture. The increased use of particle board which does not lend itself to traditional jointing methods has increased the use of this construction method.

laminboard A man-made board product that has its inner part made from core strips not to exceed 7 mm.

leathercloth Introduced in the 1850s, it is an imitation leather made from castor oil, cellulose nitrate, and colouring matter. It was replaced by PVC in the 1950s.

limed oak A finishing process that pickled oak with a coating of lime brushed into the surface which was then left unpolished. Used for the cottage style of the early twentieth century.

Lloyd Loom The trade name for a flexible woven material that was very successfully used to make prams and furniture. It consists of a steel wire warp which is wrapped in kraft paper and a weft of twisted kraft paper. Once the woven fabric was fitted to a chair or cabinet frame it was painted and decorated. The resultant furniture has the look of wicker but was offered in a wide range of colours and designs at popular prices during much of the twentieth century.

marquetry The process of covering an entire surface with decorative veneers. These can take many forms and have included wood, metal and animal shells or horns. Most commonly the required design is fitted into a thin wood veneer which is then glued to the sub-surface. Distinct from inlay work which is inserted into a solid ground.

medium density fibreboard A man-made panel material made from wood fibres which are bonded together with a urea-formaldehyde resin under heat and pressure. The resulting product allows intricate machining to all surfaces and edges as well as being able to take a fine finish.

nitrocellulose A variety of lacquer used in finishing furniture. It has low resistance to heat and spillage but can be pulled over to create a burnished effect.

panel-processing A manufacturing method that cuts, prepares and finishes panels to pre-selected sizes ready for assembly processing.

particle board Graded chips of wood mixed with synthetic glue to produce a stable board material suitable for veneering. Often makes use of forest waste bough wood and thinning; should be treated in its own right and not seen as a substitute.

plastic foam An upholstery filling that was originally a substitute for latex foam. More recently synthetic rubbers have been based on mixes of polymers and additives such as fillers, reinforcements, pigments, plasticisers, flame retarders, and blowing agents which have made them important fillings in their own right.

plastic laminate A sheet material that has high degrees of resistance to the hazards of furniture use. It is made from resin impregnated sheets of paper, one of which carries the required design. The varieties of finish are enormous and have been used in the most utilitarian as well as the most high-style furniture since their introduction early in the century.

Powellising process A process of seasoning timber without using the kiln. It used solutions to impregnate the timber which would remove excess moisture in a few weeks rather than the years that natural seasoning would take. The use of electric kilns superseded the idea.

PVC A man-made upholstery material, produced since 1928, which provided a leather substitute. It was more flexible than American cloth because the coated fabric was often laid on to a knitted backing, whilst the top surface was often textured to imitate the look of leather.

rattan A climbing palm of the genus Calamus. In furniture-making it is

used in its complete form, as well as being divided into the outer (cane) bark and the inner reed.

rubberised hair Curled hair formed into a pad with a natural or synthetic binder. Used for upholstery padding.

shooting Planing a frame to provide a close fit.

softwood A term that refers to timber that is usually from a coniferous tree, i.e. evergreen. It does not refer to the density or texture of the woods.

stressed-skin A method of construction in which a sandwich of plywood is filled with other material to keep the two outer sections separate. This enables them to take the stresses of the construction without buckling whilst saving weight.

sub-assembly A manufacturing term that refers to the partial construction of parts that will be brought together for final assembly.

tacking strip A method of finishing upholstery (especially backs) which allows the material to have a tack-less finish without the need to cover the fixing nails. It comprises a pre-nailed strip which is fitted between the seam and the frame.

tension springs An upholstery support in the form of a spring tube that is fixed horizontally in the frame. The tension of the spring is operated by expansion rather than compression in coil springs.

Utility A term that refers to the British government's 1942–48 wartime emergency controls over the production and consumption of furniture, fashions, and household goods.

Bibliography

Abercrombie, P., *The Book of the Modern House: A Panoramic Survey of Contemporary Domestic Design*, London, 1939.

Adams, M., *My Book of Furniture*, 1926.

Agius, P., *British Furniture 1880–1915*, Woodbridge, 1978.

Airscrew Co and Jicwood Ltd, *Furniture you can make with licence-free Weyroc man-made timber*, Weybridge, 1953.

Akers, L. E., *Particle Board and Hardboard*, Oxford, Pergamon, 1966.

Allsop, H. B., *Decoration and Furniture*, 2 vols, London, 1952–53.

The Anatomy of Design, A Series of Inaugural Lectures by Professors of the Royal College of Art. London 1951.

Andersen, A., *Der Kragstuhl*, Stuhl Museum Burg Beverungen, Berlin, Alexander Verlag, 1986.

Anderson, M. L., *Everyday Things*, Catalogue of the Exhibition arranged by the RIBA, London, 1936.

Associated Rediffusion, *London Profiles No. 14, Women and Furniture*, London, 1962/3.

Attfield, J., 'Then we were making furniture, and not money'; A case study of J. Clarke, Wycombe furniture-makers, *Oral History*, Autumn, 1990.

Attfield, J. and Kirkham, P., *A View From the Interior*, London, The Women's Press, 1989.

Baermann, W. P., 'Furniture industry in transition', *Industrial Design*, 14, May 1967.

Ball, A. M., *Woodworking machinery for small workshops*, London, Technical Press, 1937.

Barker, G. H., *Modern Woodwork and Furniture-making*, London, Technical Press, 1937.

Barty-King, H., *Maples, Fine Furnishers*, London, Quiller, 1992.

Bast, H., *New Essentials of Upholstery*, 1947.

Bell, N., *Tower of Darkness*, London, Collins, 1942.

Benton, C., 'L'Aventure du Mobilier. Le Corbusier's Furniture Designs of the 1920s', *Journal of the Decorative Arts Society*, 6.

Benton, T., 'Up and Down at Heal's: 1929–1935', *Architectural Review*, 972, February 1978, pp. 109–16.

Benton, T. and C. and Sharp, D. (eds), *Form and Function: A Source Book for the History of Architecture and Design 1890–1939*, London, 1975.
Bevier, I., *The House: its Decoration*, Library of Home Economics, 1, 1907.
Binstead, H. E., *Furniture*, London, Pitman, 1918.
Bitmead, R., *The Practical Upholsterer*, 2nd edn, London, Technical Press, 1954.
Board of Trade, *Working Party Reports, Furniture*, HMSO, 1946.
Board of Trade, *Furniture* – An Enquiry made for the Board of Trade by the Social Survey, HMSO, 1946.
Board of Trade, *Proposals for a Development Council of the Furniture Industry*, HMSO, 1948.
Board of Trade, *Report by the Committee appointed by the Board of Trade under the chairmanship of Lord Gorell on the Production and Exhibition of articles of good design of everyday use*, HMSO, 1932.
Bond, D. E. and Wonnacott, R. J., *Trade Liberalisation and the Canadian Furniture Industry*, 1968.
Bonnett, D., *Contemporary Cabinet Design and Construction*, London, Batsford, 1956.
Booth, D., 'Notes on the construction of cheap furniture', *Journal of the RIBA*, 42, July 1935.
Boulton, B., *The Manufacture and Use of Plywood and Glue*, London, Pitman, 1921.
Boumphrey, G., 'Nationality in easy chairs', *Design for Today*, May 1933.
Braddell, D. A., 'Common sense in furniture design', *Journal of the Royal Society of Arts*, 90, 3 April 1942.
Branton, P., *The Comfort of Easy Chairs*, FIRA, Stevenage, 1966.
Briggs, A., *Friends of the People, The Centenary History of Lewis's*, London, Batsford, 1956.
Britain at Work, a Pictorial Description of our National Industries, Cassell, 1902.
British Furniture Trade Productivity Team, *Report on a Visit to the USA in 1951*, London, 1952.
British Productivity Council, *A Review of Productivity in the Furniture Industry*, London, 1954.
Brookman, P., 'The development of furniture manufacturing methods', *Furniture Manufacturer*, February 1977.
Brown, R., 'The Furniture Oligarchy', *Design*, 449, May 1986.
Budden, B., *The Bride and Her Home*, Odhams, 1930.
Bulletin of the Rubber Growers Association, 'The Use of Rubber in Furniture', September 1937.
Burman, W., *Housecraft*, London, 1954.
Burnett, W. J. (ed.), *Useful Toil, Autobiographies of Working People*, 1974.
Buttrey, D. N., *Plastics in the Furniture Industry*, London, Applied Science Publishers, 1964.

Cabinet Maker, *The Cabinet Maker And Complete House Furnisher Guide To Utility Furniture*, London, Benn, 1946.

Cabinet Maker, *British Furniture 1950. A pre-view of the British Furniture Trades Exhibition*, London, Benn, 1950.

Cabinet Maker, *Furniture and Furnishings 1880–1955*, London, Benn, 1955.

Cabinet Maker, *Cabinet Maker Celebrates a Century 1880–1980*, London, Benn, 1980.

Campbell-Cole, B. (ed.), *Tubular Steel Furniture*, London, The Art Book Company, 1979.

Carr, R., 'Design analysis, Polypropelene chair', *Design*, 194, February 1965.

Carrington, N., *Design in the Home*, London, 1935.

Chalkidis, G., 'Obstacles in the road to higher productivity in the furniture industry', *An Economic Review for the Furniture Industry 1964–5*, Furniture Development Council, 1966.

Chandler, A., *The Visible Hand, the Managerial Revolution in American Business*, Cambridge, Mass., 1977.

Chapman, D., 'Families, their needs and preferences in the home', *Report of a Conference held at RIBA*, July 1949.

Chapman, D., *The Home and Social Status*, London, 1955.

Coates, W., 'Furniture today furniture tomorrow', *Architectural Review*, 72, July 1932.

Cohen, B., and Sons, *A Century of Progress in the Furniture Industry*, 1947.

Collins, J. B., 'Design in Industry Exhibition National Gallery of Canada 1946: turning bombers into lounge chairs', *Material History Bulletin*, 27, Spring 1988.

Committee on Trade and Industry, *Factors in Industrial and Commercial Efficiency*, HMSO, 1927.

Conference on House Furnishings, *Journal of the Royal Society of Arts*, March 1920.

Consumer Council, *Furniture Trade and the Consumer*, HMSO, 1965.

Consumers Association, 'Furniture Shops', *Which?*, October 1974.

Conway, H., *Ernest Race*, Design Council, 1982.

Cooke, E. S., Jr, *The Study of American Furniture from the Perspective of the Maker*, in G. Ward, *Perspectives on American Furniture*, London, Norton, 1988.

Co-operative Wholesale Society, 'The wholesale as cabinet makers', *The Wheatsheaf*, Manchester, April 1908.

Corbin, P., *All About Wicker*, New York, 1979.

Council for Art and Industry, *The Working Class Home: its Furnishing and Equipment*, London, 1937.

Council for the Encouragement of Music and the Arts, *Design in the Home*, An exhibition arranged by the Victoria and Albert Museum, London, 1943.

Council of Industrial Design, *Social Survey Report – Furniture*, May 1945.

Council of Industrial Design, *Design '46. A survey of British Industrial design as displayed at the Britain Can Make It exhibition*, HMSO, 1946.

Council of Industrial Design, *New Home*, London, 1946.

Council of Industrial Design, *Furnishing to fit the family*, HMSO, 1947.

Council of Industrial Design, *Four Ways of Living*, HMSO, 1949.

Council of Industrial Design, *Report on a Conference on Furniture Design*, RIBA, 20 July 1949.

Council of Industrial Design, *Reports on Design Courses for Furniture Salesmen*, 1951.

Council of Industrial Design, *Design in the Festival*, 1951.

Council of Industrial Design, *Selling Modern Furniture*, 1971.

Covell, P., 'Structural foam for Furniture', *British Plastics*, 44, June 1971.

Crawshaw, F. D., *Problems in furniture making*, Illinois, Manual Arts Press, 1920.

Crowther, J., Survey of industry (8), Furniture, *Design*, 159, March 1962.

Curtis, L., *Lloyd Loom Woven Fibre Furniture*, London, Salamander, 1991.

Csikmentihalyi, S., *The Meaning of Things*, Cambridge, 1981.

Daily Express, Model Homes Exhibition, Westminster, 1919.

Daily Express, The Home of Today: Its Choice, Planning, Equipment and Organisation, London, c. 1935.

Daily Mail, Ideal Labour Saving Home, London, 1920.

Daily Mail, Daily Mail Book of Post-war Houses, London, 1944.

Daily Mail, Daily Mail Ideal Home Books, London, 1946–54.

Daily Mail, Daily Mail Book of Furnishing, Decorating and Kitchen Plans, London, 1965.

Daily Mirror, The Perfect Home and How to Furnish it, London, 1913.

Darling, S., *Chicago Furniture, Art Craft and Industry 1833–1983*, New York, Norton, 1984.

Davidson, H. C., *The Book of the Home*, 1902.

Deeks, J., *The Small Firm Owner Manager*, New York, Praeger, 1976.

Deese, M., 'Gerald Summers and Makers of Simple Furniture', *Journal of Design History*, 5:3, 1992.

Denning, D., *Art and Craft of Cabinetmaking. A practical handbook*, London, Pitman, 1931.

Desbrow, R., 'Latex foam in furniture design and manufacture', *Rubber Developments*, 3, 1951.

Design Council, *Report to the Design Council on the Design of British Consumer Goods*, London, 1983.

Design Council, *Key Themes in the UK Furniture Industry*, n.d., c. 1990.

Design and Industries Assoc., *The Furnishing of Standard Flats at Smedley Road*, Manchester, 1935.

Design and Industries Assoc., Register your choice Exhibition, *DIA Yearbook*, 1953.

Director General of Fair Trading, *Report on Furniture and Carpets*, 1990.

Bibliography

Dover, H., *Home Front Furniture, British Utility Design 1941-1951*, London, Scolar Press, 1991.

Dowling, H., *A Survey of British Industrial Art*, Benfleet, 1935.

Drexler, A., *Charles Eames, Furniture from the Design Collection*, MOMA, New York, 1973.

Droste, M., *Marcel Breuer Design*, Cologne, Taschen, 1992.

Dufrêne, M., 'A survey of modern tendencies in decorative art', *The Studio Yearbook of Decorative Art*, 1931.

Duncan, J., *The House Beautiful and Useful*, Cassell, 1907.

Dunnett, H., 'Furniture since the War', *Architectural Review*, 109, March 1951.

Dunnett, H., 'Packaged furniture', *Architectural Review*, 111, April 1952.

Eastlake, C., *Hints on Household Taste*, London, 1872.

Economic Development Council, *Furniture Industry Survey*, London, 1987.

Economist Intelligence Unit, *A Study of the Furniture Industry and Trade in the United Kingdom*, 1958.

Economist Intelligence Unit, *Retail Business*, No. 50, April 1962.

Economist Intelligence Unit, *Retail Business*, No. 81, Special Report, Furniture, November 1964.

Economist Intelligence Unit, *Retail Business*, Furniture Part 1, November 1967.

Edwards, C., *Victorian Furniture*, Manchester, Manchester University Press, 1993.

Encyclopedia of the Social Sciences, Macmillan, 1931.

Ercolani, L., *A Furniture-maker, His Life, His Work and His Observations*, Tonbridge, Benn, 1975.

Exton, E. N. and Littman, F. H., *Modern Furniture*, London, Boriswood, 1936.

dal Fabbro, M., *Modern Furniture: its design and construction*, New York, 1950.

Farr, M., *Design in British Industry*, Cambridge, Cambridge University Press, 1955.

Farrant, P., 'Good going at Gommes', *Management Today*, June 1970.

Faulkner, H., 'Chromium tubing is as dead as mutton', *Architects Journal*, 86, October 1937.

Fehrman, C., *Post-war Interior Design*, New York, 1987.

Fiell, C. and P., *Modern Furniture Classics*, London, Thames and Hudson, 1992.

Forty, A., *Objects of Desire*, London, Thames and Hudson, 1986.

Frank, E., 'The Good Design Years 1940–1950s', *Art and Architecture* 2:2, 1983.

Frankl, P. T. and Bultitude, H. F., 'Furniture for the House of Tomorrow; two divergent opinions', *Architecture* (N.Y.), 69, 1934 (189–196).

Fraser, W. H., *The Coming of the Mass Market 1850–1914*, London, 1981.

Fulop, C. and March, T., 'The effects of the abolition of resale price maintenance in two trades', *European Journal of Marketing*, 13:7, 1979.

Furnishing Trades Encyclopedia, Who's Who, Diary and Buyers Guide, London, 1935 *et al.*

The Furnishing Trades Organiser, London, 1931.

Furniss, A. D. S. and Phillips, M., *The Working Woman's House*, Swarthmore Press, 1920.

Furniture Development Council, *First Annual Report*, 1949.

Furniture Development Council, '*You and your industry*', 1953.

Furniture Development Council, *Statistical Review and Comparative Costs*, Appendix to 7th Annual Report, 1956.

Furniture Development Council, *A Design Manual for Cabinet Furniture*, London, 1958.

Furniture Development Council, *Report on a Study Tour to the USA 1959*, 1960.

Furniture Industry Research Assoc., *An Economic Review for the Furniture Industry 1968–9*, July 1970.

Furniture Industry Research Assoc., *A Discussion Document on Consumer Attitudes to buying Furniture*, 1978.

Furniture Industry Research Assoc., *The Furniture Trade in France*, FIRA Translations 357, 1978.

Furniture Industry Research Assoc., *Buying and Selling Furniture*, Stevenage, 1980.

Furniture Industry Research Assoc., *Domestic Furniture Purchasing Habits*, Stevenage, 1983.

Furniture Record, *Golden Jubilee Number*, 24 June 1949.

Furniture, Timber and Allied Trades Union, *The Furniture Industry – Problems and Prospects*, London, 1981.

Furniture Trades Yearbook, 1926.

Gale, A., 'Schreiber furniture factory Runcorn', *Architects Journal*, 172, November 1980.

Geffrye Museum, *CC41 Utility Furniture and Fashion, 1941–1951*, ILEA, 1974.

Gibberd, F., *Built-in Furniture in Great Britain*, London, Tiranti, 1948.

Gill, K., 'Approaches in the treatment of twentieth century upholstered furniture' in M. Williams (ed.), *Upholstery Conservation*, Preprints of a Symposium held at Colonial Williamsburg, February 1990, American Conservation Consortium, East Kingston, NH.

Gloag, J., *Simple Furnishings and Arrangement*, London, Duckworth, 1921.

Gloag, J., 'Towards a Style', *Architectural Review*, July 1933.

Gloag, J., *Design in Modern Life*, London, 1934.

Gloag, J., *Industrial Art Explained*, London, 1934.

Gloag, J., *The Missing Technician in Industrial Production*, London, 1944.

Gloag, J., *English Furniture*, London, A & C Black, 1952 (first published in 1934).

Gloag, J., 'English furniture in the later twentieth century,' *Connoisseur*, 200:806, April 1979, pp. 248–9.

Gloag, J. and Mansfield, L., *The House we Ought to Live in*, London, 1923.

Goldfinger, E., *British Furniture Today*, London, 1951.

Goodden, S., *At the Sign of the Four Poster: A History of Heals*, London, 1984.

Graefe, R. T., 'Marquetrie', *Wood*, April 1939, pp. 151–5.

Great Britain Patent Office, *Patents for Inventions*, abridgements for specifications, HMSO.

Bibliography

Greater London Enterprise Board, *Turning the Tables: Towards a Strategy for the London Furniture Industry*, 1985.

Greater London Industrial Archaeology Society, *A. Howard and Sons, Upholstery Spring Makers*, March 1976.

Greaves and Thomas, *The Golden Jubilee of Greaves and Thomas Ltd., 1905–1955*, London, 1955.

Greenberg, C., *Mid-Century Modern, Furniture of the 1950s*, London, Thames and Hudson, 1985.

Gregory, A., *The Art of Woodworking and Furniture making*, Dryad, 1935.

Gregory, E. W., *The Art and Craft of Home-making*, Murby, 1913.

Griffin, J. W., 'Czech furniture production methods in bentwood and cabinets', *Woodworking Industry*, 23, November 1966.

Groneman, C. H., *Bent Tubular Furniture*, Milwaukee, Bruce, 1949.

Hackney Furnishing Company, *British Homes: Their Making and Furnishing*, 1911.

Haigh, A., *Furnishing and Hardware, A textbook for Co-operative Society Salesmen*, Central Education Committee, Co-operative Union, Manchester, 1925.

Hall, C., *Wood and what we make of it*, 1928.

Hall, P. G., *The Industries of London Since 1861*, 1962.

Hanks, D. A., *Innovative Furniture in America from 1800 to the Present Day*, New York, Horizon, 1981.

Hargreaves, E. and Gowing, M., *Civil Industry and Trade*, HMSO, 1952.

Harrison, R. E., 'Furniture Production', Paper presented to the Institution of Production Engineers, Glasgow Section, 16 December 1948 (FDC Library).

Hartland-Thomas, M., 'Unit furniture, built-in furniture and modular co-ordination', *Design*, 68, August 1954.

Hasluck, P. N., *Cassell's House Decoration*, London, 1908.

Heal, J., *Planning an Ideal Home*, Ass. Newspapers, London, 1956.

Herler, I., *Alvar Aalto Furniture*, Chicago, 1985.

Heskett, J., *Industrial Design*, London, Thames and Hudson, 1980.

Heughan, D. M., 'Furniture production', *Production Engineer*, 51, November 1972.

Higgins, J. W., 'Design and mass production', *The Studio*, 107, 1934.

Hilton, J., *Rich Man Poor Man*, 1938.

Hjorth, H., *Machine Woodworker*, Milwaukee, 1937.

Hobbs, E. W., *Modern Furniture Veneering*, Lockwood, 1928.

Hoffman, W. G., *British Industry 1700–1950*, Oxford, 1965.

Hoggart, R., *The Uses of Literacy*, Harmondsworth, Penguin, 1957.

Hollier, D., 'Mass production at Meredews', *Woodworking Industry*, 22, March 1965, pp. 35–8.

Hollier, D., 'Austin invest in mechanisation', *Woodworking Industry*, 23, March 1966, pp. 18–22.

Holloway, E. S., *The practical book of furnishing the small house or apartment*, Philadelphia, 1922.

Holmes, H. A., 'Design and the retailer', *Journal of the Royal Society of Arts*, 25 October 1946.

Holst, L., 'Quantity production to hand-built standards', *Art and Industry*, 53, August 1952.

Hooper, J. and R., *Modern Furniture and Fittings*, London, Batsford, 1948.

Hordern, R. H., *Woodworking by Machinery*, London, Pitman, 1937.

Hounshell, D., *From the American System to Mass Production 1800–1932*, Baltimore, 1984.

House, F. H., *Timber At War*, London, Benn, 1965.

Huxley, A., Notes on Decoration, *The Studio*, October 1930.

ICC Business Ratios, *Furniture Manufacturers*, 1990.

Ideal Home, *Ideal Home Householders Guide – Decorating and Furnishing*, Odhams, 1966.

Jay, B. A., 'Wood', Conference on Furniture Design held at RIBA, London, 1949.

Jay, M., 'Furniture: Autocracy versus Organisation', *Design*, 194, February 1965.

Jeffreys, J. B., *The Distribution of Consumer Goods*, Cambridge, 1950.

Jeffreys, J. B., *Retail Trading in Britain 1850–1950*, Cambridge, 1954.

Jennings, H. J., *Our Homes and How to Beautify them*, London, 1902.

Jephcott, J., 'The National Plan and the furniture industry', *An Economic Review for the Furniture Industry 1964–5*, Furniture Development Council, 1966.

Joel, B., 'A House and a Home', in J. Valette (ed.), *The Conquest of Ugliness*, London, 1935.

Joel, D., *The Adventure of British Design 1851–1951*, London, 1953.

Joel, D., *Furniture Design Set Free*, London, Dent, 1969.

Jolley, S. A., 'How G-Plan is made', *Woodworking Industry*, 20, March 1963.

Jones, A., *Cellulose lacquers, finishes and cements. Their history, chemistry and manufacture*, 1937.

Julius, L., 'The Furniture Industry', *Journal of the Royal Society of Arts*, May 1967.

Julius, L., 'Furniture industry in transition', *Industrial Design*, 14, May 1967.

Katz, S., *Plastics, Design and Material*, London, Studio Vista, 1978.

Keeble, A. L., *Cabinet Making Theory and Practice*, London, Longmans, 1930.

Kelehar, R., 'Furniture starts to polish up its act', *Marketing Week*, 19 August 1988.

Keynote Reports, *Home Furnishings*, 1990.

Kirkham, P., Mace, R. and Porter, J., *Furnishing the World, The East End Furniture Trade 1830–1980*, London, Journeyman, 1987.

Knobel, L., *Office Furniture*, London, 1987.

Kotas, T., Application of Research to Furniture Production, *Journal of the Royal Society of Arts*, 30 March 1956.

Kron, J. and Slesin, S., *High Tech Industrial Style and Source Book for the Home*, London, Allen Lane, 1978.

Bibliography

'Latex Foam in Furniture', *Report of the Conference held in London*, British Rubber Development Board, May 1954.

Latham, B., *Timber: A Historical Survey of its Development and Distribution*, Harrap, 1957.

Leake, G., 'PEL furniture' in B. Tilson (ed.), *Made in Birmingham, Design and Industry 1889–1989*, Brewin, 1989.

Lebus, S., 'A consideration of mass and flow production', RIBA Conference, London, 1949.

Le Corbusier, *The Decorative Art of Today*, 1925, translated by J. Dunnett, Architectural Press, London, 1987.

Leicester Polytechnic, *Hille – Profile of a British Furniture Company 1906–1982*, Exhibition Leicester, 1982.

Lippit, V. G., *Determinants of Consumer Demand For Home Furnishings and Equipment*, Cambridge, Mass., 1959.

Lloyd, C. G., 'The new factory of Castle Brothers (Furniture) Ltd.', *The Metropolitan-Vickers Gazette*, 18, February 1939.

Logie, G., *Furniture from Machines*, London, Allen and Unwin, 1947.

Logie, G., 'The design of mass produced furniture', RIBA Conference, London, 1949.

London Cabinet And Upholstery Trades Federation, *London Furniture*, 1, 1925; 2, 1929.

London School of Economics, *The New Survey of London Life and Labour*, 2, 1931.

Lovell, R. G., *Home Interiors*, Caxton Publishing, 1913.

Lyall, S., *Hille – 75 years of British furniture*, London, Elron, 1981.

MacDonald, S. and Porter, J., *Putting on the Style, Setting Up Home in the 1950s*, Geffrye Museum, 1990.

Macel, O., 'Avant-garde design and the law litigation over the cantilever chair', *Journal of Design History*, 2:3, 1990.

McFadden, D., *Scandinavian Modern Design 1880–1980*, New York, 1982.

McGeoghegan, B., 'Transition in furniture', *Design*, 101, 1957.

McGrath, R., 'New materials – new methods', *Architectural Review*, 67, 1930, pp. 273–80.

Manchester and Salford Council of Social Service, *Setting up House, Furnishing Problems on New Housing Estates*, October 1960.

Manser, J., 'Free-form furniture', *Design*, 240, December 1968.

Manser, J., 'You can lead a horse to water', *Design*, 455, November 1986.

Mansfield, J. H., 'Woodworking machinery, 1852–1952', *Mechanical Engineering*, 74:12, December 1952.

Manzini, E., *Material of Invention*, London, Design Council, 1986.

Marshal, G., 'Furniture' in *Encyclopedia of the Social Sciences*, Macmillan, 1931.

Martenson, R., *Innovation in Multi-national Retailing – IKEA*, IKEA, 1981.

Martin, J. E., *Greater London. An Industrial Geography*, London, Bell, 1966.

Martin, J. L. and Speight, S., *The Flat Book*, London, 1939.

215

Massey, J. H., *Sales Planning Guide for the Furniture Industry*, Stevenage FIRA, 1965.

Mass Observation, *Report on the Reception of Utility Furniture*, 1942.

Mass Observation, *Report on 'Britain Can Make It' Exhibition*, 1946.

Maufe, P., 'Modern painted and decorated furniture', *Architectural Review*, 63, 1928, pp. 32–5.

Mayes, L. J., *The History of Chairmaking in High Wycombe*, London, Routledge, 1960.

Meade, D., 'Furnishing in the new towns', *Design*, 98, February 1957.

Meade, D., 'Furnishing by hire purchase', *Design*, 104, August 1957.

Meade, D., 'Perrings at the crossroads', *Design*, 227, November 1967.

Merrick, M. J., 'Research in the furniture industry', *Journal of the Royal Society of Arts*, 30 March 1956.

Minimum Standard: furnishing design and economics for the mass, *Art and Industry*, 23, 1937, pp. 64–7.

Ministry of Labour, *Report of a Commission of Inquiry on an application for the Establishment of a Wages Council for the Retail Furnishing and Allied Trades*, London, 1947.

Ministry of Labour, Industrial Information Series, *Woodworking Industries*, 1962.

Modern Chairs 1918–1970 see Whitechapel Art Gallery.

Modern Homes Illustrated, see Yerbury.

Monroe, D., *Family Expenditure for Furnishings and Equipment*, US Dept. of Agriculture, Misc. Publication No. 436, 1941.

Moody, E., *Modern Furniture*, London, Studio Vista, 1966.

Morris, N., *Shavings For Breakfast*, Glasgow, n.d.

Murphy, E., 'Some early adventures with latex', *Rubber Technology*, 39, 1966.

Museum of Modern Art, New York, *Organic Design*, New York, *c.* 1941.

Myer and Co., *Myer's First Century 1876–1976*, London, 1976.

National Association of Retail Furnishers, Report of NARF sub-committee on 'Better Retailing', A Guide for Furnishers, n.d., *c.* 1966.

National Economic Development Council, *Furniture Industry Survey*, London, 1987.

National Federation of the Furniture Trade, *The Furniture Year Book*, 1926.

National Trade Press, *Survey of British Furniture Industry*, 1950.

National Trade Press, *Survey of the British Furnishing Industry; A guide for buyers, traders and importers*, 1952 and 1954.

Nelson, G., 'The Furniture Industry', *Fortune*, January 1947.

Nelson, G., 'Modern furniture. An attempt to explore its nature, its sources, and its probable future', *Interiors*, 108, 1949.

Neuhart, J. and M. and Eames, R., *Eames Design*, London, Thames and Hudson, 1989.

'New design for an old craft – G-plan Furniture', *Art and Industry*, May 1954.

Nothhelfer, K., *Das Sitzmobel. Ein fachbuch fur polsterer, shulbauer*, Ravensburg, 1942.

Bibliography

Noyes, E., *Organic Design*, New York, MOMA, 1941.

Odhams Press Ltd, Research Division, *Woman and the National Market: Furniture and Furnishings*, 1964.

Office Of Fair Trading (and trade organisations), *Voluntary Code of Practice for Furniture*, February 1978.

Office Of Fair Trading, *Report on Furniture and Carpets*, 1990.

Oliver, J. L., 'The East London furniture industry', *East London Papers*, 4:2, October 1961.

Oliver, J. L., *The Development and Structure of the Furniture Industry*, Oxford, Pergamon, 1966.

Open University, *A305 History of Art and Design, 1890–1939*, Milton Keynes, Open University 1975.

Opie, J., 'Geoffrey Dunn of Dunns of Bromley', *Journal of the Decorative Arts Soc.*, 10, 1986, pp. 34–9.

Ostergard, D., 'Gilbert Rohde and the evolution of modern design 1927–41', *Arts Magazine*, October 1981, pp. 98–107.

Ostergard, D., (ed.), *Bentwood and Metal Furniture: 1850–1946*, New York, University of Washington Press, 1987.

Parker Knoll, *New principles applied to old . . . embodied in Parker Knoll chairs*, c. 1935.

Parks, B. A., 'Engineering in furniture factories', *Mechanical Engineering*, February 1921.

Patmore, D., *Modern Furnishing and Decoration*, London, The Studio, 1936.

Payne, R., 'Bath cabinet makers', *Journal of the Decorative Arts Society*, 5, 1981, pp. 23–30.

Peel, D. C., *The New Home*, Westminster, 1903.

Pelton, B. W., *Furniture Making and Cabinet Work*, New York, Nostrand, 1949.

Perring, R., 'Retail Distribution – Popular', CoID, *Report on a Conference on Furniture Design*, RIBA, 1949.

Pevsner, N., *An Enquiry into Industrial Art in England*, Cambridge, Cambridge University Press, 1937.

Pfannschmidt, E. F., *Metalmobel*, Stuttgart, Hoffman, 1960.

Philips, B., *Conran and the Habitat Story*, London, Weidenfeld and Nicolson, 1984.

Phillips, H. G., *Practical Cabinetmaking*, London, Routledge, 1924.

Phillips, R. and Woolrich, E., *Furnishing the House*, London, Country Life, 1921.

Pick, B., 'Displaying the Ideal Home', *Art and Industry*, July 1948.

Plastics in furniture; a symposium held at Brunel University, 1965.

Post, E., *The Personality of a House*, The blue book of home design and decoration, New York, 1930.

The Post War Home, A series of lectures on its interior and equipment, 1942, The Studio for RSA.

Potter, W. C., *The House of Mallinson*, Southern Editorial Syndicate, 1947.

Pound, J., Particle board in furniture manufacture, *Wood*, 27, April 1962.

217

Praga, A., *How to Furnish Well and Cheaply*, London, 1901.

Pritchard, J. C., 'The changing character of furniture', *Journal of the Royal Society of Arts*, 100, February 1952.

Pritchard, J. C., 'Interfirm comparison in the British Furniture Industry', E. P. A. *Productivity Measurement Review*, 5 May 1956.

Pritchard, J. C., 'An old industry develops technically', *Engineering*, 18 May 1956.

Pritchard, J. C., *View from a Long Chair*, London, Routledge, 1984.

Putnam, T. and Newton, C. (eds), *Household Choices*, London, 1990.

Pye, D., 'Developments in the design and construction of furniture', *Journal of the RIBA*, 58, January 1951.

Pye, D., 'How will furniture develop', *Country Life*, 23 March 1967, pp. 667–8.

Pye, D., *The Nature and Art of Workmanship*, Cambridge, Cambridge University Press, 1968.

Race, *Case Histories describing the design and production of five Race Furniture chairs*, Race Ltd, 1969.

Radford, V. N., *The Stag and I*, Nottingham, 1981.

Ransom, F. R., *The City Built on Wood, Grand Rapids 1550–1950*, Michigan, 1955.

Ransome, S., *Modern Woodworking Machinery*, London, Rider, 1924.

Reid, H., *The Furniture Makers*, Oxford, Malthouse, 1986.

Reilly, P., 'Same room same cost', *Design*, 52, April 1953.

Report of the Committee on Purchase Tax and Utility Goods, 1952.

Reports on the Census of Production, HMSO.

Reyburn, S. W., *Selling Home Furnishings Successfully*, Pitman, 1938.

Robertson, H., *Reconstruction and the Home*, London, Studio, 1947.

Rogers, J. C., 'Modern Craftsmanship: Furniture', *Architectural Review*, 59, 1926, pp. 176–81.

Rogers, J. C., 'Modern furniture at Schoolbred's. The enterprise of a furnishing trades organisation', *Architectural Review*, 63, 1928, pp. 116–8.

Rogers, J. C., *Modern English Furniture*, London, Country Life, 1930.

Rogers, J. C., *Furniture and Furnishing*, Oxford, Oxford University Press, 1932.

Rogers, N. R., *The Technology of Woodworking and Metalwork*, London, 1935.

Rudd, J., *Practical Cabinet Making and Draughting*, Benn, 1912.

Russell, G., Hand or Machine, in J. Valette (ed.), *The Conquest of Ugliness*, London, 1935.

Russell, G., *How to Buy Furniture*, CoID, 1947.

Russell, G., *Designer's Trade*, London, 1968.

Russell, G. and Jarvis, A., *How to Furnish Your Home. With a shopping guide by Veronica Nisbet*, London, 1953.

Russell, R. D., 'Furniture today, tuppence plain: penny coloured', *The Anatomy of Design*, A Series of Inaugural Lectures by Professors of the Royal College of Art, London, 1951.

Russell, R. D., 'People want furniture that is warm and cosy', *Design*, 42, June 1952.

Sanderson, I., *Science Applied to Housecraft*, 1956.

Schindler, R. M., 'Furniture and the Modern Home', *Architect and Engineer*, 123, December 1935.

Schneck, A. G., *Die Konstruction des Mobels*, 1932.

Schonfield, H. J. (ed.), *The Book of British Industries*, London, 1933.

Scottish Council, *Report of the Panel on the Furniture Industry in Scotland*, Edinburgh, 1948.

Sembach, K. J., *Contemporary Furniture: An International Review of Modern Furniture 1950 to Present*, London, 1986.

Shand, P. M., 'An adventure in colour, Ideal Home Exhibition', *Design for Today*, May 1934.

Shand, P. M., 'Timber as a reconstructed material', *Architectural Review*, 79, February 1936, pp. 75–89.

Shapland, H. P., *Report on the Position of Industrial Decorative Art, Paris 1925 Exhibition*, Dept. of Overseas Trade, 1927.

Shapland, H. P., *The Practical Decoration of Furniture*, 3 vols, London, Benn, 1926–27.

Shapland, H. P., 'Furniture design: fashions and essentials', *Journal of the Royal Society of Arts* 83, 1934, pp. 53–67.

Sharp, D., Benton, T. and Campbell-Cole, B., *Pel and the tubular steel furniture of the Thirties*, AA, 1977.

Sheridan, M. (ed.), *The Furnisher's Encyclopaedia*, London, 1955.

Sizer, P. W., *Structure of the British Furniture Industry*, University of Aston Management Centre, Working Papers Series No. 31, November 1974.

Skinner, W. and Rogers, D., *Manufacturing Policy in the Furniture Industry*, 3rd edn, Homewood, Illinois, 1968.

Slom, S. H., *Profitable Furniture Retailing*, New York, 1967.

Smith, H., 'On taking furniture seriously', *Furniture Trades Yearbook*, 1926.

Smithells, R., *Make yourself at Home, ways and means of furnishing today*, London, Royle, 1948.

Smithells, R., *News of the World Better Homes Book*, London, 1954.

Smithells, R. and Woods, S. J., *The Modern Home: its furnishing and equipment*, Benfleet, 1936.

Smithson, P., 'Reproduction Modern', *Architectural Review*, August 1964, 136, pp. 143–4.

Sparke, P., *Did Britain Make It? British Design in Context 1946–1986*, London, Design Council, 1982.

Sparke, P., *Furniture*, London, Bell and Hyman, 1986.

Sparkes, I., *Wycombe Chairmakers in Camera*, Buckingham, 1989.

Sparrow, S. W., *Hints on Home Furnishing*, 1909.

Spooner, C., *The Arts Connected with Building*, London, 1909.

Standing Committee on Price Investigation, *Findings and Decisions of a sub-committee appointed to investigate furniture pricing*, HMSO, 1920.

Stevenson, J. W., *Practical Upholstery, A Complete Handbook*, 1937.

Stier, L. G., *Analysis of the Cabinetmakers Trade*, University of California, Berkeley, 1923.

Strategic Policies Unit, *Beneath the Veneer, London Furniture Workers Report on the Collapse of their Industry*, 1986.

Survey of the British Furniture Industry, London, NTP, 1950, 1952, 1954.

Swaisland, A., 'Furniture's small firm problem', *Personnel*, 1:10, September 1968, pp. 32–4.

Symonds, R. W., 'English furniture, traditional and modern', *Journal of the Royal Society of Arts*, July 1948.

Tilson, B., 'Modern Art Department, Waring And Gillow 1928–1931', *Journal of the Decorative Arts Society*, 8, 1984, pp. 40–9.

Tilson, B., 'Stones of Banbury, 1870–1978, a casualty of the recession', *Furniture History*, 23, 1987.

Tilson, B., 'Plan Furniture 1932–1938: the German connection', *Journal of Design History*, 2:3, 1990.

Times Furnishing Co., *The Times Furnishing Company: its History, its Service, its Policy*, c. 1925.

Times Furnishing Co., *Better Furniture*, c. 1936.

Tookey, D., *The Market for Imported Furniture*, 1984.

Tomrley, C. G., *Furnishing your Home; A Practical Guide to Inexpensive Furnishing and Decorating*, London, 1940.

Tomrley, C. G., 'Contemporary decoration for furniture', *Design*, 47, November 1952.

Trippe, P., 'Mass production methods in a craft industry', *Mass Production*, 38, February 1962.

Ullmann, F., *Report of a lecture given to the Worshipful Company of Furniture Makers*, at the RSA, 6 April 1970.

United Nations, *Technical Assistance, administration design and manufacture of wooden and rattan furniture in the Philippines*. Report and Recommendations of a UN expert, New York, 1952.

United States Dept. of Commerce, *European Markets for Furniture*, 1925.

United States Dept. of Commerce, *Austrian, Czechoslovak Lumber and Woodworking Industries*, Trade Information Bulletin # 196 Lumber Division, n.d.

United States Dept. of Commerce, *Furniture, its Selection and Use*, Washington, 1931.

Vachel, H. A., *The Homely Art. An Essay on Furnishing*, Schoolbred, 1928.

Vaughan, A., *The Vaughans, East End Furniture Makers*, ILEA, London, 1984.

Venesta Ltd, *Our First Fifty Years, the Story of Venesta, 1898–1948*.

Wainwright, S., *Modern Plywood*, London, Benn, 1927.

Wainwright, S., 'The Waring Exhibition', *Creative Art*, 4, February 1929.

Wainwright, S., 'The modern home and its decoration', *Decorative Art*, 1930.

Walters, N., 'Surveys of Industry, Furniture', *Design*, 147, March 1961.

Warner, C. F., *Home Decoration*, The Library of Work and Play, 1917.

Ways, *Modern Ways of Increasing your Sales of Furnishings etc.*, London, 1952.

Weaver, L., 'Tradition and modernity in craftsmanship, II, furnishing and shopkeeping', *Architectural Review*, June 1928.

Weaver, L., 'Tradition and modernity in craftsmanship, IV, furniture at High Wycombe', *Architectural Review*, January 1929.

Weaver, L., *Laminated Board and its Uses. A Study of Modern Furniture*, London, Fanfare, 1930.

Wells, P., 'The DIA, the Machine and Furniture Design', *Artwork*, February-April 1925.

Wells, P. and Hooper, J., *Modern Cabinet Work, Furniture and Fitments*, 6th edn, Batsford, 1952.

Westwood, B., 'Plywood – A Review', *Architectural Review*, 86, 1939, pp. 123–42.

White, J. N., *The Management of Design Services*, London 1973.

Whitechapel Art Gallery, *'Setting up Home for Bill and Betty'*, Exhibition Handbook, London, 1952.

Whitechapel Art Gallery, *Modern Chairs 1918–1970*, exhibition catalogue, 1970.

Whitehead, W. J., *Within the Private Office of the House Furnishing Trade*, Chatham, 1931.

Whiteley, N., 'Semi-works of art, consumerism, youth culture and chairs in the 1960s', *Furniture History*, 1987.

Whiteley, N., 'Towards a throwaway culture. Consumerism, style obsolescence and cultural theory in the 1950s and 1960s', *Oxford Art Journal*, 10:2, 1987.

Wilk, C., *Thonet: 150 Years of Furniture*, New York, 1980.

Wilk, C., *Marcel Breuer, Furniture and Interiors*, New York, 1981.

Wilson, J., *Decoration and Furnishing: Materials and Practice*, London, 1960.

Wilson, L. and Balfour, D., 'Developments in upholstery construction in Britain during the first half of the 20th century', in M. Williams (ed.), *Upholstery Conservation*, American Conservation Consortium, East Kingston, NH, 1990.

Witt-Dorring, C., 'Illusion and reality – form and function in modern furniture *c.* 1900', *Journal of the Decorative Arts Society*, No. 7.

Wollin, N. G., *Modern Swedish Decorative Art*, London, 1931.

Wood, A. D. and Linn, T. G., *Plywoods, Development, Manufacture and Application*, London, Johnstons, 1942.

Wood, H. W., *Old Charm for Ever*, Ilfracombe, Arthur Stockwell, 1990.

Worswick, G. D. N. and Ady, P., *The British Economy 1945–50*, Oxford, Clarendon, 1952.

Yakobson, L., 'Standard furniture', *Design for Today*, September 1935.

Yerbury, F. R. (ed.), *Modern Homes Illustrated*, London, Odhams, 1947.

Yorke, F. R. S., 'An Architect visits the Ideal Home Exhibition', *Architectural Review*, 71, 1932, pp. 216–18.

Young, D., 'Freedom of design with latex foam', *Latex Foam in Furniture*, Report of a Conference organised by the British Rubber Development Board, London, May 1954.

Young, D., *Home Furnishings on a small income*, London, 1955.
Young, D. and B., *Furniture in Britain Today*, London, Tiranti, 1964.

Unpublished sources

A History of Harris Lebus 1840–1947, typescript, 1965, Furniture Collection Archives, Victoria and Albert Museum, London.
Lowe, D., *The Furniture Industry of High Wycombe since 1870*, M.Phil. London, 1983.
Sizer, P. W., *Some Economic Problems of Hire Purchase*, M.Sc. University of London, 1966.
Weale, M., *Contributions of Designers to Contemporary Furniture Design*, thesis, Florida State University, 1968.

Magazines and journals

Architects Journal
Architectural Review
Art and Industry
Blueprint
British Plastics
Business Monitor
Cabinet Maker
Design
Design for Today
Engineering
European Journal of Marketing
Fortune
Furniture and Decoration
Furniture History
Furniture Manufacturer
Furniture Record
Furnishing
Industrial Design
Interiors
International Management
Journal of Decorative Arts Society
Journal of Design History
Journal of the Royal Institute of British Architects
Journal of the Royal Society of Arts
Machine Woodworker
Management Today
Marketing Week
Market Place
Mass Production

Bibliography

Material History Bulletin
Mechanical Engineering
Production Engineer
Rubber Developments
Rubber Technology
Studio
Timber and Plywood Annual
Times Review of Industry and Technology
Woman's Journal
Woodworking and Furniture Digest
Woodworking Industry

Index

Index

Index

Utility, *See* industry, Government restrictions

veneer, 89
Venesta, 12

Waring and Gillow, 161, 169
wartime influences, 57–62
Whitechapel Art Gallery, 187
wholesaling, 136
wicker, 49
Williams Furniture supermarkets, 165
Windsor chair, 61, 94, 111, 179
wire and rod, 41
Wood H., 29

wood, 8–10
 beech, 61
 densified, 21
 elm, 61, 63
 mahogany, 176
 oak, 9, 176, 179
 pulp, 46
 synthetic, 21
 teak, 86, 87
 walnut, 176, 180
 wood fibre, 46
Woodmet, 45
work study, 67
Working Party Report (1946), 15, 61, 66, 80, 107, 117, 125, 183–4, 185